Japanese Ink Painting

THE HEIBONSHA SURVEY OF JAPANESE ART

For a list of the entire series see end of book

CONSULTING EDITORS

Katsuichiro Kamei, *art critic*
Seiichiro Takahashi, *Chairman, Japan Art Academy*
Ichimatsu Tanaka, *Chairman, Cultural Properties Protection Commission*

Japanese Ink Painting: Shubun to Sesshu

by ICHIMATSU TANAKA

translated by Bruce Darling

New York · WEATHERHILL/HEIBONSHA · Tokyo

This book was originally published in Japanese by Heibonsha un-
der the title *Shubun kara Sesshu e* in the Nihon no Bijutsu Series.

First English Edition, 1972

*Jointly published by John Weatherhill, Inc., 149 Madison Avenue, New York,
New York 10016, with editorial offices at 7-6-13 Roppongi, Minato-ku, Tokyo
106, and Heibonsha, Tokyo. Copyright © 1969, 1972, by Heibonsha; all rights
reserved. Printed in Japan.*

LCC Card No. 73-183522 *ISBN 0-8348-1005-0*

Contents

Japanese Ink Painting

The Transition from the Ancient to the Medieval Age

BEFORE EMBARKING on the main theme of this book I should like first to discuss the transition from the ancient to the medieval period and thus to place the subject of Japanese ink painting in proper historical perspective. This transition represents an important change in the overall flow of Japanese art history and reflects the social upheavals of the times. Indeed, according to some scholars, the change amounted to a full 180-degree shift. Thus, if we proceed merely with a discussion of Shubun and Sesshu and their followers, we are destined to end up without a real understanding of the significance of these artists in terms of the history of art or of the new artistic trends they represented.

THE ART OF THE ANCIENT PERIOD In Japanese art history the term *kodai*, or ancient period, generally refers to the approximately 250-year span encompassing the Asuka (552–646) and the Nara (646–794) periods. While various theories have been proposed concerning the terminal date of this age, here I shall consider the Heian period (794–1185) as an extension of it. Since the ancient period as a whole is too broad an expanse to cover in the present limited space, we shall concentrate instead on the rather small number of paintings that have come down to us from that time.

The earliest remaining examples of *kodai* painting are the seventh-century murals in the Golden Hall of the Horyu-ji in Nara (Fig. 2), which were almost completely destroyed in a fire in 1949, and the paintings in the eighth-century Shoso-in repository of art treasures, also in Nara. The foundation for the development of *kodai* art lay in the support provided by the aristocracy. While the works themselves included some painted by members of this class, they were for the most part produced by artisans and others of low social status who served the aristocracy in what I would venture to call a kind of slavish existence. From such sources as the eighth-century *Nihon Shoki* (Chronicles of Japan) and documents preserved in the Shoso-in, we can discern no more than a hundred or so names of artisans who served in this capacity during the Asuka and Nara periods. We know that the majority of these people arrived in Japan as emigrants from the Asian mainland, and it was they who formed the core of artistic production during this age. Rather than being artists in the present sense of the word, these people were more likely highly skilled technicians or craftsmen. Their existence, though I have called it slavish, was not at all like that of slaves in Europe. It was, rather, a one-dimensional existence, for, in spite of their being the people responsible for transplanting the highly developed

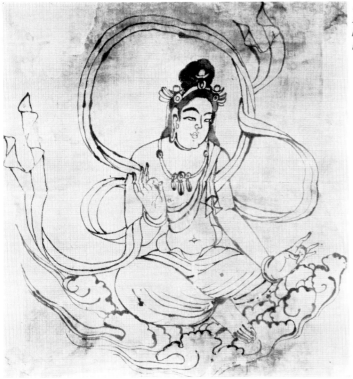

1. Bodhisattva *(detail)*, *by an unknown artist. Ink on hemp cloth; dimensions of entire painting: height, 138.5 cm.; width, 133 cm. Eighth century. Shoso-in, Nara.*

2. The Paradise of Amida Buddha *(detail)*, ▷ *by an unknown artist. Colors on white clay wall; dimensions of entire painting: height, 312 cm; width, 266 cm. Late seventh or early eighth century. Destroyed by fire in 1949. Horyu-ji, Nara.*

continental culture, they were treated much like mere objects and were not recognized as individuals. In any event, these artisans supplied their own skills in a cooperative and specialized effort within the framework of the craft-production studios, their individualities being absorbed into the solidarity of the workshops through a division of labor.

The works produced by the artisans of this age, such as the Horyu-ji murals and the Shoso-in treasures, exhibit a uniformity of style that has an international quality about it. At this time, cultural exchange flourished between T'ang-dynasty (618–906) China and its neighbors by means of goods carried back and forth on the backs of men and animals along the famous Silk Road across Central Asia. Ch'angan, the lively T'ang capital, formed the hub of a large cultural area that stretched across Central Asia to the borders of the West and

included Japan in the East. Even when we consider periodic artistic styles rather than particular individual qualities derived from nation and race, we find a strong coherence and universality that characterized the general artistic style of the Japanese ancient period and pervaded the whole Orient. A comparison of T'ang art with that of the Nara period in Japan reveals many works so similar that it is extremely difficult to discern their true origin. In seeking the explanation of this similarity, we must not overlook the role of the foreign artisans living in Japan. The aristocratic society that appreciated such art was based not only on wealth and social status but also on international culture.

The artisans and technicians embodied the artistic tastes of this aristocracy in their works. They were of low rank and were employed in the service of the government. Several dozen such painters

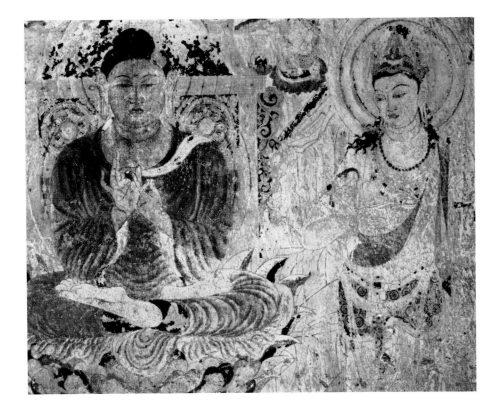

belonged to the Edakumi no Tsukasa, or Painters' Bureau, a government office within the Ministry of Central Affairs. During the Nara period many of the heads of this bureau were chosen from among the foreign artisans living in Japan. The painters employed by the bureau, which was the center of ancient-period painting, fulfilled the requests of the aristocracy. For example, when a hall of a large temple was to be constructed, employees of the Painters' Bureau were assigned to do the wall paintings and decorations. When the aristocrats required certain articles for daily use, employees of the Painters' Bureau would meet their requests. Sometime after the beginning of the Heian period (the exact date is unknown) this center of painting production was transformed into the Edokoro, or Painting Office, of the imperial court and thus became the predecessor of the Japanese academy.

SECESSION FROM THE CHINESE CULTURAL SPHERE

The Edokoro served as the center of painting activity throughout the Nara period and for quite a long time during the Heian period. As time went by, the foreign painters who made up the core of the original Painters' Bureau became naturalized in the Japanese milieu. Their personalities and painting styles were gradually acclimatized to their new country, and their work began to emerge from the overriding influence of the continental style that was so strong in the paintings of the preceding generation. These painters did not completely abandon their adoration of China and withdraw from the nearly homogeneous Oriental cultural sphere, which remained intact through the Nara period, but still continued, rather, to borrow from the previous generation. During the late Hei-

3. *Landscape detail from decoration on a* biwa *(lute), by an unknown artist. Colors on leather; dimensions of entire painting: height, 40.5 cm.; width, 16.5 cm. Eighth century. Shoso-in, Nara.*

4. Lady Under a Tree *(detail from a screen panel), by* ▷ *an unknown artist. Colors on paper, embellished with feathers; dimensions of entire painting: height, 136 cm.; width, 56 cm. Eighth century. Shoso-in, Nara.*

5. *Sung-dynasty miniature pagoda of gilt bronze. Tenth cen-* ▷ *tury. Seigan-ji, Fukuoka City, Fukuoka Prefecture.*

an, or Fujiwara, period (897–1185), however, the style exhibited considerable change. This was the period of the regency government controlled by the Fujiwara family, the most powerful of aristocratic families, which largely abandoned the structure of the earlier bureaucratic government established under a legal system. The bureaucratic government, derived from the governmental structure of T'ang China, gradually lost its continental flavor and adapted itself to the purely Japanese situation.

The collapse of the T'ang empire, which had held sway over the Asian world for nearly three centuries, marks the dismantling of the Oriental cultural sphere and hence indicates a significant change in the direction of Oriental culture as a whole. The traffic along the Silk Road across Central Asia declined, and China now stood alone while the newly risen Sung dynasty managed to extract itself from the T'ang universalism and pro-

ceeded to create a culture and an art of its own, although still retaining aspects of the T'ang. Meanwhile, Japan, Korea, and other neighboring countries began to develop their own individual artistic traditions.

The island nation of Japan, which had formerly been the eastern reach of the cultural sphere centering on Ch'angan and Loyang, now removed itself from T'ang universalism and created its own separate cultural and artistic world, with its center located at the new Heian-period capital Heian-kyo (the present Kyoto). The art that Japan had been adopting from the continent had at last been assimilated, and the opportunity to create a more indigenous culture was at hand.

We must now determine how the flow of *kodai* art diminished during the four centuries of the Heian period. While the painting of the Nara period may be divided into two main types—religious (Bud-

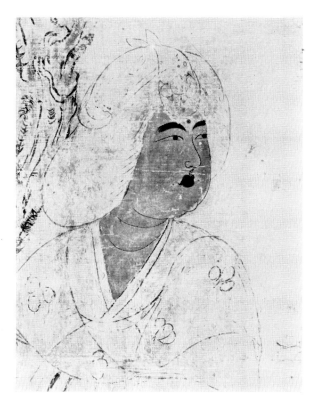

dhist) painting and nonreligious (secular or genre) painting—stylistically there was not much difference between the two, and we may view them as two aspects of the aristocratic society of the ancient period. The main format for the nonreligious paintings, tied in as they were with the daily lives of the aristocracy, was the *shoheiga*, a generic term for paintings on walls, sliding interior partitions (*fusuma*), and screens (*byobu*). The main format for the religious paintings—for example, the Horyu-ji murals—was also a large painting surface on which scenes of the Buddhist paradise were often depicted (Fig. 2).

Gradually, however, the production of such large-scale wall paintings began to decline on the continent, and in Japan, too, they diminished in size and little by little lost their importance. One reason for this may be that there was an increase in the production of hanging scrolls (kakemono), which could be displayed or removed as the occasion required. During the ninth century, large-scale hanging scrolls were still produced, but later, like the wall paintings, they gradually decreased in size. The representation of Buddhist deities with strange tropical shadings and other continental features, as in the Horyu-ji murals, became less and less frequent, and the paintings acquired a gentleness and delicacy through a process that we may call "Japanization."

Any discussion of nonreligious painting necessitates distinguishing between *kara-e* (literally, "Chinese painting") and *yamato-e* (literally, "Japanese painting"). Briefly, the former term generally refers to paintings with Chinese themes and the latter to paintings dealing with native Japanese subject matter. An examination of the art of this early time reveals that practically no paintings were done on Japanese themes in the Nara period,

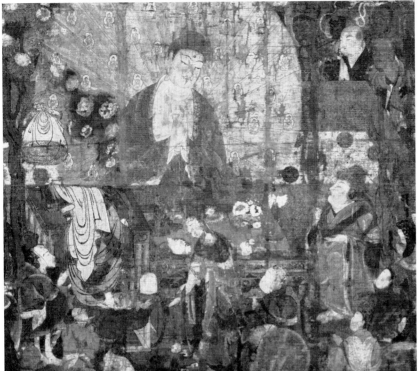

6. Shaka Rising from the Golden Coffin *(detail)*, *by an unknown artist. Colors on silk; dimensions of entire painting: height, 160.3 cm.; width, 229.7 cm. Late eleventh or early twelfth century. Matsunaga Memorial Hall, Odawara, Kanagawa Prefecture.*

7. *Landscape detail from a door* ▷ *painting of the genre known as* Amida Raigo *(Amida descending from paradise to welcome the soul of a dying believer), by an unknown artist. Colors on wood. Dated 1052. Phoenix Hall, Byodo-in, Uji.*

thus allowing us to state that throughout this period nearly all the painting may be referred to as *kara-e*. But with the decline of continental influence a gentle and more appropriately Japanese style slowly evolved for the depiction of Japanese themes, and this style is known as *yamato-e*.

During the Heian period the *kara-e* style was transformed into a distinctively Japanese style, and the differences between the two gradually disappeared. Hence I think there are only minor problems to be resolved in placing this period, along with the Nara and Asuka periods, in the ancient age. For, while the subject matter of *kara-e* and *yamato-e* was different, the painting styles themselves were rather similar, and there was nothing in either one that was not inherited during the Nara period from the T'ang style. There was no such occurrence as the adoption of a completely new and separate style that arose and challenged the inter-national T'ang style. Oriental art of the ancient period was transplanted to Japan during the Nara period and then developed into a beautiful aristocratic Japanese art. Consequently, there should be no difficulty in viewing this art as falling within a stylistic extension of the *kodai* style. The late Heian, or Fujiwara, period thus nurtured an art within the same stylistic flow as that which had already been assimilated in Japan and did not cultivate an art that exhibited any changes toward a new artistic style that rejected the earlier tradition. This fact further supports my contention that the Heian period may be viewed as an extension of the *kodai*.

Now, who were the producers of this art? Official government establishments like the above-noted Edakumi no Tsukasa and the Edokoro of the Japanese court have, in fact, a precedent in the bureaucratic office called the Shangfang (in Japanese, Shobo) that existed in China from the Six

Dynasties period (c. 222–589) to the T'ang period. The employees of this office shared some characteristics with the Japanese painters referred to above. For example, they displayed qualities more like those of technicians than those of artists and seemed to be lower-ranking craftsmen. Of course the Shobo organization, the authority for *kodai* art, remains an important area for future research. In the T'ang period this office changed its name to Hanlin Yuan (in Japanese, Kanrin-in), or what may be called the T'ang Academy. In the Sung period (960–1279) the office assumed the character of a true academy with the establishment of the Hanlin T'uhua Yuan (in Japanese, Kanrin Toga-in), or Sung Academy. The painters now rose to positions of rank in the Chinese court, thereby advancing from the state of mere craftsmen to that of real artists given the freedom to pursue, more or less, their own individual roles.

In Japan, however, painters with freedom equivalent to that of the Chinese artists did not appear immediately, although in the latter half of the ninth century the names of famous individual painters like Kudara no Kawanari and Kose no Kanaoka do come to attention. The name of Kawanari indicates that he was of Korean descent, for Kudara is the Japanese name for the ancient Korean kingdom of Paekche. Kanaoka was a man of high social position, head of the imperial Shinsen-en garden-estate and friend of the poet and state minister Sugawara no Michizane (845–903). Here at last, in the person of Kanaoka, we see a real artist emerging from the bureaucratic organization. Thus, although artists like Wu Tao-tzu and Han Kan had already made their appearance in China by the T'ang period, in Japan conditions did not begin to move in this direction until about the beginning of the tenth century. The Japanese painting world continued to

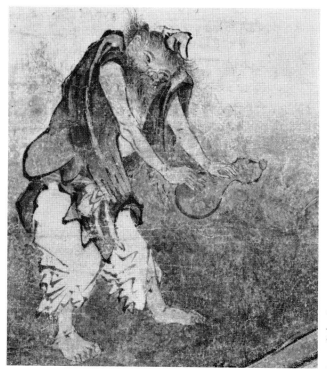

8. Catching a Catfish with a Gourd *(detail)*, *by Jasoku. (See also Figures 10 and 65). Colors on paper; dimensions of entire painting: height, 111.5 cm.; width, 75.8 cm. Early fifteenth century. Taizo-in, Myoshin-ji, Kyoto.*

retain a little longer the technician-craftsman character that it displayed in the *kodai* age. A real academy had not yet been established. The power of the *kodai* aristocracy, which served to support this classical artistic tradition, continued throughout the Heian period, thus allowing no real opportunity for an opposing artistic style to arise and challenge the tradition. In summary, the development of *kodai* art in Japan proceeded along a single, fairly tranquil path until about the twelfth century, during which time it merely acclimatized itself to the Japanese setting and represented only a variation of the basic T'ang international style.

THE END OF THE ANCIENT PERIOD

As the twelfth century drew to a close, the Heian aristocracy crumbled in the bitter civil war between the Taira and the Minamoto clans, which ended with the defeat of the Taira and

the establishment of a shogunate government at Kamakura, in eastern Japan, by the Minamoto leader Yoritomo. Using military might to maintain control, Yoritomo and his warriors established a system of government that eclipsed the aristocratic government in Kyoto, even though the new system did not entirely replace the old one.

Now, how did the nature of Japanese art change when the social base that had fostered it underwent such violent upheaval and lost its power? Roughly speaking, the art of the new age revealed for the first time a current that denied the *kodai* tradition. As we shall see, this is not just an abstract theory but is borne out by an examination of actual works of art.

Nevertheless, a complete conquest of the *kodai* tradition cannot be claimed for the Kamakura period (1185–1336), as the new age came to be known in Japanese history. In the political arena,

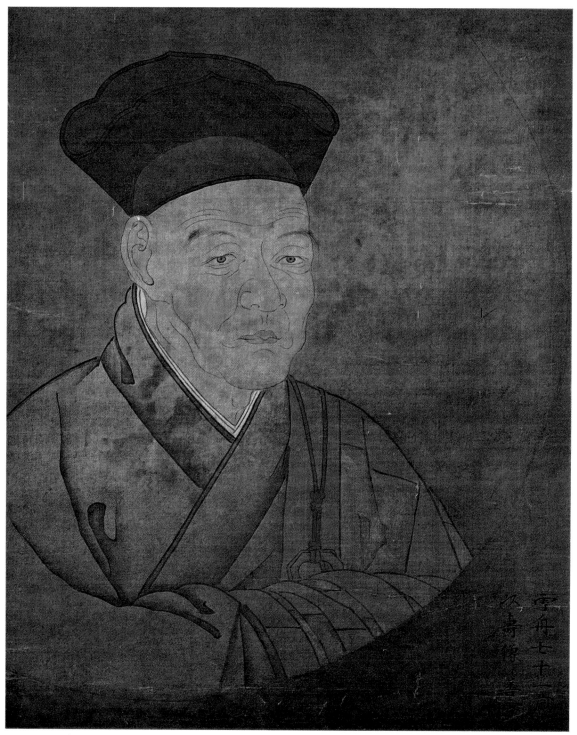

雪舟七十 ー
以壽徳善

9. *Portrait of Sesshu (detail), by Tokuriki Zensetsu. Colors on silk ; dimensions of entire painting : height, 76 cm. ; width, 34.5 cm. Seventeenth century. Collection of Yukihiko Yasuda, Kanagawa Prefecture.*

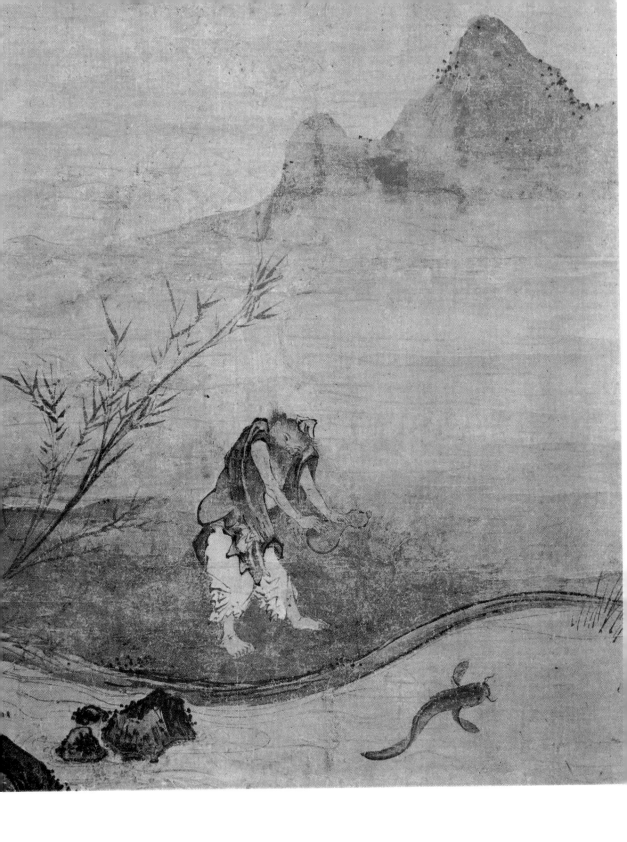

六年飢食微些用髓
苦行是佛祖玄旨
信道世天釋迦子
天下相逢飲益子
右題芦り釈迦像元
酬恩庵常信
康正二戴乗如々一莖十宗比

◁ *10. Catching a Catfish with a Gourd, by Josetsu, with inscriptions by Daigaku Shusu and thirty other priests (see Figure 65). Colors on paper; dimensions of entire painting, including inscriptions; height, 111.5 cm.; width, 75.8 cm. Early fifteenth century. Taizo-in, Myoshin-ji, Kyoto. (See Figure 8 for detail.)*

11. Shaka Practicing Austerities, attributed to Jasoku, with an inscription by Ikkyu. Colors on paper; height, 115.4 cm.; width, 54 cm. Dated 1456. Shinju-an, Daitoku-ji, Kyoto.

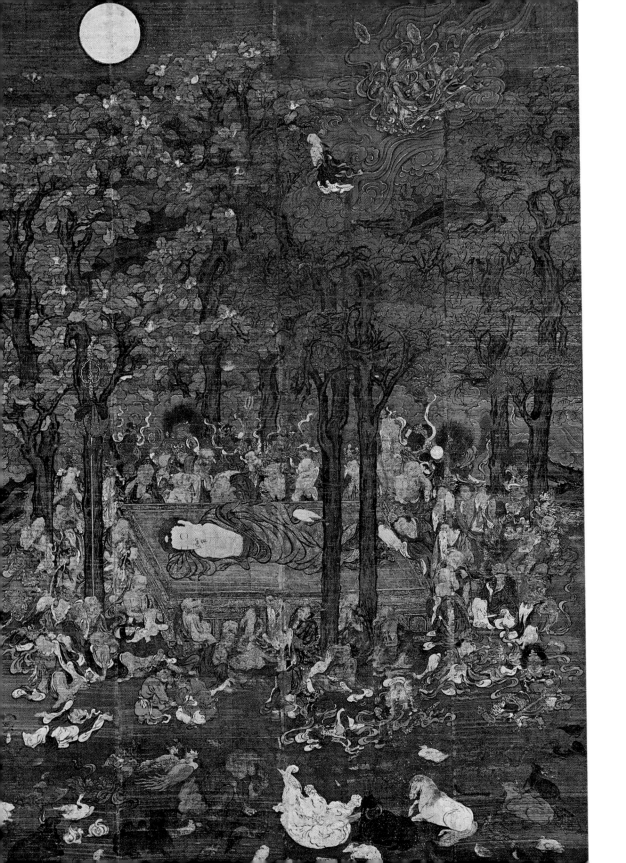

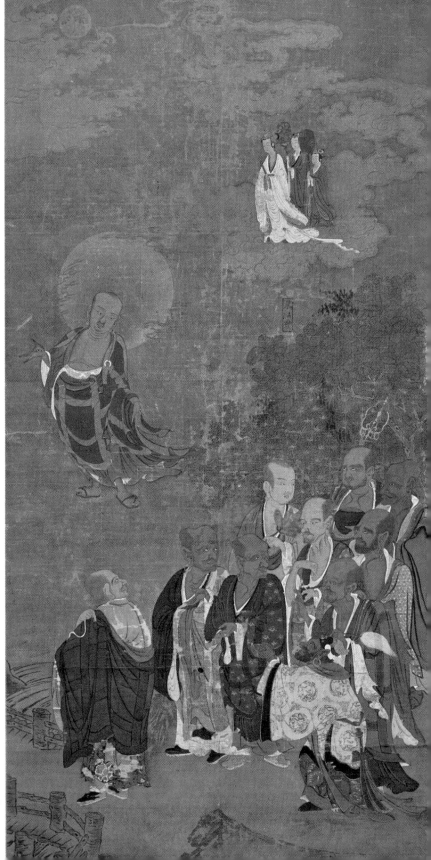

◁ 12. The Nirvana of the Buddha, by Reisai. Colors on silk; height, 206 cm.; width, 145.5 cm. Dated 1435. Taizokyo-ji, Yamanashi Prefecture.

13. Scroll from The Five Hundred Rakan (a set of fifty scrolls), by Mincho. Colors on silk; height, 173 cm.; width, 89.7 cm. About 1386. Nezu Art Museum, Tokyo.

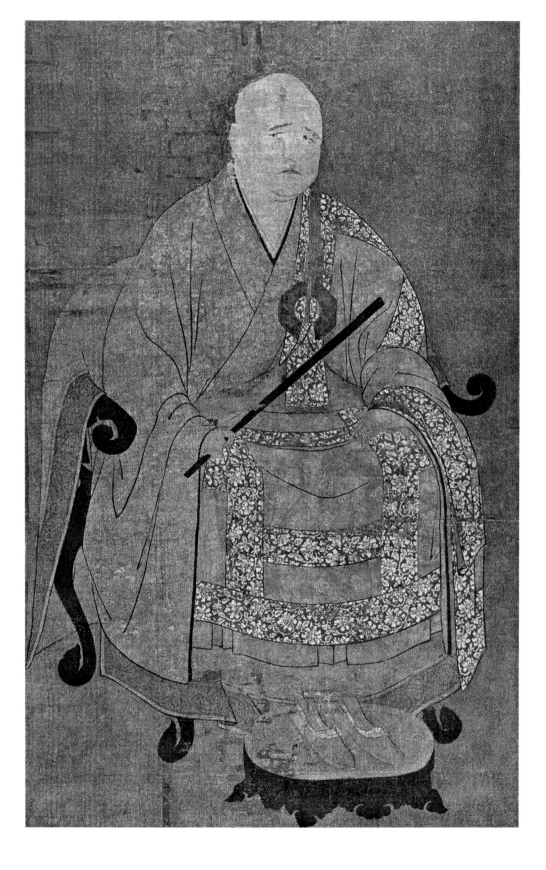

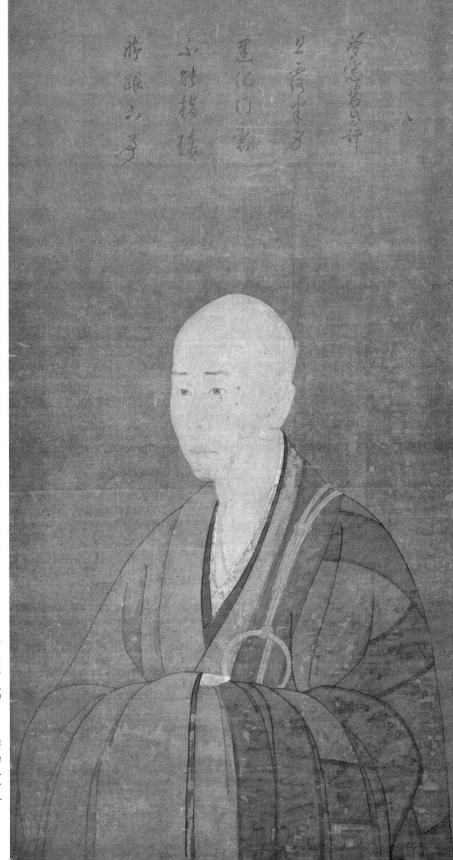

14. *Portrait of Daito Kokushi (Shuho Myocho), by an unknown artist, with an inscription by Daito Kokushi. Colors on silk; height, 115.7 cm.; width, 56.7 cm. Dated 1334. Daitoku-ji, Kyoto.*

15. *Portrait of Muso Kokushi (Muso Soseki), by Muto Shui, with an inscription by Muso Kokushi. Colors on silk; height, 119.1 cm.; width, 63.9 cm. Dated 1349. Myochi-in, Tenryu-ji, Kyoto.*

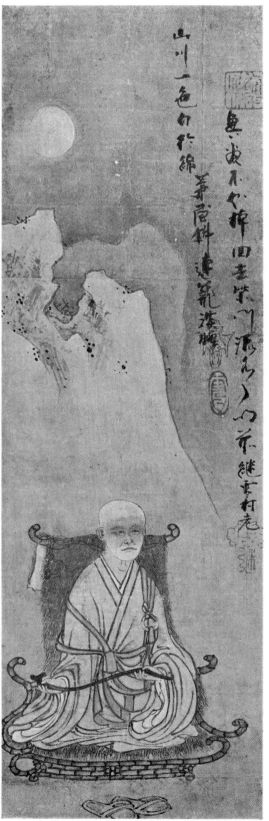

16. *Self-portrait, by Sesson, with an inscription by the artist. Colors on paper; height 65.5 cm.; width, 22.2 cm. Sixteenth century. Yamato Bunkakan, Nara.*

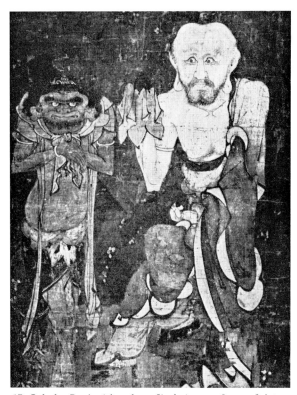

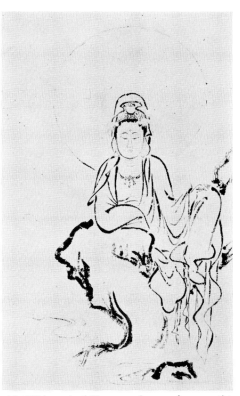

17. Jubaka Sonja *(the* rakan *Jivaka) : one of a set of sixteen scrolls portraying the Sixteen Rakan, by an unknown artist of the Northern Sung dynasty. Colors on silk; height, 82.1 cm.; width, 36.4 cm. Late tenth century. Seiryo-ji, Kyoto.*

18. White-robed Kannon, *by an unknown artist. Ink on paper. Thirteenth century. Formerly in the Kozan-ji, Kyoto.*

the military rulers did not cleanly sweep away either the system of rule by cloistered (or retired) emperors or the *kodai* system called the *ritsuryo:* a structure based on a penal code *(ritsu)* and a civil and administrative code *(ryo).* A double-layered structure was thus created as the Kamakura rulers drove in a wedge of force to assume economic and military power, while at the same time the old bureaucratic organization continued to exist. In the cultural arena, *kodai* art had been assimilated to a considerable degree, and its entrenched stylistic tradition could not be conquered overnight. Thus a double-layered framework also existed in the painting world of the Kamakura period, for both the

supporters of the *kodai* tradition and those who denied it were part of this world. In other words, the Kamakura period was a transitional age between the *kodai* and the *chusei,* or medieval period. The true emergence of a new art had to wait until the Muromachi period (1336–1568), when the Ashikaga shoguns, establishing their seat of government in Kyoto, created a new artistic world and a new academy. This is the most important point in the present discussion, for it was only during the Muromachi age that the *kodai* tradition was at last overcome.

Still, a long reform movement had to precede the establishment of the medieval academy, and the

19. Miroku Bosatsu *(the Bodhisattva Maitreya)* : *detail from a Sung-dynasty woodblock print found inside the main image at the Seiryo-ji. Dated 984. Seiryo-ji, Kyoto.*

necessary period of preparation for this artistic reformation extended as far back as the Fujiwara period. It is essential at this point to consider the influences from the Asian continent; so I should like to discuss briefly the transition from the T'ang to the Sung dynasty in China.

An examination of the trends in Chinese painting during this transitional age reveals that, on the whole, religious art of the period was already showing signs of decline. The representation of Buddhist deities fell away from that which had characterized the earlier brilliant T'ang paintings, diminishing in both scale and overall quality and perhaps thus marking the termination of religious—that is, Buddhist—painting in China. The decline resulted from the gradual estrangement between Buddhist absolutism, as represented in the T'ang devotional paintings, and the spiritual life of the Chinese

society of the time. The liberation of men from the confines of religion was one of the aims of the newly risen Sung society, and with this a new culture and a new art were brought into being. In this respect, we must not overlook the establishment of the above-noted Hanlin T'uhua Yuan by the Sung imperial court. We must note also the rise of a gentry-official class, the *shih-tai-fu* (in Japanese, *shitai-fu*), which might be described as a class of cultivated gentlemen and literati and included such eleventh-century politicans as Wang An-shih, Su Tung-p'o, and Ssu-ma Wen. Although its roots may be found in the T'ang period, the existence of such a class, struggling between the aristocracy and the military for political power, is a special phenomenon of the Sung period. In other words, during this period the gentry were breaking away from China's own *kodai* traditions, which had had their center in

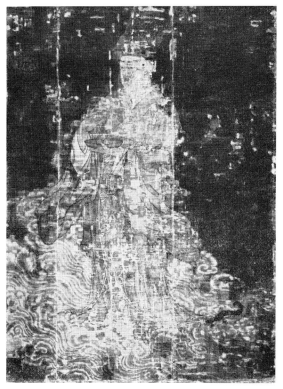

21. Zennyo Ryuo *(a Buddhist deity)*, *by Jochi. Colors on silk; height, 164.3 cm.; width, 111.7 cm. Twelfth century. Kongobu-ji, Mount Koya, Wakayama Prefecture.*

20. The Departure of the Buddhist Saint Hai-tung, *by an unknown artist of the Southern Sung dynasty. Ink on paper; height, 64.5 cm.; width, 37.2 cm. Late twelfth or early thirteenth century. Tokiwayama Bunko, Kanagawa Prefecture.*

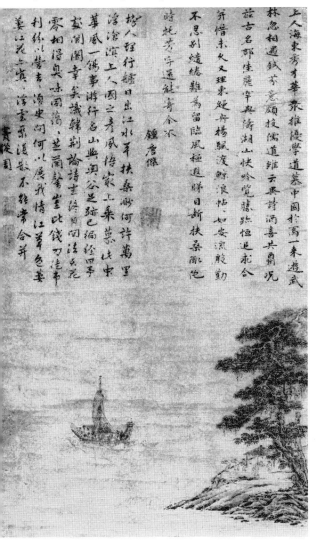

the aristocracy. In artistic circles, this change is reflected in the existence of the Hanlin T'uhua Yuan, which functioned to create an independent world of artists. The gentry, although holding political power gained through their success in the Chinese examination system, also pursued their personal literary and artistic interests and, after retiring from public life, enjoyed a pastoral existence surrounded by painting, literature, and music. This was an entirely different world from that of *kodai* society: a world characterized by a kind of human freedom that would have been unthinkable in earlier ages.

Let us examine the relationship between Japan and Sung China to see how the emergence of this free class of people affected Japan. The cultural exchange between Japan and China continued to some extent even after the official Japanese missions

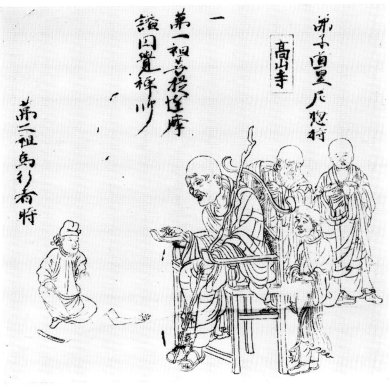

22. The First Zen Patriarch, Bodhidharma *(detail from a painting portraying the six patriarchs of the Daruma sect of Zen Buddhism), by an unknown artist. Ink on paper. Thirteenth century. Kozan-ji, Kyoto. In the scene shown here, Hui-k'o (in Japanese, Eka) has cut off his arm and offered it to Bodhidharma in proof of his determination to become one of the patriarch's disciples.*

23. *Section of picture scroll* Choju Jimbutsu Giga *(Scroll of Frolicking Animals and People), attributed to Toba Sojo (Kakuyu). Ink on paper; height, 30.3 cm. Twelfth century. Kozan-ji, Kyoto.* ▷

to the T'ang court ended. The priest Nichien of the Enryaku-ji (the Tendai Buddhist monastery on Mount Hiei on the outskirts of Kyoto), one of the early Japanese travelers to Sung China, crossed over to the continent during the first half of the tenth century and returned with a miniature Buddhist pagoda (Fig. 5) and other works of art. We do not know for sure the effect of priest Nichien's trip in relation to Japanese art, but we do know that other Chinese art objects continued to reach Japan. In the last half of the tenth century the priest Chonen of the Nara temple Todai-ji went to Sung China and returned with paintings of the Sixteen Rakan (a *rakan*, or *arhat*, is a Buddhist sage who has attained enlightenment) and a famous wooden statue of Sakyamuni (in Japanese, Shaka Nyorai), the historical Buddha, which today remains the main image in the Kyoto temple Seiryo-ji. Al-

though the *rakan* paintings brought back by Chonen are said to have been lost in a fire, other depictions that convincingly reflect the characteristics of Sung paintings still exist (Fig. 17).

Again, such travelers as Oe Sadamoto, who changed his name to Jakusho after entering the Buddhist priesthood, and the priest Jojin of the Onjo-ji (the temple in Otsu also known as Miidera), author of the *San Tendai Godaisan Ki* (Record of a Pilgrimage to the T'ient'ai Temple at Wut'aishan), sent back to Japan a number of Sung art works that they acquired in China. About the same time, various Buddhist iconographical drawings also found their way to Japan. In the twelfth century, documents sent by the Sung emperor Hui Tsung are said to have arrived in Kyoto, and the Sung court dispatched gifts to the powerful Taira leader Kiyomori in the hope of opening trade

between the two countries. Kiyomori, in turn, tried to encourage such trade by clearing the Ondo Strait so that large trading vessels could use the harbor. Moreover, Chinese records show that Japanese ships made a number of voyages to Sung China around this time. We also know that the third Minamoto shogun, Sanetomo (1192–1219), ordered the construction of a large ship suitable for trade with the continent, placing in charge of the project a Sung sculptor (known to the Japanese as Chinakei) who was resident in Japan and had achieved fame for his restoration of the Great Buddha at the Todai-ji. Chogen, a leading spirit in the restoration of the Todai-ji itself and the author of an important Buddhist treatise, visited Sung China twice. Nor should we forget the effect on the new cultural and artistic movement of such religious reformers of the day as the priest Eisai (1141–1215), who first transmitted Rinzai Zen Buddhism from China; Shunjo, who transmitted the Kairitsu doctrine; and Dogen, who introduced the Soto Zen doctrine.

Such cultural exchange between Japan and China as occurred from the Fujiwara period through the first part of the Kamakura period played an important role in preparing the ground for the germination of a new culture and a new art in the fourteenth century. Thus, while Sung art and culture entered Japan a little at a time over a rather long period in connection with trade between the two countries, we must also note the significant role played by Buddhist priests in introducing the same culture and art after having sojourned in China to further their religious studies.

CHAPTER TWO

Trends in the World of Early Medieval Painting

THE CONFRONTATION OF OLD AND NEW At the juncture of the twelfth and thirteenth centuries the confrontation between the long-established aristocracy and the newly risen warrior class produced widespread turmoil throughout the whole of Japanese society. Cultural and artistic currents began to move in a new direction with the advent of the *chusei,* or medieval age. The aristocracy, however, making no effort to extricate itself from its ancient style of life or from the cultural world that centered in Kyoto, sought to maintain its prestige and influence through the still-functioning *ritsuryo* political system. It goes without saying that the aristocrats strove to preserve the art of the *kodai* world as one of their traditions, but it was inevitable that the undercurrent of a new movement in art, paralleling the new movement in society itself, should be reflected in the art of the time.

The center of artistic activity at the beginning of the medieval age still lay in the court, the shrines, and the temples, which had been the authority for *kodai* culture and had fostered the earlier tradition. In fact, the artistic interests and intentions—the artistic will, so to speak—of the court nobles, the aristocracy, and the priests not only continued as before but also grew stronger. At the same time the court maintained the Edokoro as a government bureau of professional painters, or *eshi,* while temples and shrines sponsored the *ebusshi,* or painters of religious pictures. It is almost impossible, however, to make a clear distinction between the works of these two classifications of painters on the basis of content, style, or other characteristics, for there was much reciprocal borrowing and blending as they went about fulfilling the demands of their patrons for paintings of annual court events, paintings of Shinto and Buddhist deities for devotional purposes, and paintings for use as interior decorations in palaces and mansions.

The court-sponsored Edokoro, which was at a rather advanced stage of development in the thirteenth century, showed few changes in its organization, but the repercussions of the overall social upheaval permeated the whole of society. The aristocracy and the priesthood, representing the old tradition, offered rather strong resistance to the advance of the warrior class, but from the time of the civil war of the Jokyo era in 1221 the older tradition showed a steady decline.

Where, then, was the force that initiated the new artistic trend during the early years of the thirteenth century? It was not, in fact, to be found in the environs of Kamakura, the seat of the new military government, but rather in the court salon surrounding the retired emperors Goshirakawa (reigned

24. *Portrait of the retired emperor Gotoba, by Fujiwara Nobuzane. Colors on paper; height, 40.3 cm.; width, 30.6 cm. Dated 1221. Minase-jingu, Osaka.*

1155–58) and Gotoba (reigned 1183–98) in Kyoto. The *eshi* and the aristocratic painters assembled there had the opportunity to seek a new realism in their work. The *ebusshi* traveled back and forth between the Todai-ji and the Kofuku-ji in the old Nara capital and the Jingo-ji and the Kozan-ji in the northern part of Kyoto, where the retired emperors lived. These painters displayed two main tendencies, one of which was an attempt to revive the Nara court style, the other an attempt to grasp the new Sung Chinese style. Politically, a medieval feudal organization with the samurai class at its center gained strength in the provinces; culturally, the long-accumulated and refined artistic tradition of the aristocracy held sway in the nominal capital, Kyoto. But this tradition, rather than being thoroughly reactionary or rigidly conservative, was now stimulated by social developments and exhibited a self-conscious activity in the direction of a new

humanism and realism. There arose an almost spontaneous movement to absorb the popular spirit of the times, evidenced, for example, in the collecting of narrative tales (*setsuwa*) and songs (*kakyoku*) of the common people by the court and the aristocracy. Generally speaking, a variety of new movements appeared everywhere during the Kamakura period, set off, so to speak, by the sparks originating from the contact between the new and the old.

I should like to speak briefly here of the underlying power of the old tradition in its confrontation with the new. During the *insei* period—that is, the period of government by retired or "cloistered" emperors (1086–1321)—there was a group of *hokumen no bushi* (literally, "warriors of the north side") who served as protectors of the retired emperor's palace against the military forces of the Taira and the Minamoto clans and who took their name from

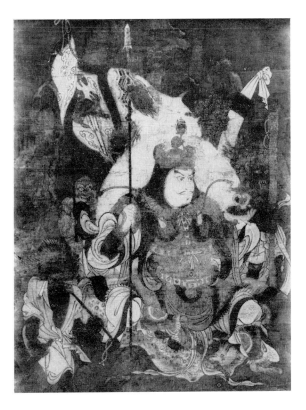

the fact that their quarters were located to the north of the palace. The famous wandering priest-poet Saigyo (1118–90) is said to have been one of the *hokumen no bushi* in the service of the retired emperor Toba (reigned 1107–23). Saigyo is of course well known for his *waka* poetry, which received the highest praise from the aristocracy, but he had another side that is perhaps less well known, for he was a powerfully built warrior type, more than a match for most of the brawny samurai from eastern Japan. One story about him relates that when he received a silver cat as compensation for having taught archery to Yoritomo, the future Minamoto shogun, he promptly gave it to a child playing at the gate of Yoritomo's residence. Another well-known anecdote tells about his encounter with Mongaku, a rough priest from the Jingo-ji at Takao in Kyoto who raised troops for Yoritomo. It seems that Mongaku had ridiculed Saigyo's

refined poetic life and threatened to give him a real thrashing if they ever chanced to meet. But when Saigyo at last went on an excursion to view the cherry blossoms at Takao, Mongaku, meeting him there, merely engaged him in pleasant conversation and parted from him without trying to strike a single blow. When Mongaku's followers reminded him of his earlier threat, he could only sigh and say, "Didn't you get a good look at his face? No sooner had I gone at him than I'd probably have been beaten within an inch of my life." The veracity of these stories aside, they do suggest the strong antagonism that the court-oriented people of Kyoto harbored toward the military upstarts from Kamakura.

The case of the military Taira clan, which joined the aristocracy against the Minamoto and ended up disastrously weakened and powerless after the Taira-Minamoto war, gives some idea of how

25 (opposite page, left). Bishamon Ten (one of the Twelve Celestial Beings): detail from a painting by an unknown artist. Colors on silk; dimensions of entire painting: height, 97.5 cm.; width, 40.6 cm. Thirteenth century. Collection of Nagataka Murayama, Hyogo Prefecture.

26 (opposite page, right). Portrait of the priest Gottan Funei (detail), by Choga. Colors on silk; dimensions of entire painting: height, 111.5 cm.; width, 50 cm. Dated 1265. Shoden-ji, Kyoto.

27. Portrait of the priest Saigyo, by an unknown artist. Colors on silk; height, 78.9 cm.; width, 39.5 cm. About fourteenth century. Collection of Yuji Eda, Tokyo.

strong the mysterious forces of *kodai* culture must have been to assimilate so quickly such recently rebellious warriors as the Taira. Thus we may appreciate Yoritomo's wisdom in deciding not to go into Kyoto, as the more impetuous Taira clan had done, but to locate his seat of government far to the east in Kamakura. When Yoritomo finally did come to the old capital to participate in the dedication of the restored Todai-ji, which had been destroyed by Taira warriors, the retired emperor Goshirakawa took out many scrolls and masterpieces of painting from the storehouse of the temple Rengeo-in for him to enjoy at the end of his long journey. But Yoritomo, perhaps somewhat apprehensive about Goshirakawa's motives, returned to Kamakura without having given them so much as a single glance. This episode illustrates the Kamakura warriors' reciprocal antipathy toward Kyoto culture.

Although the third Minamoto shogun, Sanetomo, was strongly infected by the Kyoto culture and for this reason met a tragic end by assassination, the Hojo regents, who held the real power in Kamakura after Yoritomo's death, followed closely Yoritomo's policy of maintaining a safe distance from Kyoto. This attitude of the warrior class, viewed from a slightly different angle, allowed the old tradition a long-term monopoly in the cultural arena and relegated the new artistic movement to a mere corner of the stage. The first encouragement of artistic reform came, strangely enough, not from the new military leaders but from the temples and shrines, which were so deeply involved with the old tradition. While the activities of the *yama hoshi*, or mountain priests—specifically the soldier-priests of the Enryaku-ji—brought suffering to the court and grief to the warrior class because of their militant behavior, the temples and shrines, which possessed

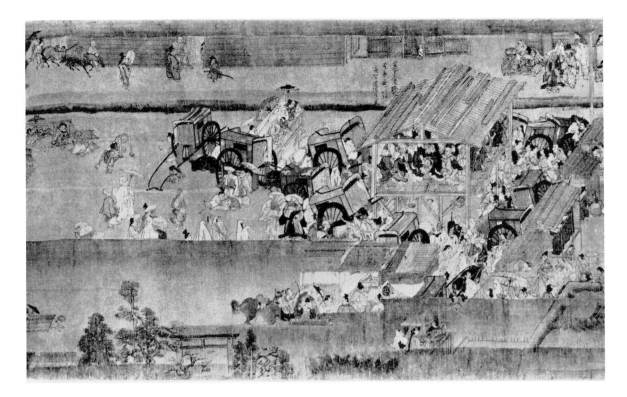

real social influence and were shielded by the old religious authority, also presented no mean opposition to the rising warrior class.

The new artistic movement was closely linked with the movement for religious reform in the Kamakura period. At a time when the *kodai* society was being dismantled, this religious reformation, whether in the newly founded Jodo Nembutsu sect of Buddhism or in the revitalized Kegon and Kairitsu sects, was a large and extremely important movement that strove for a spiritual regeneration across a wide range of classes extending from the aristocracy through the samurai class to the common people. It was accompanied by various artistic movements in both the old and the new traditions. No matter whether religious or artistic in motivation, Japanese receptivity to Sung culture was most vital in giving direction to the progress of the reform. Because one aspect of Sung culture included a denial, to a certain extent, of the preceding T'ang period, this same culture, imported into Japan, served as an excellent medium through which to attempt a conquest of the *kodai* tradition. The Takuma school of painting, which belonged to the *ebusshi* tradition, illustrates this very well. Surviving works from this school indicate that there were two sides to its reception and selection of Sung art, one involving a revival of Kamakura Buddhist painting, the other a thrust away from the idealism of *kodai* art toward a kind of new realism.

Although the movement for religious reform at this time deeply affected both the aristocracy and the common people, it did not necessarily offer sufficient spiritual support for the warrior class, since it actually adhered with little deviation to the old *kodai* tradition. It was under these conditions that Zen Buddhism stepped in to perform an essential function in giving support to the warriors

28. Section of picture scroll Ippen Shonin Eden *(Pictorial Biography of Saint Ippen) showing a Buddhist ritual dance, by En'i. Colors on silk; height, 38.2 cm. Dated 1299. Kankiko-ji, Kyoto.*

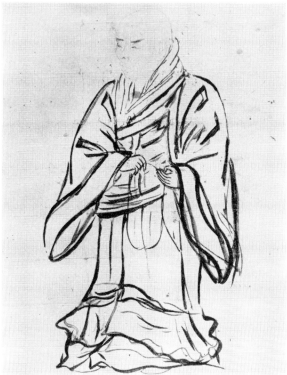

29. Portrait of the priest Shinran, by Fujiwara Tametsugu. Ink on paper; height, 39.7 cm.; width, 32.7 cm. Thirteenth century. Nishi Hongan-ji, Kyoto.

and bringing about the establishment of medieval military society as a whole. More than anything else, it was Zen's progressive and thoroughgoing spirit of denial that became the source of the vitality of the samurai class and the main constituent for accomplishing the religious reformation. This development was linked, in turn, with the overall reform movement away from the life and culture of the previous age.

In the realm of art the Zen sect, by its repudiation of religious images, forcefully shook off the *kodai* tradition and determined a course that eventually led to the establishment of an independent medieval art based on a new genre of *suibokuga*, or ink painting. In other words, the appearance of the Zen sect as a spiritual prop for the samurai was essential in order to realize a complete victory over the *kodai* tradition. It was altogether natural that Zen, linked with the medieval political leadership,

should also seize command of the artistic center of authority in the field of painting.

The transition period in art between the ancient and medieval ages required almost two hundred years, from the early twelfth to around the end of the thirteenth century. During this time, various old and new modes of expression and stylistic development, the methods and aims of which were often at cross-purposes, resulted in confused images. This confusion was eliminated only with the establishment of an academy based on the new Sung *suibokuga* style under the auspices of the early Ashikaga shoguns. These rulers of Japan set up their government headquarters precisely in the middle of Kyoto, the old aristoratic capital and center of *kodai* culture, about two hundred years after Yoritomo. The academy that they established was the basis of Muromachi culture. From the start the Ashikaga rulers included talented artists and

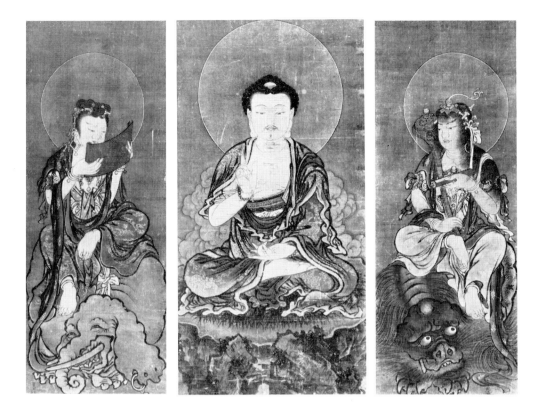

knowledgeable art connoisseurs, among them the fourth shogun, Yoshimochi (1386–1428), an especially gifted painter who left some fine works.

NEW TRENDS IN BUDDHIST PAINTING

We have already taken note of the important role played by Buddhist priests in the transmission of Sung culture to Japan. Now we shall examine somewhat further the process by which Zen came to be accepted in Japan, giving attention first to the priest Eisai (1141–1215) and the Kennin-ji, the temple he established in Kyoto. Eisai, one of the founders of Japanese Zen, was formerly a Tendai priest who learned about Sung China from the Sung translator Li Te-chao (in Japanese, Ri Tokusho) in the city of Hakata in Kyushu. In 1168, Eisai voyaged to China, arriving in what is now the city of Ningpo in Chekiang Province. He is said to have climbed Mount T'ient'ai, site of a great Buddhist center, in the company of Chogen, another Japanese Buddhist priest, who entered China at exactly the same time and who also played an important role in introducing Sung culture into Japan. The two priests are sometimes said to have been brothers, although no proof of such a relationship exists. The earliest connection between Japanese Zen and tea drinking is said to have occurred when Eisai stopped at a teahouse during his visit to the Yuwang-ssu (in Japanese, Io-ji), one of the five highest-ranking Chinese Zen temples.

In 1202, after he had returned from China, Eisai founded the Kennin-ji, a temple that combined in its teaching and worship the doctrines of various sects. It was the practice at this time to combine Zen, as well as Kairitsu, with the already established sects like Tendai and Shingon rather than to found temples for the Zen sect alone. As a new

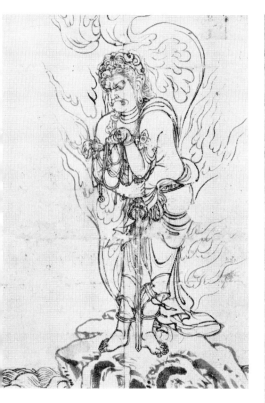

30 (opposite page). Shaka Triad, by Ryozen. Colors on silk. Center scroll: height, 113 cm.; width, 59.5 cm. Left and right scrolls: height, 110 cm.; width, 44.5 cm. Fourteenth century. Seicho-ji, Hyogo Prefecture.

31 (above). Fudo Myo-o, by Shinkai. Ink on paper; height, 91 cm.; width, 51.5 cm. Dated 1282. Daigo-ji, Kyoto.

32 (right). Portrait of the priest Myoe (detail), by Enichibo Jonin. Colors on paper; dimensions of entire painting: height, 145.7 cm.; width, 58.8 cm. Early thirteenth century. Kozan-ji, Kyoto.

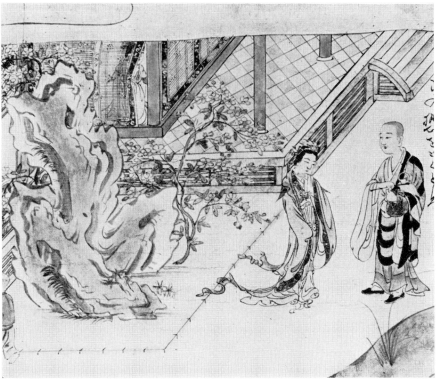

33. Section of picture scroll Kegon Engi *(Legends of the Founders of the Kegon Sect)* showing the priest Gisho and the woman Zemmyo, by an unknown painter. Colors on paper; height, 31.5 cm. Early thirteenth century. Kozan-ji, Kyoto.

34. View of the Kozan-ji, Kyoto.

religion in Japan, Zen had to make compromises with the older sects if it was to be promulgated at all, and for this reason the doctrines and liturgies of the old Esoteric sects were mixed into Zen teaching, thus preventing for a while the emergence of pure Zen. Eisai, however, strongly opposed such haphazard diffusion of Zen and held an especially strong animosity toward the kind of Zen practiced at the Enryaku-ji, the Tendai stronghold on Mount Hiei, near Kyoto. He not only approached the court to request that this practice be forbidden but also wrote a treatise condemning it: the *Kyozen Gokoku Ron* (Propagation of Zen for the Protection of the Country). With the passage of time the influence of the Zen sect increased, and it developed an organization of its own. After the beginning of the fourteenth century, a formal ranking of Zen temples—the Gozan Jissetsu, or Five Great Temples and Ten Lesser Temples—was

established, and the Zen sect itself was unified.

Eisai's enthusiasm for the pleasures of tea drinking and what he considered to be the healthful properties of tea itself is illustrated by the story that when he went to say prayers for the recovery of Minamoto Sanetomo, who had been taken ill, he took with him both medicine and tea. It was also probably around this time that he wrote the famous treatise *Kissa Yojo Ki* (Drink Tea and Prolong Life), the earliest existing literary document in tea-ceremony lore.

Associated with Eisai was another noteworthy priest of the early Kamakura period, Myoe (1173–1232; also known as Koben), who revived the Kozan-ji (Fig. 34) at Togano-o in Kyoto. Although Myoe was not directly connected with the Zen sect, he must not be forgotten during a consideration of the art of this period. He brought new life to the flagging Kegon sect, centered then at the Todai-ji

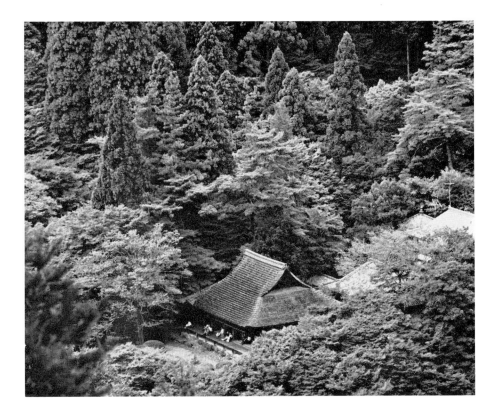

in Nara, and his own temple, the Kozan-ji, combined the doctrines of the Tendai, Shingon, and Kairitsu sects. His relationship with the considerably older Eisai seems to have been like that of a junior student with a respected senior.

It is of particular interest that Myoe received from Eisai the seeds of several varieties of the tea plant—seeds that Eisai had brought back with him from China—and that he cultivated a garden for growing tea at the Kozan-ji. Tea, at that time, was highly valued as a beverage for preventing drowsiness during the Zen meditation periods known as *zazen*, for suppressing wrong thoughts, and for prolonging life. In other words, it was prized as a medicinal aid to the practice of religious discipline. A famous portrait of Myoe, painted by the priest-painter Enichibo Jonin, who is sometimes said to have been Myoe's spiritual brother, shows him seated in the *zazen* position in the crotch of a tree

(Fig. 32) and thus reveals that he practiced *zazen* as a religious discipline even though he was not himself a Zen priest.

To return for a moment to the subject of tea, we may note that its cultivation soon spread to Uji (near Kyoto) and other places, but the tea garden at Togano-o was still the most famous. The especially prized Togano-o tea was called *honcha* (true tea) to distinguish it from the tea of Uji and other places, which came to be known as *hicha*, or "not true tea." Throughout the Muromachi period it was popular to give parties at which the guests vied with one another in trying to distinguish the taste of *honcha* from that of *hicha*.

Myoe was a disciple of Mongaku, the Jingo-ji priest who refrained from fighting with the virile priest-poet Saigyo, as we have noted above. Myoe's religious beliefs, though including aspects of Zen, appear to have had strong conservative or even

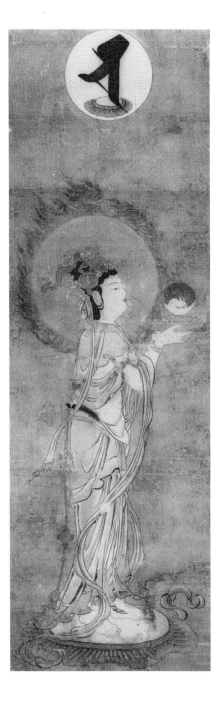

35. *Three panels from a pair of six-panel screens picturing the Juni Ten, or Twelve Celestial Beings (Devas), by Takuma Shoga. Left to right: Gatten, Bishamon Ten, Fu Ten. Colors on silk; each painting: height, 130 cm.; width, 42 cm. Dated 1191. To-ji (Kyo-o-gokoku-ji), Kyoto.*

reactionary tendencies that make them look like the very antithesis of Zen. Taken as a whole, however, his creed was a pure one, and it emphasized salvation by one's own efforts (*jiriki hongan*). His worthy antagonist was the priest Honen (1132–1212), who believed in salvation by faith alone (*tariki hongan*) in

36. Viewing a Waterfall in the Lu-shan, *by Shinso* ▷
(Soami), with an inscription by Genryu Shuko (see Figure 163). Ink on paper; dimensions of entire painting, including inscription: height, 113.8 cm.; width, 29.5 cm. Early sixteenth century. Private collection, Japan.

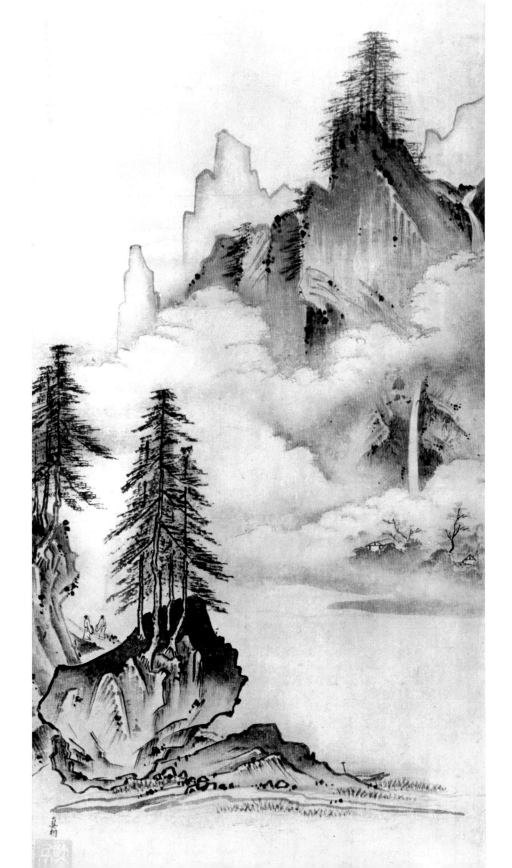

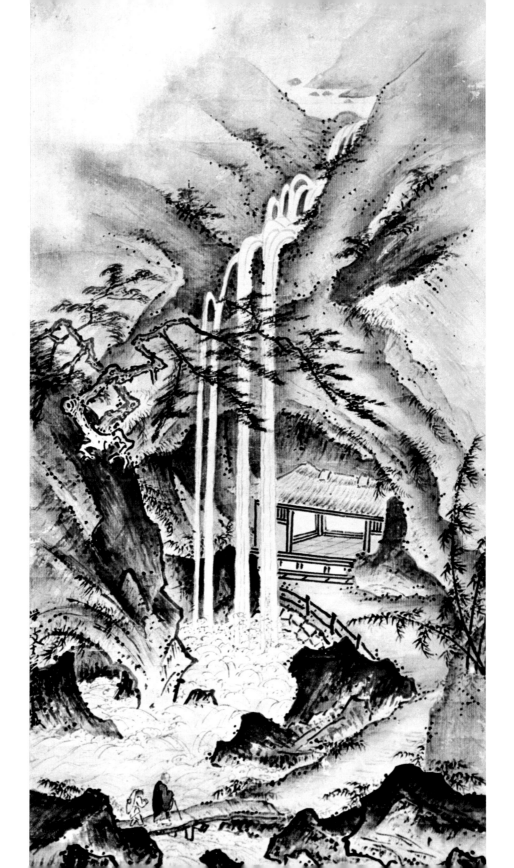

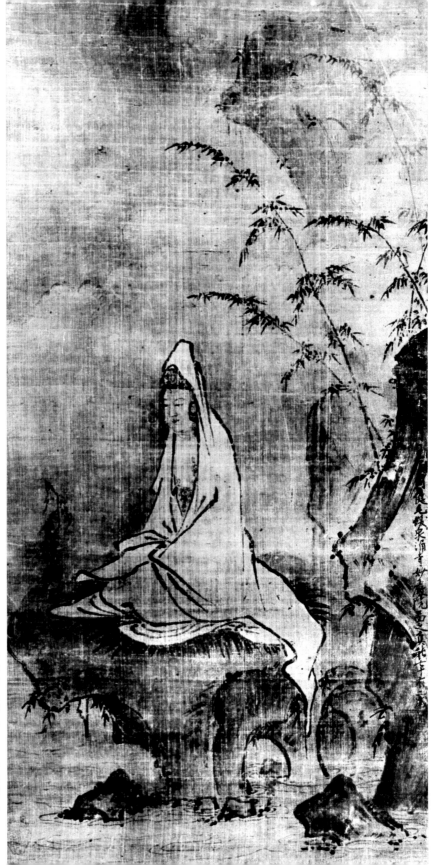

37. Viewing a Waterfall, *by Shingei (Geiami), with inscriptions by Osen Keisan and two other priests (see Figure 162). Ink and colors on paper; dimensions of entire painting, including inscriptions: height, 105.8 cm.; width, 30.3 cm. Dated 1480. Nezu Art Museum, Tokyo.*

38. White-robed Kannon, *by Shinno (Noami). Ink and colors on silk; height, 109 cm.; width, 38.2 cm. Dated 1468. Private collection, Japan.*

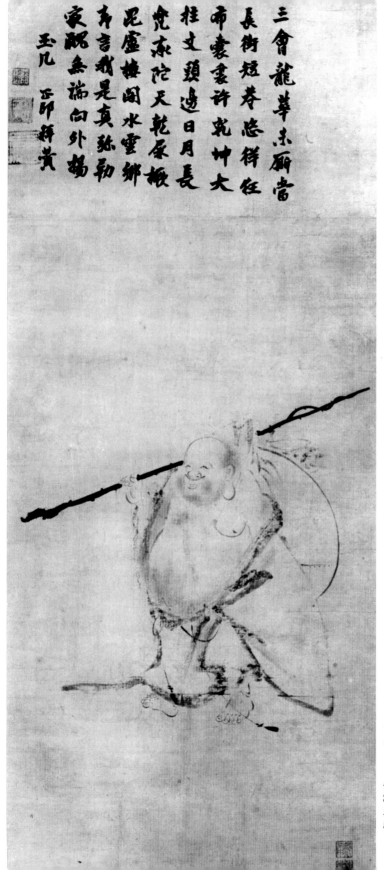

三會龍華未厭當
長街短巷恣徉徉在
布袋裏許乾坤大
拄丈頭邊日月長
兜率陀天乾坤振
尼盧撼閣水靈鄉
者言我是真彌勒
寂默無端向外揚
玉几 正印禪賞

39. Hotei *(Pu-tai)*, *by Mokuan, with an inscription by Gekko Shoin. Ink on paper; height, 114.5 cm.; width, 48.5 cm. Fourteenth century. Private collection, Japan.*

40 *(opposite page, left)*. The Priest Hsien-tzu, *by Kao. Ink on paper; height, 98.6 cm.; width, 33.5 cm. Fourteenth century. Collection of Shoji Hattori, Tokyo.* ▷

41 *(opposite page, right)*. Bamboo and Sparrow, *by Kao. Ink on paper; height, 90.9 cm.; width, 30.3 cm. Fourteenth century. Yamato Bunkakan, Nara.* ▷

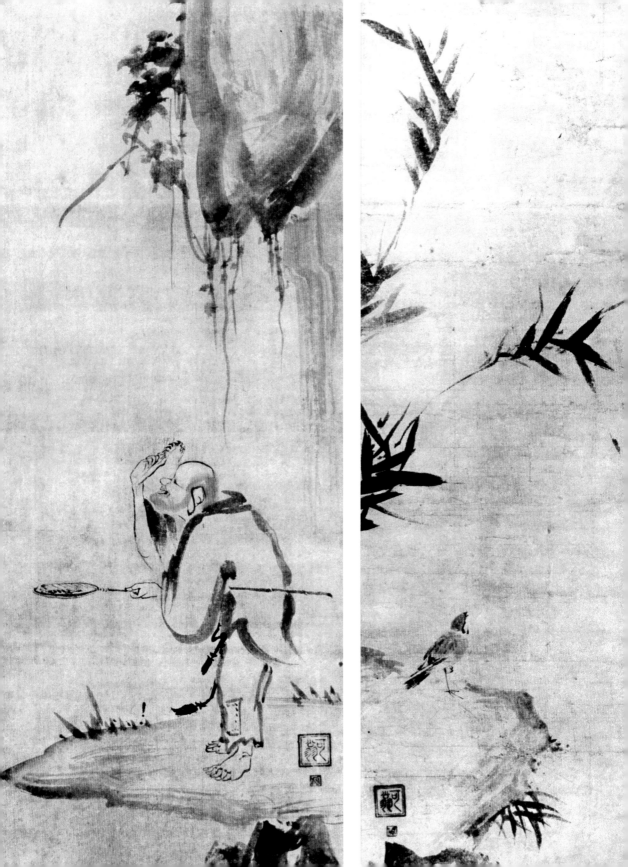

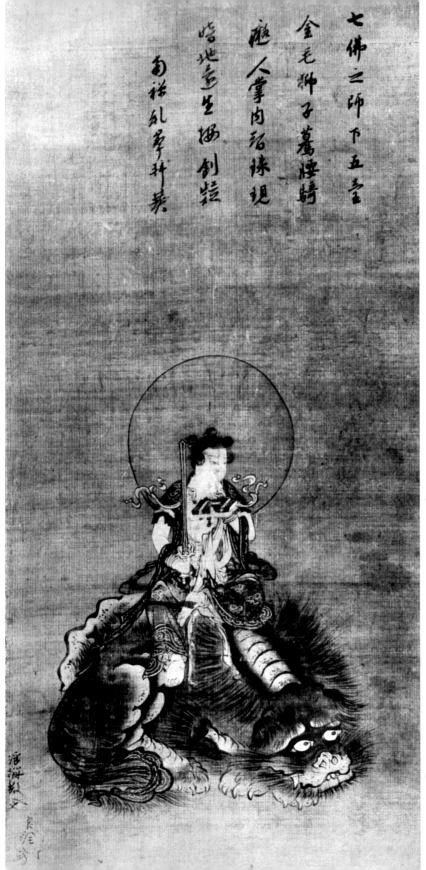

七佛之師下五臺

金毛獅子萬騎

癡人掌内碧珠埿

暗地童生撼釗粒

南祥乱筆抖藪

42. Monju *(the Bodhisattva Man-jusri)*, *by Ryozen, with an inscription by Kempo Sudon. Ink on silk with touches of color and gold; height, 79.7 cm; width, 39.4 cm. Fourteenth century. Private collection, Japan.*

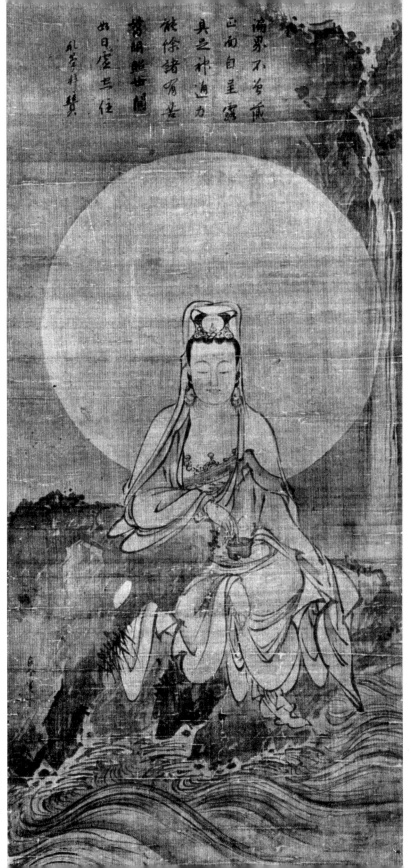

43. White-robed Kannon, *by Ryozen,*
with an inscription by Kempo Sudon. Ink
on silk; height, 88.7 cm.; width, 41 cm.
Fourteenth century. Myoko-ji, Aichi Pre-
fecture.

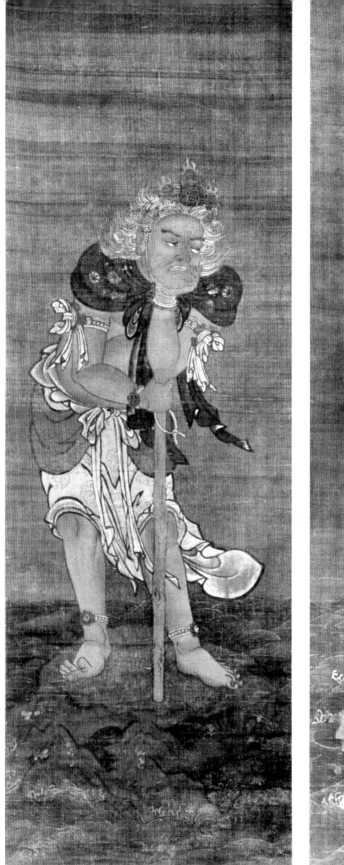

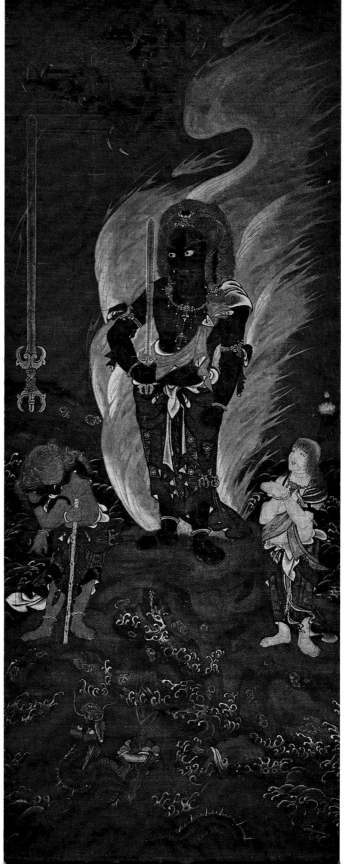

44. Two Attendants of Fudo Myo-o *(left- and right-hand scrolls of a triptych)*, *by Choga. Each scroll: colors on silk; height, 125.3 cm.; width, 41.8 cm. Thirteenth century. Private collection, Japan.*

45. Fudo Myo-o, *by Takuma Eiga. Colors on silk; height, 145.2 cm.; width, 47 cm. Fourteenth century. Seikado, Tokyo.*

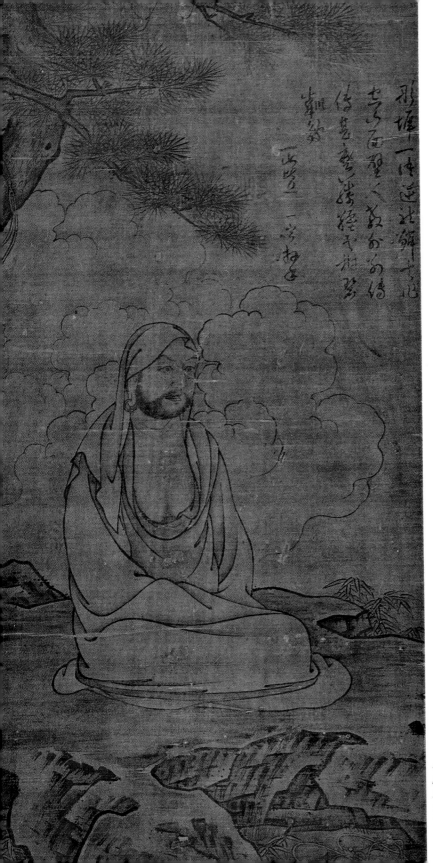

46. Daruma *(Bodhidharma)*, *by an un-
known artist, with an inscription by Issan
Ichinei. Colors on silk; height, 99 cm.;
width, 45.5 cm. Early fourteenth century.
Tokyo National Museum.*

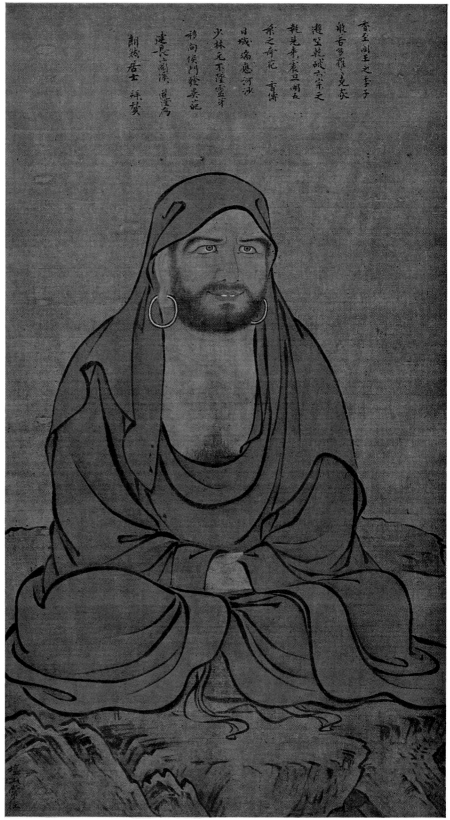

香至國王之季子
般若多羅之克夾
遊空亂碰六宗之
乾毛寿来震旦開五
采之奇花 青領
日域编魅河汕
少林元不隆靈芽
誰向候門終呉跬
建良古蘭漢 道隆属
朗俭居士 洋贅

47. Daruma (Bodhidharma), by an unknown artist, with an inscription by Rankei Doryu. Colors on silk; height, 123.3 cm.; width, 61.2 cm. Thirteenth century. Kogaku-ji, Yamanashi Prefecture.

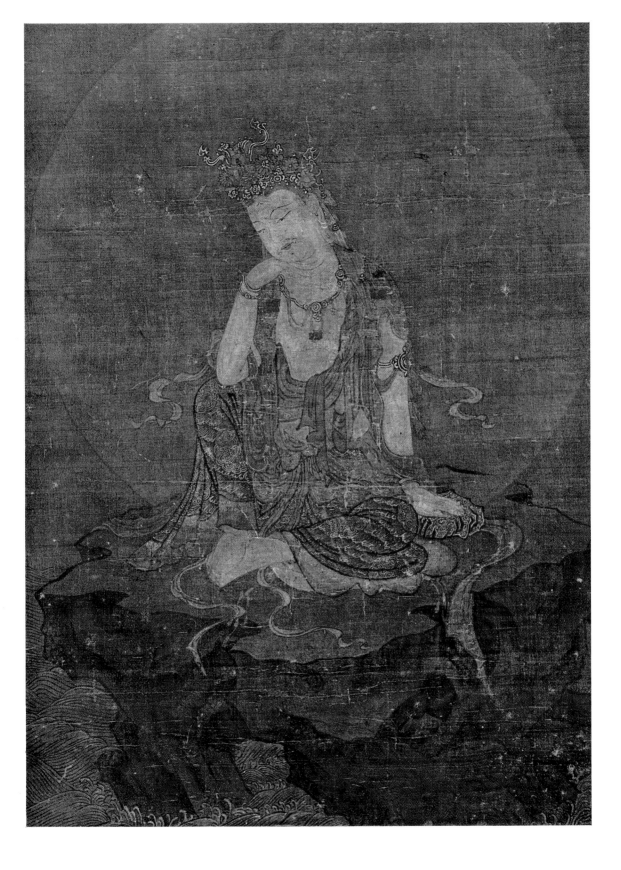

48. Nyoirin Kannon *(Cintamanicakra), by an unknown artist, with an inscription by Kyodo Kakuen (see Figure 159). Colors on silk; dimensions of entire painting, including inscription: height, 8.78 cm.; width, 36.3 cm. Late thirteenth century. Taiju-ji, Aichi Prefecture.*

49. Butsugen Butsumo *(detail), by an unknown artist. Colors on silk; dimensions of entire painting: height, 183.3 cm.; width, 127.9 cm. Late twelfth century. Kozan-ji, Kyoto.*

the benevolence of Amida Nyorai, the Buddha of Boundless Light. A closer examination of the beliefs of these two priests, however, reveals that they had some points nearly in common and that Myoe and Honen did not necessarily disagree over the proper direction of the movement for religious reform. With regard to the concept of evil, for example, Myoe emphasized the idea of moral cleanliness and self-examination. In the final analysis he recognized evil as an aspect of karma shared by all mankind and hence as something that, in truth, everyone must experience. Thus, though Myoe traveled a different path from that taken by Honen, the founder of the Amidist Jodo sect, and Shinran (1173–1262), the founder of the Amidist Shin (or Jodo Shin) sect, he arrived at rather similar conclusions. His revival of the Kegon sect was therefore not by any means a mere reactionary movement. While the concept of salvation by faith

contrasts sharply with that of salvation by one's own efforts, Myoe, Shinran, and Honen may be said to have been spiritual brothers. The importance of *zazen* as part of Myoe's ascetic discipline is thus not so strange when we consider that both in his creed and in Zen the two concepts of salvation are in the end subordinated and that it is Zen that tries to find the practical means that allow this to be accomplished. We should note also the aesthetic dimension added to *zazen* by the drinking of tea during these sessions of meditation.

Myoe thus led a most noteworthy life that relates to the very core of the religious reform that took place in this period, but it was not a life that can be understood by merely giving attention to the religious sect to which he belonged. It is interesting that such an extremely pious man could emerge from the tutelage of a priest as notoriously rough as Mongaku. The contrast between the two men is height-

NEW TRENDS IN BUDDHIST PAINTING · *53*

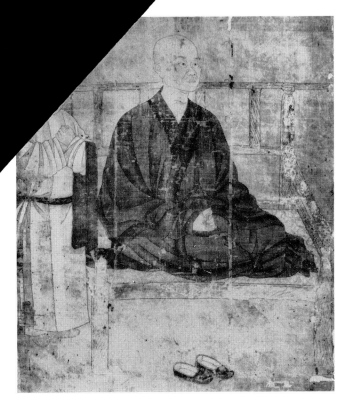

50. Portrait of the priest Keika and an attendant (from a set of portraits of the eight patriarchs of the Shingon sect), by Shunga. Colors on silk; height, 104 cm.; width, 46.2 cm. Dated 1231. Jingo-ji, Kyoto.

51 (opposite page, left). Jubaka Sonja (the rakan ▷ Jivaka): one of a set of scrolls portraying the Sixteen Rakan, by Takuma Eiga. Colors on silk; height, 108.4 cm.; width, 39.1 cm, Fourteenth century. Fujita Art Museum, Osaka.

52 (opposite page, right). Han-shan (Kanzan), by ▷ Kao. Ink on paper; height, 98.6 cm.; width, 33.5 cm. Fourteenth century. Collection of Shoji Hattori, Tokyo.

ened when we recall the previously mentioned encounter between Mongaku and Saigyo. Mongaku, combining his priestly duties with court intrigue and politics, was almost the exact opposite of Saigyo, who abandoned his wife and children and fled the mundane life. The appearance of such reform-minded priests as Saigyo and Myoe in the early Kamakura period decidedly contributed to the reformational character of the age.

Many of the religious paintings of the period survive at the Kozan-ji. Let us look, for example, at the painting of Butsugen Butsumo (Fig. 49), the female deity whom Myoe made the guardian of this temple. This mysterious divinity, wearing a lion crown and exquisitely painted in light, clean colors, was for Myoe, who lost his mother at an early age, his own personal substitute guardian as well, and his inscription on the painting informs us that he had kept this work of art since his childhood. The

painting dates from the closing years of the twelfth century, but it has already seceded from the aristocratic Heian Buddhist tradition and moved toward the lighter Sung Buddhist painting style.

A search for other Buddhist painters of the day who displayed tendencies similar to those of the anonymous painter of the Butsugen Butsumo leads us to two or three artists among the people who surrounded Myoe. One of these is Enichibo Jonin, whom we have noted earlier as the painter of Myoe's portrait. The style of the famous thirteenth-century Kegon Engi (History of Kegon Buddhism) picture scroll (Fig. 33), which deals with legends of the Kegon-sect patriarchs Gisho and Gangyo, compares favorably with that of the Myoe zazen portrait, and it seems safe to assume that the scroll also came from Enichibo's brush. The brushwork shows strength and vitality, and the use of light colors indicates considerable Sung influence.

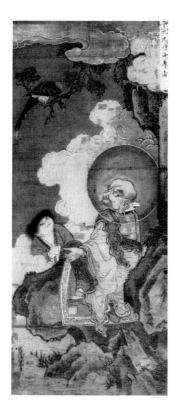

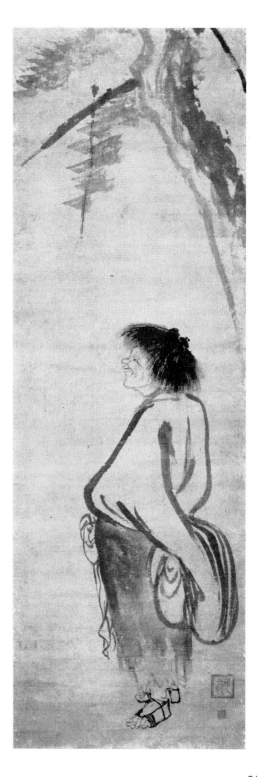

Another artist worthy of attention is Shunga, who was active at the beginning of the thirteenth century and who received the designation of *hokkyo*, an honorary Buddhist priest's title granted to outstanding artists. Old records tell us that Shunga painted the murals in the three-story pagoda of the Kozan-ji and the *rakan* (*arhat*) pictures in the Rakando at the same temple. He was perhaps an *ebusshi*, and the portraits of the eight Shingon Buddhist patriarchs in the treasure repository of the Jingo-ji (Fig. 50) may be examples of his work. These paintings, however, are of classical Heian style and do not exhibit the new Sung painting techniques. The painters of the time no doubt worked in two different styles, sometimes painting in the old classical style and sometimes in the new Sung style as the occasion demanded.

Among artists of the Takuma school, which specialized in painting Buddhist subjects, perhaps

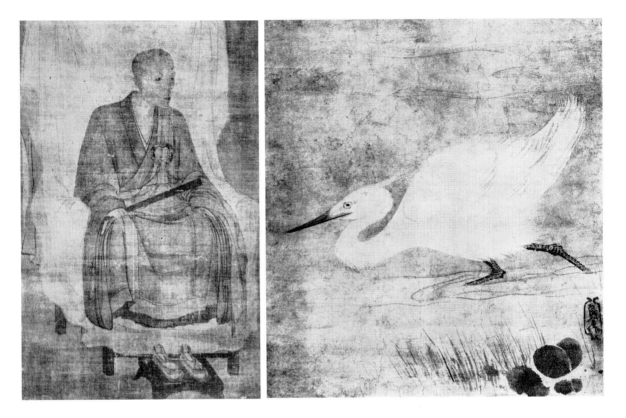

the most noteworthy is Takuma Shoga, who was active in the late twelfth century and worked mainly at the Jingo-ji. Both the Jingo-ji and the To-ji, another Kyoto temple, preserve works attributed to him: paintings of the Juni Ten, or Twelve Celestial Beings (Fig. 35). While many of the Jingo-ji paintings are done in the old classical style, several of those at the To-ji display a truly dashing line in an energetic depiction typical of the Sung style—a style that the succeeding Takuma-school *ebusshi* would follow.

The Takuma school was supposedly founded by Takuma Tamenari, to whom an unconfirmed tradition attributes the paintings on the wooden doors of the Byodo-in at Uji, the famous temple dedicated in 1052. Next appear the names of Tametoki (or Tametatsu, elder brother of Shoga) and Tameto (active in the mid-fourteenth century), followed by those of Shoga and, about the same time, Tamehisa,

who was Shoga's younger brother. In all cases, however, there is uncertainty regarding their actual paintings, except perhaps for the above-noted attribution to Shoga. The painter Choga, active from the mid-Kamakura period, may also be viewed as a member of the Takuma school, judging by both his name and his painting style. His masterly paintings of the Sixteen Rakan (Fig. 59) and the attendants (*doji*) of the deity Fudo Myo-o (Fig. 44) have a strong Sung flavor. Eiga, a painter who worked in the opening years of the Muromachi period, also shows decided tendencies of the same sort in his *rakan* portraits and various other Buddhist paintings as well (Figs. 45, 51). While the penetration of the Sung style was a phenomenon that affected not only the Takuma school but nearly all other painting groups as well, it is true that the Takuma school was the most strongly influenced by the new style in the Kamakura period

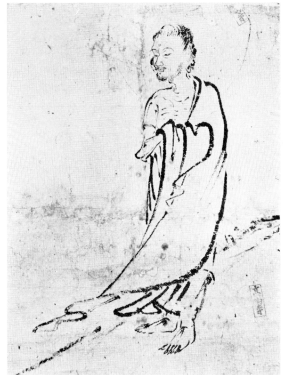

53 (opposite page, left). *Portrait of Rankei Doryu (detail), by an unknown artist. Colors on silk; dimensions of entire painting: height, 106 cm.; width, 46.6 cm. Dated 1271. Kencho-ji, Kamakura, Kanagawa Prefecture.*

54 (opposite page, right). White Heron, *by Ryozen. Ink on paper; height, 83.1 cm.; width, 32.6 cm. Fourteenth century. Collection of Nagatake Asano, Tokyo.*

55. Shaka Descending from the Mountain, *by an unknown artist. Ink on paper; height, 90.8 cm.; width, 41.9 cm. Thirteenth century. Seattle Art Museum (formerly in the Kozan-ji, Kyoto).*

and the early years of the Muromachi period.

We also know that many rough sketchlike ink drawings were once stored at the Kozan-ji, but they were largely scattered and lost in the civil strife that accompanied the Meiji Restoration of 1868. Those that survive today are dispersed all over the country. Many of these ink drawings were sketches of Buddhist divinities—the work of the Esoteric priest Gensho Ajiyari of the Getsujo-in on Mount Koya, stronghold of the Esoteric Shingon sect. The collection of drawings apparently came into the possession of the Kozan-ji after Gensho's death and is generally known as the *Gensho-bon* (Gensho Book). This popular source for iconographic research included may striking and novel works. From the time of Myoe, *ebusshi* artists of the Takuma school and others made their appearance at the Kozan-ji, beginning the collection of iconographic drawings and, one by one, keeping up the production of

Buddhist and *emaki* (picture scroll) paintings. Today such scroll paintings as the above-mentioned *Kegon Engi* and the celebrated *Choju Giga* (Scroll of Frolicking Animals) are still among the temple's treasures. The *Choju Giga* (Fig. 23) is attributed to the priest-painter Toba Sojo, although with not much certainty. In any event, it clearly reveals that talented *ebusshi* working from the end of the twelfth through the thirteenth century created a new painting movement that centered upon such temples as the recently revived Kozan-ji. The *Shogunzuka Emaki*, a thirteenth-century picture scroll dealing with an event that took place when the capital was moved from Nara to Kyoto in the reign of Emperor Kammu (reigned 718–806), is another work that seems to belong to this same tradition. Throughout the Kamakura period, the Kozan-ji played the role of early herald for the rise of ink painting because it collected iconographic drawings

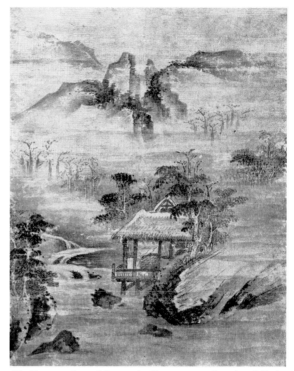

57. Cottage by a Mountain Stream, *attributed to Mincho. Ink on paper; height, 101.5 cm.; width, 34.5 cm. Dated 1413. Konchi-in, Nanzen-ji, Kyoto.*

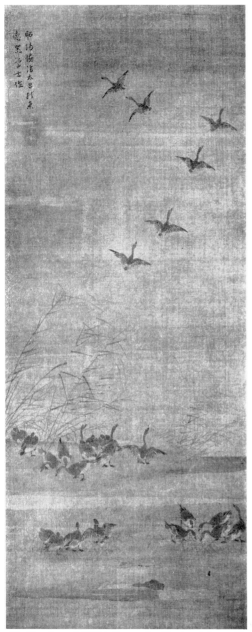

56. Reeds and Wild Geese, *by Tesshu. Ink on silk; height, 110.5 cm.; width, 44 cm. Dated 1434. Collection of Soshiro Yabumoto, Tokyo.*

such as those in the *Gensho-bon,* including the superb *Shaka Descending from the Mountain* (Fig. 55), the *White-robed Kannon* (Fig. 18), and the portraits of the six patriarchs of the Daruma sect of Zen Buddhism (Fig. 22). For this reason I think that in many respects there were connections between this painting tradition and the activity of such Buddhist painters as those of the Takuma school.

FROM DEVOTIONAL TO PURELY AESTHETIC PAINTING
With the construction of the Kencho-ji and, soon afterward, the Engaku-ji in the mid-thirteenth century, the Kamakura area became a center of the Zen religion like Kyoto. The founder of the Kencho-ji was Lan-ch'i Tao-lung (in Japanese, Rankei Doryu), a venerable

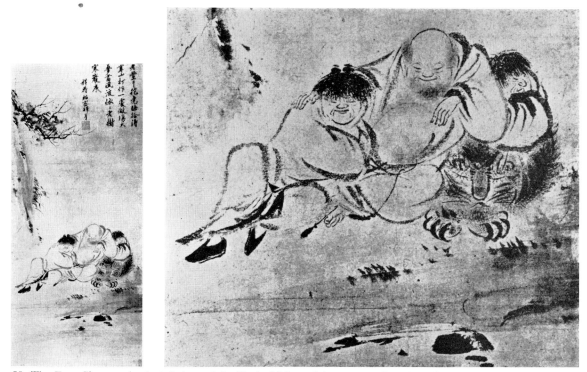

58. The Four Sleepers *(entire painting and detail)*, *by Mokuan. Ink on paper; dimensions of entire painting: height, 70 cm.; width, 36 cm. Fourteenth century. Maeda Ikutoku-kai, Tokyo.*

Southern Sung priest who came to Japan in 1246 at the invitation of the regent Hojo Tokiyori (1227–63) and passed through Hakata and Kyoto on his way to Kamakura (Fig. 53). The Engaku-ji was founded by the Chinese priest Wu-hsueh Tsu-yuan (in Japanese, Mugaku Sogen), who came to Japan in 1279. He was already famous in China as the subject of a legend telling how he stood calmly before the onrushing Mongol armies in their assault on the Sung forces and, holding up a great sword that he claimed could "cut lightning and divide the spring winds," caused them to scatter. Both Rankei and Mugaku may be viewed as Sung political refugees who, at the time of the attempted Mongol invasions of Japan, offered their aid to the regent Hojo Tokimune. That such priests settled in Kamakura, the center of new religious activity,

suggests that here a pure Zen religion was developing—a religion that would not compromise with the older Buddhist sects. One result of the religious upsurge in Kamakura was the establishment of the Gozan Jissetsu (Five Great Temples and Ten Lesser Temples) of eastern Japan in addition to those already designated in the Kyoto region.

In the field of painting, new problems arose concerning the previously noted *suibokuga*, or ink painting, and the *chinzo*, or paintings of distinguished Zen priests (Figs. 14, 15, 26, 53). The disciple of a Zen master customarily received a *chinzo* of the master to certify his adherence to the doctrine and his qualification to teach. The *chinzo* was rather like a graduation diploma and served as proof of its owner's legitimacy. The important role that the *chinzo* played in introducing Sung realism

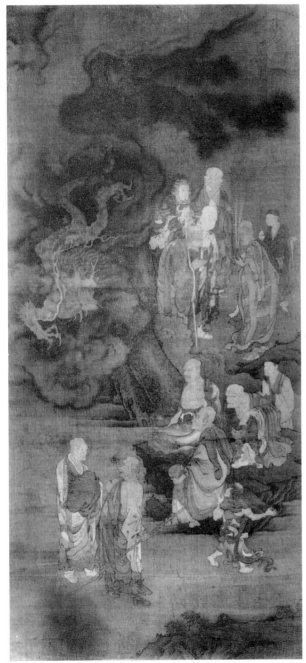

into Japanese portraiture still remains unclear and hence is a significant topic for further research.

A valuable catalogue of art treasures of this time is the *Butsunichi-an Kumotsu Mokuroku* (Catalogue of Treasures of the Butsunichi-an), compiled in 1320 and preserved at the Butsunichi-an, a subtemple of the Engaku-ji and the site of the memorial chapel of Hojo Tokimune. Listed in the catalogue are a fair number of Sung *doshakuga* (paintings on Taoist and Buddhist themes), landscapes, and flower-and-bird paintings as well as a large number of *chinzo* paintings, many of which were probably *suibokuga*. We also come across works by famous Chinese artists—for example, Mu Ch'i's *Monkeys* (Fig. 135). The list thus reveals the kinds of Sung painting that were available for collection by connoisseurs and for study by artists in the Kamakura period, an age that must be considered still rather early with regard to the quality of imported Sung paintings and the degree to which they were assimilated by Japanese painters. Judging by the examples of Sung painting listed in the catalogue, however, it is reasonable to assume that the Sung influence was already manifesting itself in the Japanese painting of the time.

From around the time of the Mongol invasions of the late thirteenth century to the early decades of the fourteenth century, many other Chinese Zen priests came to Japan, including such men as (to give their Japanese names) Dakyu Shonen, Minki Soshun, Gottan Funei, and Issan Ichinei. Numerous paintings from this period have inscriptions or appreciations written on them by these Zen priests, testifying to their close relationship with the art of the time. But while many such inscriptions were written in Japan, we cannot automatically conclude that the paintings themselves are also Japanese works, for they may have been brought from China with the immigrant priests, or they may have been painted in Japan by Chinese priest-painters who accompanied the priests to Japan. The solution to such problems must await the results of future research.

In any event, the paintings bearing the inscriptions of such Zen priests include many of the above-noted *doshakuga* type—that is, paintings on Taoist

59. The Sixteen Rakan *(one of a pair of hanging scrolls)*, *by Choga. Colors on silk; height, 117.2 cm.; width, 53 cm. Late thirteenth century. Private collection, Japan.

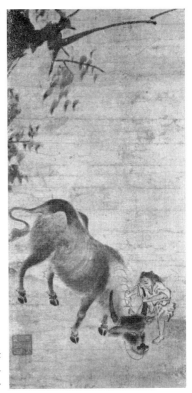

60. Landscape with Woodcutter and Fisherman, *by Ue Gukei. Ink on silk. Late fourteenth or early fifteenth century. Private collection, Japan.*

61. Ox and Herdsman, *by Sekkyakushi. Ink on paper; height, 47.8 cm.; width, 23.1 cm. Early fifteenth century. Private collection, Japan.*

and Buddhist themes. These works, however, are not of the purely religious type intended as objects of worship. Instead, they come near to being works intended for appreciation as figure paintings. At the same time that their style shows a progression from the use of light colors to the use of black ink, the paintings themselves evidence an escape from the classical religious-image category into the independence of painting for pure aesthetic appreciation. The climax of this transformation seems to have been reached in the so-called Period of the Northern and Southern Courts (1332–90). In the strict sense of the word, the paintings are still Taoist and Buddhist representations, but they are no longer religious pictures in the classical sense. The historical Buddha Shaka (Sakyamuni), for example, is treated not as the deity Shaka but as the man Shaka coming down from the mountain after his enlightenment, thus representing his human, ascet-

ic aspect. As far as Taoism in concerned, in Japan the majority of Taoist gods were treated more often as *sennin* (hermits or "immortals") than as heavenly beings. The above-noted drawings at the Kozan-ji have some characteristics that may indicate the beginnings of this transition.

There is no question about the importance of Kichisan Mincho as a painter who stood at the critical turning point in the movement from color to *suibokuga*, from purely religious to *doshakuga* painting, and from object-of-worship painting to painting for the sake of aesthetic appreciation. Mincho, who was active during the first half of the fifteenth century, was a priest-painter from the Tofuku-ji in Kyoto. He was also known as Cho Densu because he held the position of *densu*, which required that he look after the cleaning and orderliness of the temple halls. Today many of his *doshakuga* of Daruma (Bodhidharma), Kannon, the

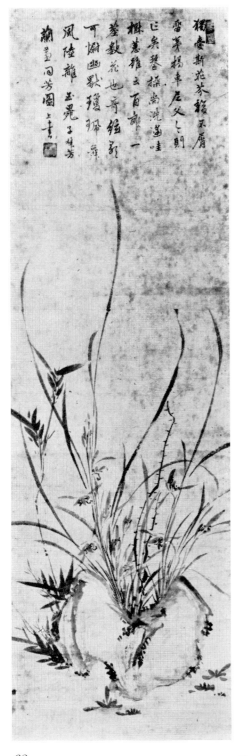

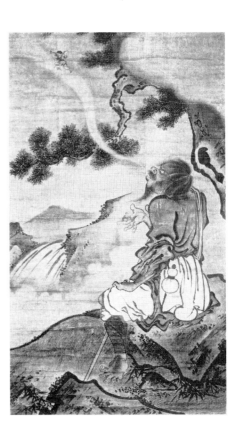

Taoist immortals Gama Sennin and Tekkai Sennin, *rakan*, and other religious subjects survive at the Tofuku-ji (Fig. 63) and in other collections (Fig. 13). Two artists considered to have been Mincho's students, Sekkyakushi (Fig. 61) and Reisai (Figs. 12, 64), both recognized as Zen priest-painters, also painted *doshakuga* in their teacher's style. It has recently been discovered that Reisai journeyed to Korea in 1463 and presented a *White-robed Kannon* to one of the Zen patriarchs there.

These followers of Mincho attained recognized positions within the Zen-temple organization and led lives that were essentially those of priest-painters: an *ebusshi* style of existence resembling that of the Takuma-school painters. The first thing we take note of in their work is the shift from purely religious painting to *doshakuga*. We also note the appearance of *suiboku* landscape and flower-and-bird paintings. The famous poem-and-painting

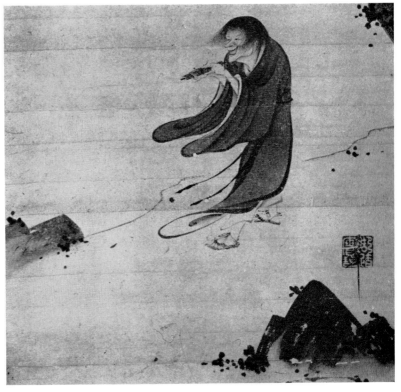

62 (opposite page, left). Wild Orchids, by Bompo, with an inscription by the artist. Ink on paper; height, 106.5 cm.; width, 34.5 cm. Fourteenth century. Collection of Nagatake Asano, Tokyo.

63 (opposite page, right). Tekkai Sennin (one of the Eight Taoist Immortals), by Mincho. Colors on paper; height, 231.5 cm.; width, 118.8 cm. Late fourteenth or early fifteenth century. Tofuku-ji, Kyoto.

64. Detail from Han-shan (Kanzan), by Reisai. Ink on paper; dimensions of entire painting: height, 83.9 cm.; width, 35.5 cm. About mid-fifteenth century. Goto Art Museum, Tokyo.

scrolls (*shigajiku*) entitled *Blue Mountains and White Clouds* and *Cottage by a Mountain Stream* (Fig. 57) are two landscapes attributed to Mincho, but they were preceded by the works of the Zen priest-painters Tesshu Tokusai and Ue Gukei, who painted such themes as *Shaka Descending from the Mountain* and the *White-robed Kannon* as well as *Grapes, Bamboo and Sparrow,* and *Landscape with Woodcutter and Fisherman* (Fig. 60).

Another painter roughly contemporary with Gukei was Ryozen, who was active in the mid-fourteenth century and became well known as a pioneer in both *ebusshi*-style painting and painting for aesthetic appreciation alone. The notation "man from west of the sea," written above his seal on one of his paintings, suggests that Ryozen may have been from Kyushu. At one time he seems to have been acquainted with the Zen priest Kempo Sudon of the Shoten-ji in Hakata, for his paintings of Kannon and Monju (Figs. 42, 43) bear inscriptions written by Sudon. Such works as the *Shaka Triad* (Fig. 30), the *Sixteen Rakan,* and the *White Heron* (Fig. 54) indicate that he was perhaps an artist in the *ebusshi* tradition who belonged to a Zen temple.

We must also take note of Kao Ninga, the well-known priest-painter who was active during the first half of the fourteenth century and whose work, until recent times, was confused with that of Ryozen. His brushwork resembles that of Ryozen's *suiboku doshaku* paintings, and its particular quality of freedom and relaxation, as seen in the *doshakuga* attributed to him—for example, in his *Han-shan* (Fig. 52) and *The Priest Hsien-tzu* (Fig. 40)—as well as in his *Bamboo and Sparrow* (Fig. 41), certainly elevates him to a position as a pioneer in the establishment of Japanese *suibokuga* in the fourteenth century.

There is an inconclusive theory to the effect that Kao Ninga was the same person as Kao Sonen, the famous Zen priest who headed the Kennin-ji in the first half of the fourteenth century and also made a trip to Yuan China. The basis for viewing him as a different person lies in Kao Ninga's use of the character *ga*, meaning "felicitations," in the small seal reading "Ninga" that was affixed beneath the seal "Kao" on his paintings. This indicates the possibility that Ninga was in the *ebusshi* line of the Takuma school. All such reasoning aside, both Kao Ninga and Kao Sonen lived at the same time, and in the work of neither do we find genuine professional Buddhist painting—a fact, incidentally, that tends to support the theory that they were perhaps one and the same person.

A solution of the problem of whether these paintings reflect the *ebusshi* tradition or whether they represent the avocational interests of Zen priests must be deferred until later. Both of these currents did exist in the fourteenth century: first, the *suiboku-ga* that was reared within the *ebusshi* tradition; second, the *suibokuga* produced by distinguished Zen priests amusing themselves with brush and ink. While these two traditions developed separately, they tended to draw together and to share many characteristics.

Mokuan Reinen (Figs. 39, 58) and Tesshu Tokusai (Fig. 56), followed a little later by Gyakuen Bompo (Fig. 62), were skillful priest-painters who extended the practice of *zazen* and asceticism into the arts by means of brush and ink. These artists created their own fresh, individual painting styles in the genre of *suiboku doshakuga* and flower-and-bird

painting. Each had his own favorite theme. For Mokuan, it was Hotei (in Chinese, Pu-tai); for Tesshu, it was reeds and geese; for Bompo, it was orchids. These priest-painters were not professionals; so the breadth of their ability was naturally somewhat limited. Both Mokuan and Tesshu went to Yuan China for Zen training, and Mokuan died there. Kao Ninga's many paintings of the Chinese comic Zen sages Han-shan and Shih-te (in Japanese, Kanzan and Jittoku) may indicate that he also shared this tendency of Zen priests to amuse themselves by painting relaxed *doshakuga*.

The early years of the Muromachi period saw the wholesale importation into Japan of Sung and Yuan paintings, centering especially on Zen. The strong transitional movement in religion and art not only achieved the conquest of the old religious art that had endured since the Heian period but also, almost hour by hour, provided ink painting with new opportunities to rise to greater and greater heights.

Generally speaking, the most important aspect of this development was the creation of a new academy centering around the Muromachi shogunate or, to be more specific, the Ashikaga shoguns. The old Edokoro, sponsored by the imperial court, had continued to exist ever since the ancient period, but during the transition period of the thirteenth century, under the Kamakura shogunate, it faced declining fortunes even though it managed to preserve some of its former renown. Its decline reflected that of the aristocracy, and at this point the *kodai* artistic style was solidified by the Edokoro and molded into a traditional stereotype.

The Establishment of the Medieval Academy

JOSETSU AND THE SHOKOKU-JI The first artist of note to appear in this new period was the priest-painter Josetsu of the Shokoku-ji, one of the leading Zen temples in Kyoto under the Ashikaga shogunate. Although the details about Josetsu's life are by no means clear, three existent paintings are recognized as his works: *Catching a Catfish with a Gourd*, *Three Teachers*, and *Wang Hsi-chih Writing on Fans*. The inscriptions written by various Zen priests on these three works allow us barely to make out Josetsu's profile.

Catching a Catfish with a Gourd (Figs. 10, 65) was originally painted on a small screen made for the use of the Ashikaga shogun but was later made into a hanging scroll. The upper part of the scroll comprises inscriptions by some thirty Zen priests in which they attempt to interpret the theme of the painting: a Zen *koan* about a catfish and a gourd. (A *koan* is an enigmatic statement that a Zen master poses to a student to induce meditation.) Josetsu's ready wit and thorough understanding of the workings of Zen may be easily appreciated by comparing the other Zen priests' comments with his own open-hearted depiction of a strange-looking fellow trying somehow to catch a catfish with a gourd that looks entirely too small for the job. Two theories about the date of this work exist: one to the effect that it

was painted before 1408, thus indicating that it was the third Ashikaga shogun, Yoshimitsu (1358–1408), who commissioned it; the other to the effect that it was painted around 1413 and was therefore commissioned by the fourth shogun, Yoshimochi (1386–1428), himself a painter and a connoisseur of art. On the basis of a close examination of the lives of the priests who wrote the inscriptions accompanying the painting, I am inclined to accept the latter date.

Three Teachers (Fig. 66) is Josetsu's imaginative depiction of the founders of Confucianism, Buddhism, and Taoism: Confucius, Sakyamuni, and Lao-tzu. In essence, the work represents the concept that the teachings of the three are fundamentally one: an idea that developed during the Sung dynasty in China and became popular with the Zen priests of Japan during the Muromachi period. The roughly drawn figures in the painting resemble that of the would-be fisherman in the preceding work. The inscription tells us that the painter, Josetsu, was given his name by Zekkai Chushin, a Zen priest of the Nanzen-ji in Kyoto. The implication of the name is that great ability is like clumsiness.

Wang Hsi-chih Writing on Fans (Fig. 68), originally painted on a round fan (*uchiwa*) but now mounted as a hanging scroll, pictures the famous Chinese calligrapher and storyteller Wang Hsi-chih, who

65. Catching a Catfish with a Gourd, by Josetsu, with inscriptions by Daigaku Shusu and thirty other priests. (See also Figures 8 and 10.) Colors on paper; height, 111.5 cm.; width, 75.8 cm. Early fifteenth century. Taizo-in, Myoshin-ji, Kyoto.

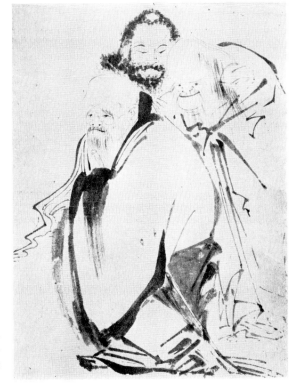

66. Three Teachers, by Josetsu, with inscriptions by two Zen priests. Ink on paper; dimensions of entire painting, including inscriptions: height, 29.8 cm.; width, 21.8 cm. Early fifteenth century. Ryosoku-in, Kennin-ji, Kyoto.

wrote on old fans for children so that they could sell them at high prices. The style of the painting, like that of the two works described above, seems to have been derived from the work of a Southern Sung painter such as Liang K'ai. The poetic inscription at the left of the painting was written by Daigaku Shusu, one of the Zen priests who recorded Josetsu's name in the comment he wrote on *Catching a Catfish with a Gourd.* Thus, in this inscription and those noted above, we have evidence of a strong relationship among the three works.

The Shokoku-ji (Fig. 83), the Zen temple where Josetsu resided, was one of the Kyoto Gozan, or Five Great Zen Temples. Its founder is generally said to have been the famous priest Muso Kokushi (1275–1351), but in fact it was Muso's disciple Shun'oku Myoha who established the temple with the support of the third Ashikaga shogun, Yoshimitsu. The office of the *tenka sorokushi*, or manager

of general affairs for all Japanese Zen temples, was located at the Shokoku-ji's subtemple Rokuon-in. Shun'oku Myoha served as its first scribe. Existing records of the Rokuon-in reveal a great deal about the state of Zen at this time. Again, because Josetsu was employed as a professional, or perhaps semi-professional, painter at the Shokoku-ji, a very high-ranking temple that had strong links with the shogunate, one has to conclude that he must also have had a close connection with the *ga-in*, or academy, set up under the Ashikaga shoguns.

SHUBUN, THE ENIGMATIC MASTER
Josetsu's successor was Shubun, who was also a priest-painter at the Shokoku-ji and is thought to have been one of Josetsu's pupils. He seems to have been very active in the academy and must have had an even closer relationship with the Ashikaga rulers than Josetsu, for he

直上三十三天築著帝釋鼻孔降下六十六州變現
觀音形容盈看萬頃碧琉璃海塊視億丈紅瑪瑙峰
不是雨六非神通呈露形山之無性指示慈流之
皆空有時施十四無畏而出跳魚網鵁青上有時起
十九說法而游戲鷹巢蜂腹中破犀牛歸鹽官孤貧
白花巖之月靈窗子嚮大士飛舞紫竹林之風兀聖
不隔理相是同一生成佛記利鏡童把臂於善財童
三昧畫師子周文公借六於菅城公廳二甬也剁二
爾普門境界志圓顱

仲方和尚嘗有一童子自十齡至十八戴周旋于左
右不倦勞役厭進退舉措給于仙陀婆也靖退間若
之時殊克服勤竟無懈色奄息之頃自書小簡附以
周文公之畫簍紙而奉于座下蓋旌別之惆戀者
也仍惓彼意致之無一便與雛深伴圓僧儀遂重命
文公圖大悲尊像并善財詢禮之變相於其上而裝
為幀軸由以前所奉之小簡而貼于其背仗此睹之
則慈救之切慈慈之深不可測其涯焉余稟 嚴命
不得去辭猥以蕪穢誌其始卒云
永享五年癸丑冬節後 鷲峰恩極禮寺焚香拜書

67. Inscription by Gukyoku Reisai from a lost painting of Kannon by Shubun. Early fifteenth century.

received a retainer's stipend. But he is a very difficult artist to discuss because there is still no settled opinion as to what his actual paintings were like. At present, research on Shubun is proceeding mainly along two parallel tracks: first, biographical research based on old documents and literary sources and, second, careful study of the surviving paintings from the period when he supposedly lived and worked. Consequently, any earnest discussion of Shubun requires the utmost caution, for no simple conclusions can be reached or any clear judgments made. Therefore I shall confine myself here to presenting only a tentative outline of the general state of research on Shubun up to this time.

Shubun had the *go* (art name) of Ekkei and the *azana* (nickname) of Tensho. He was employed at the Shokoku-ji as a *tokan*, or head of an executive office, and the name Shubun Tokan appears in records of the time. Today the general tendency is to consider Shubun as a landscape painter, for the only works attributed to him are in this genre. But records indicate that he was a man of many talents who also produced flower-and-bird paintings and *shoheiga*, or paintings on *fusuma* (sliding partitions) and screens, and that he was a sculptor and a craftsman as well. Even while serving as *tokan*, in which position he had to oversee the business affairs of the Shokoku-ji, he actively carried out the additional duties of *ebusshi* and Buddhist sculptor.

On a posthumous portrait of Shubun there is an inscription by the Nanzen-ji poet-priest Son'an Reigen that provides some clues concerning the life

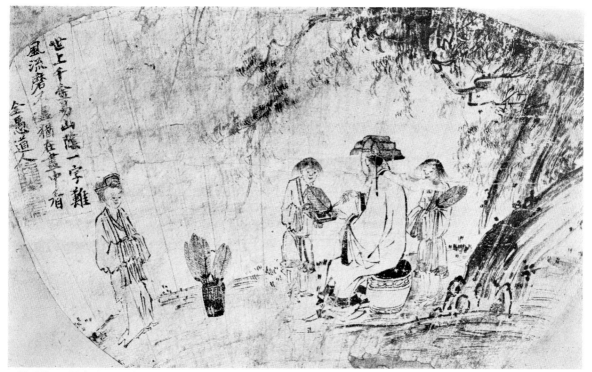

68. Wang Hsi-chih Writing on Fans, *by Josetsu, with inscriptions by Daigaku Shusu and Isho Tokugan. Ink on paper; originally painted on a fan but now mounted as a hanging scroll; breadth of fan surface, 29.7 cm. Late fourteenth century. Private collection, Japan.*

of this enigmatic artist. At the Daruma-ji in Nara there is a statue of Daruma (Bodhidharma) bearing an inscription to the effect that the shogun Ashikaga Yoshinori (1394–1441) ordered the statue made in 1430 and that Shubun applied colors to it. The ironical fact is that these colors are Shubun's only surviving work that is accepted without question as authentic, but of course they are no help at all in determining his ink-painting style. They do indicate, however, that Shubun must have been thoroughly versed in both Buddhist sculpture and painting and did not merely pursue these arts as a hobby. The *Onryoken Nichiroku,* a record kept by the previously mentioned Shun'oku Myoha of the Shoko-ku-ji, states that in 1440 Shubun completed a large Amida Triad (Amida Buddha accompanied by the

Bodhisattvas Kannon and Seishi) that was to be the main object of worship at the Ungo-ji in the Higashiyama district of Kyoto. The triad was begun by a professional Buddhist sculptor at the order of Yoshinori, the record continues, but the work did not proceed smoothly, and finally, after a second sculptor proved unequal to the task, Shubun was called in to complete it. This information indicates that he must have been a remarkably talented sculptor as well as a painter. As a sculptor, Shubun is also linked with the Nio (guardian divinities) at the Ungo-ji as well as with a statue of Prince Shotoku (Shotoku Taishi) at the Shitenno-ji in Osaka.

Now, as for Shubun's painting, the *Kammon Gyoki,* the journal of Prince Fushimi Sadashige covering the years from 1416 to 1448, relates that

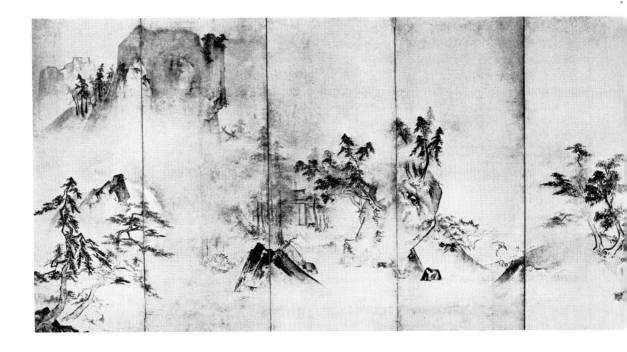

he produced a set of *fusuma* paintings. It appears that these paintings composed a landscape on the traditional Chinese theme of the Eight Views of the Hsiao and the Hsiang (see page 93). Strangely, though, there is no mention anywhere of even one Buddhist or *doshaku* painting—works that an *ebusshi* would have been likely to produce again and again. There does survive an inscription that was once part of a now lost painting of the Bodhisattva Kannon (Fig. 67), but it seems to add still more mystery to the story of Shubun. It was written by the Tofuku-ji priest Gukyoku Reisai, and it leaves no doubt that the Kannon was painted by our enigmatic artist. A Korean source, known in Japanese as the *Richo Jitsuroku* (An Authentic Account of the Yi Dynasty), tells us that Shubun visited Korea in 1423 in the company of the Zen priest Keiji Bonrei, who was sent as an envoy of the Ashikaga shogunate in search of a block-printed edition of the complete canon of Buddhist scriptures. Shubun's name comes up in the account of certain difficulties that arose as

the Japanese mission was about to return home. The problem seems to have been settled amicably, and at the farewell ceremony for the mission high officials of the Yi court wrote poetic inscriptions on a Japanese landscape and a painting of Kannon. Nothing is said about whose paintings these were, but we may suppose that they were by Shubun. Thus the *Richo Jitsuroku* contains the earliest known information about Shubun's life.

Although there is no clear record of his death, Shubun must have died around the Kansho era (1460–66), for we no longer run across his name in literary sources from about the first half of this era. A record of 1463 notes that Sotan, who is viewed as Shubun's probable successor, was granted the same stipend as Shubun had received. We can gather from all the foregoing that Shubun's period of activity covered some thirty years—from the 1430's through the early 1460's.

The most we can do in our efforts to identify Shubun's authentic works is to gather together all

69. Landscapes of the Four Seasons *(left-hand screen of a pair of sixfold screens)*, attributed to Shubun. Ink and colors on paper. Early fifteenth century. Yamato Bunkakan, Nara.

70. Mountain Landscape *(Suishoku Ranko)*, attributed to Shubun, with inscriptions by Zen priests Kosei Ryuha, Shinden Seihan, and Itoku Shinchu. (See also Figure 77.) Ink and colors on paper; height, 108.2 cm.; width, 32.7 cm. About 1445. Collection of Yuzo Fujiwara, Tokyo.

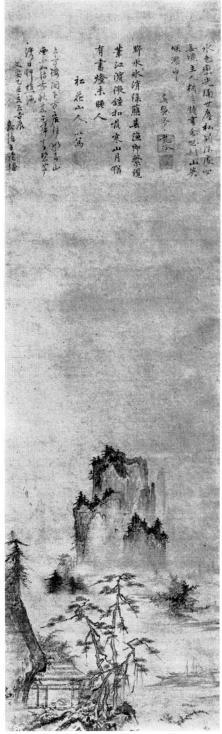

the paintings done during the approximately thirty years of his activity and search among them for those most likely to be his. We are able to date fairly closely a number of landscapes, particularly the *shigajiku* (poem-and-painting scrolls), from this period because many of them bear Chinese poetic inscriptions by Zen priests and because some of the inscriptions themselves are dated. By delving into the personal histories of the priests who wrote them, we can often come up with a reasonable date for a particular painting. Many scholars have used this method to try to single out Shubun's genuine works from the general group of *shigajiku* painted in this period, but proof to support such selections is nearly always impossible to find. Even though many of the *shigajiku* display an artist's seal, including some with Shubun's, comparative research does not allow us to reach any definite conclusions on this basis. The majority of these *shigajiku* were not paintings in which the artist could express his own spontaneous artistic vision but were, on the other hand,

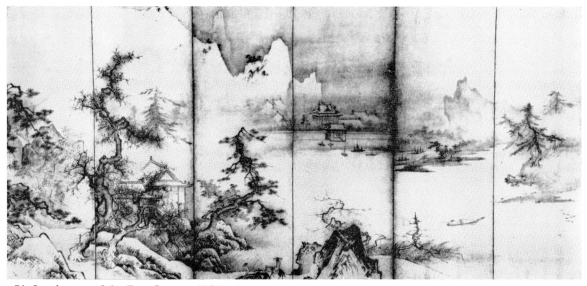

71. Landscapes of the Four Seasons *(left-hand screen of a pair of six-fold screens), attributed to Shubun. Ink and colors on paper. About mid-fifteenth century. Seikado, Tokyo.*

shosai pictures—that is, pictures in which the artist imagined himself in a *shosai:* a study set in a clear Arcadian landscape secluded and hidden away from the workaday world and designed as a place for a Zen priest to pursue his scholastic discipline. Other pictures represented attempts to grasp the emotions of priests when they were away from the secular world, off in some sequestered corner of nature where their sole companions were the "three worthy friends": the pine, the bamboo, and the plum tree. Accordingly, the Zen priests who inscribed *shigajiku* were not so much concerned with who painted the picture as with how successful the painting was in transporting the viewer into an idealistic natural setting. The same may be said for the painter himself—hence the dearth of artists' signatures on such paintings. The reason that Shubun's seal appears on some of these works is probably that people who owned them were so delighted to have what was judged to be a genuine Shubun painting that they applied the seal themselves as a kind of verification of the works' authenticity. Shu-

bun's name was fairly well known from the end of the Muromachi period and into the Momoyama period (1568–1603), when painting schools were becoming more strongly defined and new emphasis was placed upon establishing a particular group's founder and tradition. From this time, Shubun began to be honored as the founder of the new Chinese school in Japan, and it was thus all the more worthwhile to have his name affixed to a painting.

This same set of circumstances applies equally well to the seals of other similarly honored painters such as Sotan, Sesshu, and Jasoku, who will be discussed later. Another point to consider, however, is that in Shubun's day the insistence upon adding an artist's signature or seal to a painting was not very strong, nor was its significance really defined. Buddhist paintings, for example, were done as objects of worship, and hence their very nature essentially prohibited adding the name of the *ebusshi* on the surface of the painting itself. If the name of the painter was to be affixed to the painting, it had to be done as *kakushi rakkan* (literally, "hidden signa-

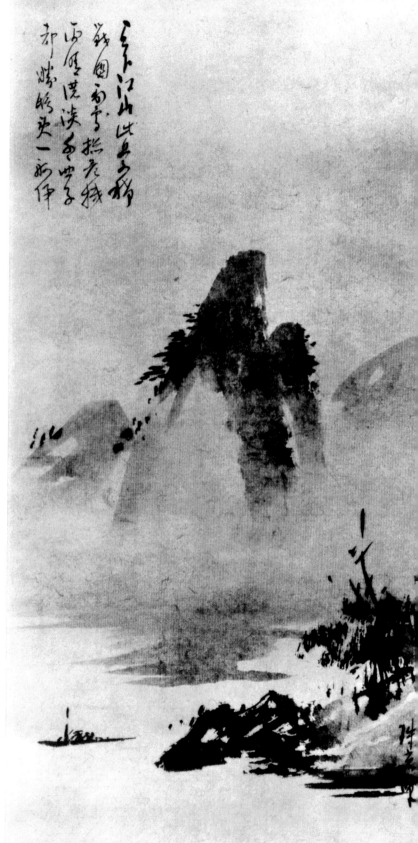

72. Landscape, *by Shuko, with an inscription by the artist. Ink on paper; height, 44.5 cm.; width, 21.7 cm. Late fifteenth century. Collection of Fumihide Nomura, Kyoto.*

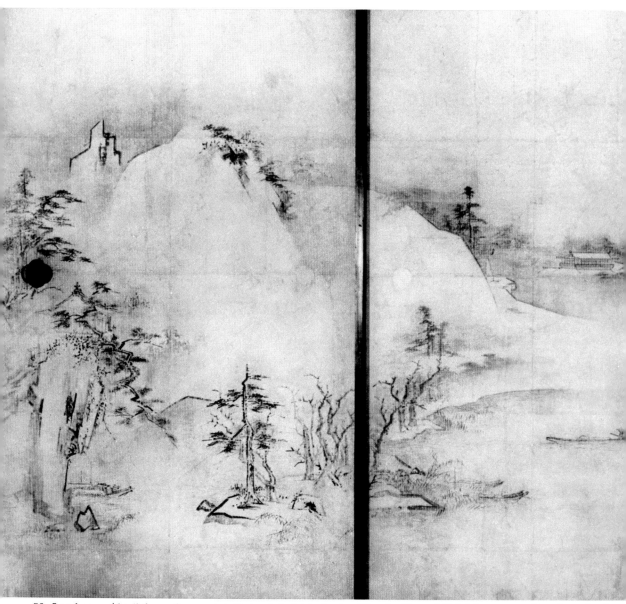

73. Landscape *(detail from a* fusuma *painting), attributed to Jasoku. (See also Figure 151.) Ink on paper; dimensions of each* fusuma *panel: height, 179 cm.; width, 143 cm. Late fifteenth century. Shinju-an, Daitoku-ji, Kyoto.*

74. Landscape, *attributed to Gakuo Zokyu. Ink on paper; height, 135 ▷ cm.; width, 33.3 cm. Late fifteenth century. Tokyo National Museum.*

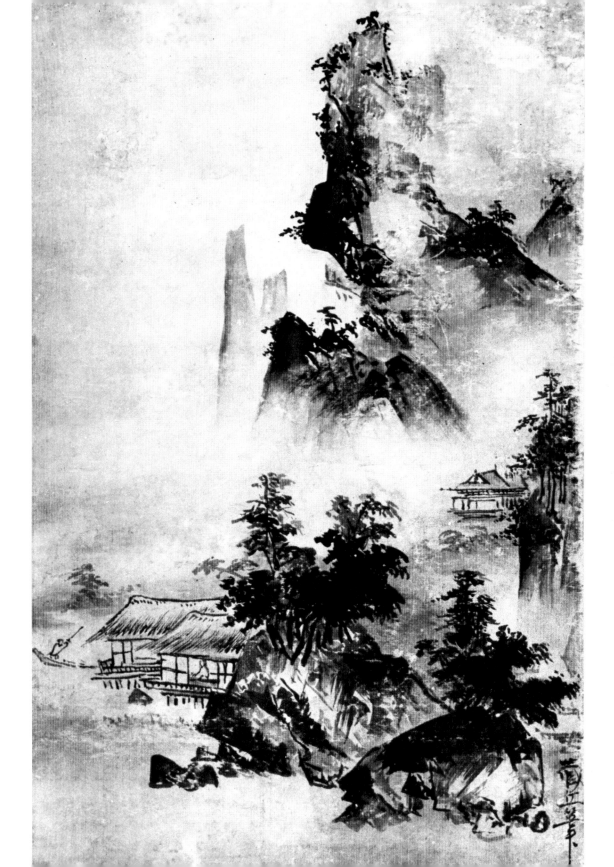

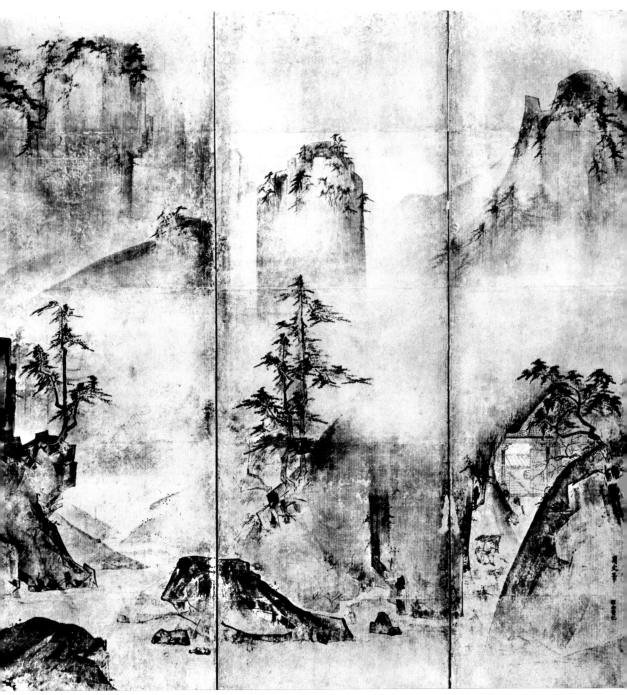

75. Landscapes of the Four Seasons *(right-hand screen of a pair of sixfold screens), attributed to Shubun. Ink and colors on paper; height, 152.7 cm.; width, 311.5 cm. Early fifteenth century. Maeda Ikutoku-kai, Tokyo. (The left-hand screen is shown in Figure 90.)*

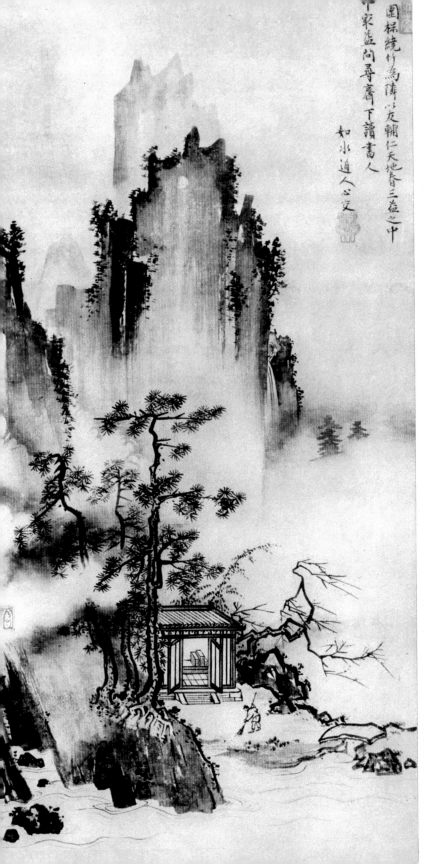

園樑繞竹為藩以友輔仁天地春三益之中

家益問尋齋下讀書人

如水道人□文

76. Hermitage of the Three Worth-
ies (San'eki Sai), attributed to Shubun,
with inscriptions by Gyokuen Bompo and
eight other priests (see Figure 96). Ink
on paper; dimensions of entire painting,
including inscriptions: height, 110.5
cm.; width, 38.8 cm. Dated 1418.
Seikado, Tokyo.

77. Mountain Landscape (Suishoku ▷
Ranko), attributed to Shubun, with
inscriptions by Zen priests Kosei Ryuha,
Shinden Seihan, and Itoku Shinchu (see
Figure 70). Ink and colors on paper;
dimensions of entire painting, including
inscriptions: height, 108.2 cm.; width,
32.7 cm. About 1445. Collection of Yuzo
Fujiwara, Tokyo.

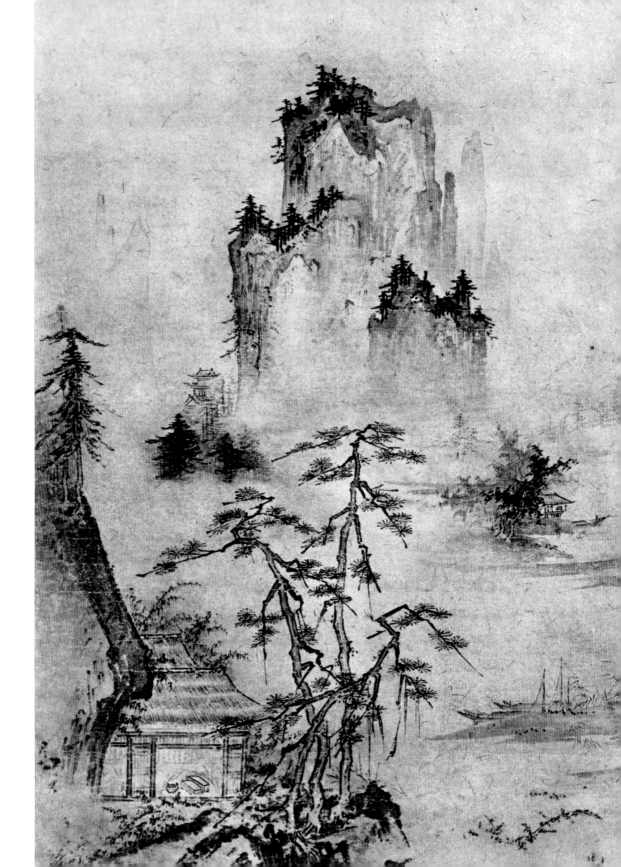

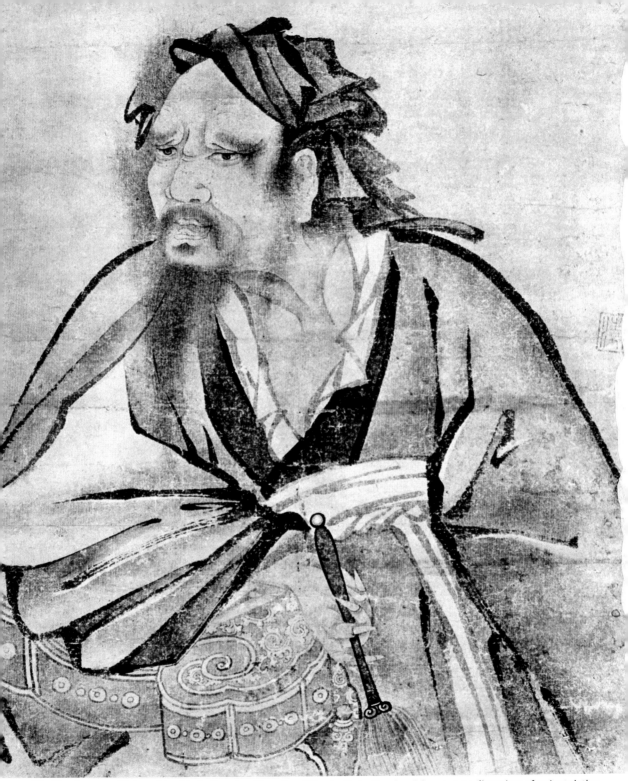

78. The Layman Yuima *(detail)*, by Bunsei, with an inscription by Sonko Somoku. Ink on paper; dimensions of entire painting, including inscription: height, 92.7 cm.; width, 34.4 cm. Dated 1457. Yamato Bunkakan, Nara.

79. Bird and Flowers, *by an unknown artist, with an inscription by Zuikei Shuho (see Figure 164). Colors on paper; dimensions of entire painting, including inscription: height, 86.6 cm.; width, 31.7 cm. Dated 1473. Collection of Yasunosuke Ogihara, Tokyo.*

80. Horse and Groom, *by Shokei. Colors on paper; height, 38.5 cm.; width, 39.5 cm. Late fifteenth century. Collection of Ataru Kobayashi, Tokyo.*

81. Crane on a Pine Branch *(detail from a* fusuma *painting now mounted as a hanging scroll), by Kano Motonobu. Ink and* ▷ *colors on paper; dimensions of entire* fusuma *panel (see Figure 167): height, 178 cm.; width, 118 cm. About 1543. Reiun-in, Myoshin-ji, Kyoto.*

82. Chou Mao-shu Admiring
the Lotus Flowers, *by Kan*
Masanobu. Ink and colors on paper
height, 84.5 cm.; width 33 cm
Fifteenth century. Collection o
Tomijiro Nakamura, Tokyo.

83. *Main hall of the Shokoku-ji, Kyoto (reconstruction of 1605).*

ture")—that is, a small signature that was practically invisible to the viewer so as not to distract from the religious nature of the work (Fig. 160). As painting for pure artistic appreciation developed, however, the aesthetic consciousness of the painter's individuality gradually increased, and with the appearance of Sesshu, who followed Shubun, large seals and signatures began to be added to paintings to signify that the work was the artist's own personal vision. This is not to say, of course, that before Sesshu no such signatures appeared on paintings but only that from around the 1390's to the 1460's it was customary for landscapes to have no artist's signature or seal. This is particularly true in the case of academy painters, who, in their roles of professional painters employed by the shogun, must have painted many pictures meant as gifts to be presented to others by their employer. For this reason such paintings, even with better supporting literary documentation, would be extremely difficult to assign with certainty to Shubun. There is really nothing firm to grasp.

I should like to mention here four pioneering research papers on Shubun that have appeared since the turn of the century. First, there is Kakujo Ogawa's full-scale thesis "Concerning the Discernment to Shubun's Paintings" (1905), published in *Kokka*, the distinguished art magazine founded by Kakuzo Okakura. The second of these papers, Professor Setsuan Ryu's "Discussion of Shubun's Painting" (1915), also published in *Kokka*, presented for the first time a general analytical discussion of Shubun's paintings from a stylistic point of view and at the same time introduced various materials for research. Third, we have Professor Rikichiro Fukui's discussion of Shubun in his book *The Mainstream of Japanese Ink Painting*, which appeared in 1928. The fourth of these pioneering explorations is

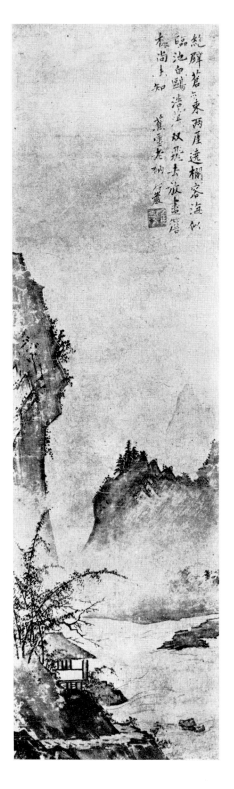

84. Landscape, *attributed to Shubun, with an inscription by Isho Tokugan. Ink on paper; height, 84.4 cm.; width, 26.1 cm. Early fifteenth century. Jisho-in, Shokoku-ji, Kyoto.*

85. Landscapes of the Four Seasons *(right-hand screen of a pair of sixfold screens), attributed to Shubun. Ink and colors on paper; height, 163 cm.; width, 362 cm. Early fifteenth century. Tokyo National Museum.*

86. Eight Views of the Hsiao and the Hsiang *(right-hand screen of a pair of sixfold screens), attributed to Shubun. Ink and colors on paper. About mid-fifteenth century. Collection of Nagataka Murayama, Hyogo Prefecture.*

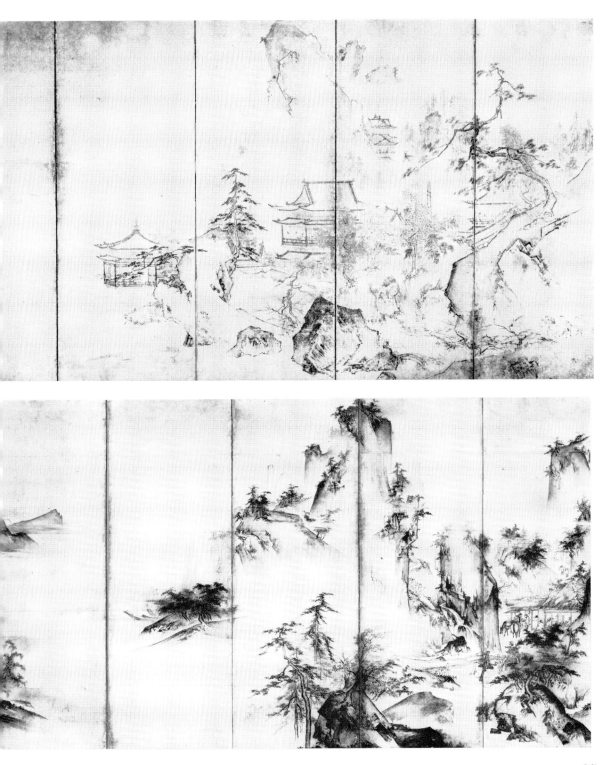

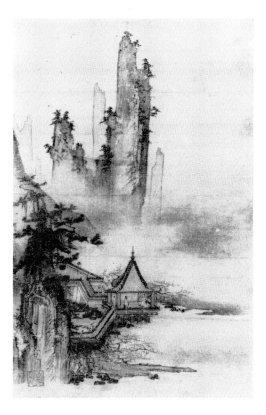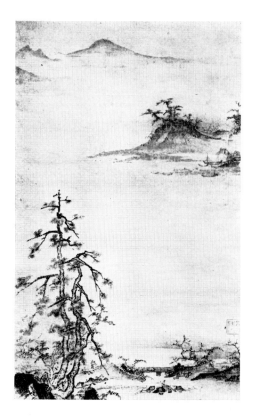

Professor Rakushiken Wakimoto's essay "The Influence of Korea on Japanese Ink Painting Circles," which appeared in the magazine *Bijutsu Kenkyu* (Art Research) in 1934.

While I cannot go into a detailed explanation of each of these theses here, generally speaking, the conclusions of these scholars are derived from their first trying to select all the paintings (primarily *shigajiku* but also including some screen paintings) produced during the thirty-year period when Shubun was supposedly active and then trying to choose from among the best of them the works most likely to be Shubun's. For example, Professor Ryu selected two paintings in the Seikado, Tokyo, as most probably by Shubun: the *shigajiku* called *Hermitage of the Three Worthies*, dated 1418 (Figs. 76, 96), and *Landscape Screen*, which bears the Ekkei Shubun seal. Professor Fukui's choices were *Setting Sun over River and Mountains* (Fig. 89), dated around

1437 and now in the Kosaka Collection, Tokyo; two pairs of landscape screens, one in the Yamato Bunkakan in Nara (Fig. 69) and the other in the Matsudaira Collection in Tokyo (Fig. 92); and two *shigajiku: Scholar's Retreat in a Bamboo Grove* (Fig. 93), now in the Tokyo National Museum, and *Mountain Landscape* (Figs. 70, 77), now in the Fujiwara Collection in Tokyo. Professor Wakimoto also selected these last two *shigajiku* and, in his discussion, emphasized the influence of Korean painting on Shubun's work. The choices of these three scholars rely less on their thorough stylistic analysis and their investigations of inscriptions and literary evidence than on their aesthetically keen powers of discernment: a kind of sensitivity that lies in the subjective and personal realm of individual taste.

Thus, setting aside for a moment the matter of the landscape screens, the evaluations of these scholars give us four scrolls. First we have the *Hermitage of the*

87 (opposite page, left). Landscape with Pavilion, *by Shokei. Ink and colors on paper; height, 55.4 cm.; width, 32.7 cm. About mid-fifteenth century. Collection of Hikotaro Umezawa, Tokyo.*

88 (opposite page, right). Landscape, *by Bunsei, with inscriptions by Ichijo Kanera and Zuikei Shuho. Ink on paper; dimensions of entire painting, including inscriptions: height, 81.2 cm.; width, 33.6 cm. About mid-fifteenth century. Private collection, Japan (formerly in the collection of the Yuasa family).*

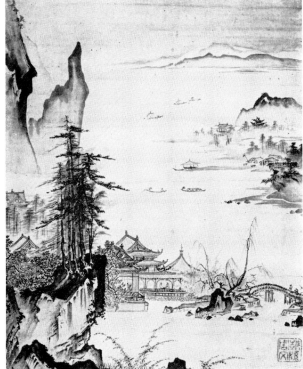

89. Setting Sun over River and Mountains, *attributed to Shubun, with inscriptions by Taigu Shochi and eleven other priests. Ink on paper; dimensions of entire painting, including inscriptions: height, 130.3 cm.; width, 30.3 cm. About mid-fifteenth century. Collection of Zentaro Kosaka, Tokyo.*

Three Worthies, a work with a vigorous line that stands practically alone among the *shigajiku* attributed to Shubun. Next is *Setting Sun over River and Mountains,* done in a clean style and bearing at the top an inscription by Taigu Shochi stating that he wrote it for Shun'iku Doji of the Erin-in, a subtemple of the Shokoku-ji. (Various histories of painting tell us that Shun'iku was one of Shubun's art names.) Finally there are *Scholar's Retreat in a Bamboo Grove* and *Mountain Landscape:* fine, strong works with breadth and depth. The style of these last two indicates that their connection with Korean painting must also be examined.

The relationship between the Ashikaga shogunate and Korea was rather close, and envoys made frequent reciprocal visits between that country and Japan. The relations became even closer after about 1423, when Shubun visited Korea. The paintings of Bunsei (Figs. 78, 88), an artist long confused with Josetsu but finally recognized as a separate individual through Professor Fukui's research, also seem to show the influence of Korean painting. Moreover, several *shigajiku* paintings often attributed to Shubun are nearly impossible to distinguish from actual Korean works.

While Korean painting at this time was of course strongly influenced by Sung painting, its particular characteristics are reflected in the minute, agitated brushwork and the *shumpo* technique of applying dots to mountains and rocks. The Shubun painting tradition, in the genre of *shigajiku,* seems to run in this same stylistic current. A thorough review of landscape painting in the first half of the Muromachi period, however, reveals that the manner of depiction had been well assimilated and that the agitated Korean-style brushwork vanished to make way for a style that was truly Japanese.

Any attempt to ferret out authentic paintings by

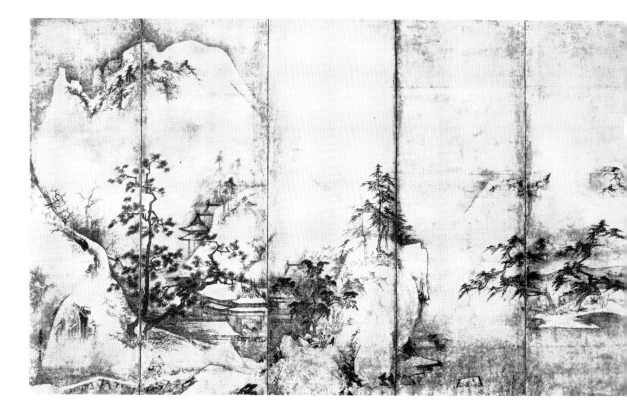

Shubun from the many *shigajiku* of the period in question leaves little recourse other than to select accomplished works that display a conspicuous style or, taking the opposite approach, to try to pick out his paintings from among those that share a common style. In all the cases noted above, however, we must also be sure to take into consideration the disparities in the dates of the various works selected. Nearly thirty years elapsed between the production of the *Hermitage of the Three Worthies* (dated 1418) and that of the *Mountain Landscape* and the *Scholar's Retreat in a Bamboo Grove.* Moreover, while the first of these was painted a few years before Shubun went to Korea, the other two, together with *Setting Sun over River and Mountains,* were painted after his return to Japan. In order to estimate the influence of Korean painting on that of Shubun, we should carefully investigate the *shigajiku* produced during the thirty-year period of his

activity, taking into consideration the dates of the works themselves and the changes they display. If we merely line the works up according to date, we shall naturally find many areas of agreement, but if we do not also take into account how influences from Korea were absorbed and adapted in Japan, this will be of little help.

Another way to approach the problem is to go the long way around, beginning with a search among the various *shigajiku* for works by any of the group of artists who surrounded Shubun and then gradually establishing some kind of order for the works attributed to Shubun himself. One such artist is the above-mentioned Bunsei, who is clearly distinguished as an individual from either Josetsu or Shubun. In addition, there exist several works by an artist known as Ten'yu who painted the *Small Landscape of Lake and Mountains* inscribed by the Tofuku-ji priest Eho and is thought to have been

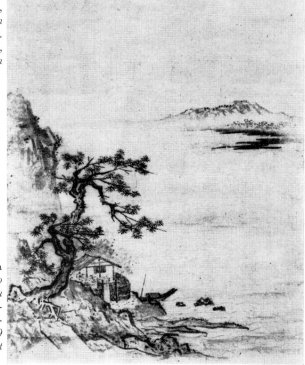

90. Landscapes of the Four Seasons *(left-hand screen of a pair of sixfold screens), attributed to Shubun. Ink and colors on paper; height, 152.7 cm.; width, 311.5 cm. Early fifteenth century. Maeda Ikutoku-kai, Tokyo. (The right-hand screen is shown in Figure 75.)*

91. Riverside Landscape Under a Clear Sky *(Koten En'i), attributed to Shubun, with inscriptions by Zengu Shusu and eleven other priests. Ink on paper; dimensions of entire painting, including inscriptions: height, 103.6 cm.; width, 33.9 cm. Early fifteenth century. Nezu Art Museum, Tokyo.*

the same person as the artist who used the name Shokei (Figs. 87, 158) and is traditionally assigned to the Takuma school. Still another such artist is Hyobu Bokkei, who painted the previously mentioned portrait of Shubun with an inscription by Son'an Reigen. The inscription states that Bokkei was a disciple of Shubun's who followed his master's painting style and practiced Zen under the guidance of the celebrated Zen master Ikkyu at the Daitoku-ji in Kyoto. The interesting problem also arises as to whether Bokkei (Fig. 145) was the same person as the artist Jasoku, a painter at the same temple. One more painter to be noted in this connection is Gakuo Zokyu, who is recorded in the *Shaken Nichiroku,* the diary of the Tofuku-ji priest Kiko Daishuku, as a disciple of Shubun's. For a long time many of Zokyu's paintings (Fig. 74) were confused with those of Shubun.

Thus a careful examination of the many similar works painted by the artists surrounding Shubun clearly indicates that a Shubun tradition existed from the time he went to Korea until after his death in the latter half of the fifteenth century. Since this is true, if we search for the focus of this tradition among the works attributed to its central artist, the most reasonable conclusion, in terms of both style and date, points to the hanging scrolls *Mountain Landscape* and *Scholar's Retreat in a Bamboo Grove.*

Another important consideration is the artist's specifically individual characteristics, so difficult to submerge completely in any style or tradition. These are most clearly hinted at by the vigorous *Hermitage of the Three Worthies,* painted before Shubun's visit to Korea. While we cannot avoid feeling that this work is stylistically isolated because of the very small number of related works, a few others do exhibit similar brushwork. One of these is the landscape in the Nezu Museum in Tokyo known as

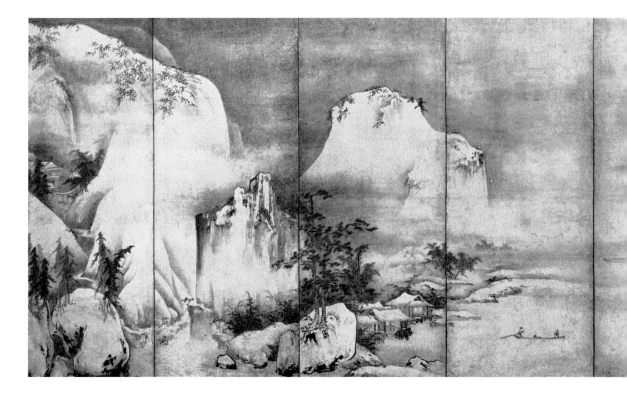

Koten En'i (Fig. 91), which was painted at about the same time as the *Hermitage of the Three Worthies.* Another is the landscape in the Jisho-in at the Shokoku-ji (Fig. 84). Such paintings enable us to discern afresh the stylistic character of *shigajiku* from the Oei era (1394–1428) that predated Shubun's visit to Korea. Further discourse on this very interesting topic must be left to another day, however, for I now wish to touch briefly on the screen paintings referred to above and thus bring to a close this discussion of the shogunate academy.

The *shigajiku* are landscape paintings of a special type—paintings in small scroll format that were related to the life of study and contemplation of the Zen priests. The paintings themselves, in spite of the excellence of some of their brushwork, were for the most part relatively simple works, the leading role being given to the poems and other inscriptions accompanying the pictures. Accordingly, the *shiga-jiku* alone cannot very well be discussed as the representative landscape painting of the period. The true landscapes are to be found instead in the large-scale *fusuma* and screen paintings—works that exhibit a development in composition, skillful brushwork, and the use of professional techniques. While research on this subject faces difficulties because of the dearth of surviving works, several outstanding examples do exist. These are the screens in the Seikado, the Yamato Bunkakan, and the Matsudaira Collection, all referred to in the pioneering studies on Shubun mentioned earlier. In addition, the pairs of sixfold screens in the Maeda Collection (Figs. 75, 90), the Murayama Collection (Fig. 86), and the Mori Collection are extremely fine examples of landscape depiction. The complexity of composition in screen format and the mastery of brush handling that they display give them a remarkable power. Stylistically they have

92. Landscapes of the Four Seasons *(left-hand screen of a pair of sixfold screens), attributed to Shubun. Ink and colors on paper; height, 151.5 cm.; width, 355.2 cm. Early fifteenth century. Collection of Ayako Matsudaira, Tokyo.*

93. Scholar's Retreat in a Bamboo Grove, *attributed to Shubun, with a long prefatory inscription by Jikuun Toren and brief inscriptions by Kosei Ryuha and four other priests. Ink on paper; height, 134.8 cm.; width, 33.3 cm. About 1446. Tokyo National Museum.*

some points in common with the smaller *shigajiku* that would make further research extremely interesting. These screen paintings are generally spoken of as landscapes depicting the four seasons, but they also often included paintings on a traditional Chinese theme: the Eight Views of the Hsiao and the Hsiang—that is, the two rivers whose point of confluence is one of China's famous scenic spots. The scenery in the paintings, however, would frequently be modified in such a way that the composition would lose some of its unity and tend to become a mere arrangement of eight scenes in a row. Sometimes the Eight Views were depicted one by one in the *shigajiku* format, with the result that the original unified theme was broken down. For this reason, it is possible to consider that the transfer of such separate scenes to the larger painting surface of a screen served as one basis for the landscape designs on the screens of this age, but the extent to which this is

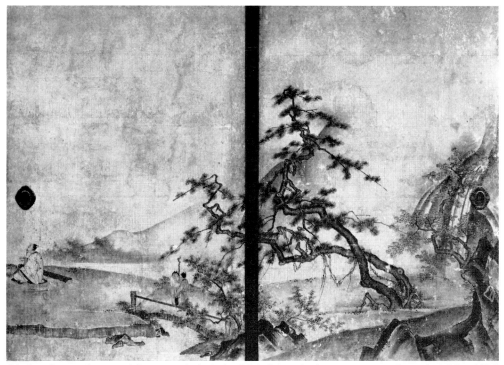

94. Landscape *(two-panel* fusuma *painting), by Sokei. Ink and colors on paper; each panel: height, 169.2 cm.; width, 115.8 cm. Dated 1490. Kyoto National Museum (formerly in the Yotoku-in, Daitoku-ji, Kyoto).*

true will have to be determined through further comparative research on these two formats.

The above-mentioned pairs of folding screens in the Maeda, Matsudaira, Murayama, and Yamato Bunkakan collections are stylistically nearly all of one order. The Maeda screens (Figs. 75, 90) are perhaps the earliest in this group, and the Murayama screens (Fig. 86) seem to have the closest relationship with the previously noted artist Gakuo Zokyu. In any event, we can interpret the continuance of this type of screen format as substantiation of the character of the academic lineage.

The life of Shubun's successor Sotan, who took charge of the academy under the shogun Yoshimasa, is even more difficult to fathom than Shubun's. We find the first mention of Sotan in an entry in the above-noted *Onryoken Nichiroku* for 1462

in which we learn that he had the family name Oguri. Soon after that time he became a Buddhist priest and took the art name Sotan. He was also known by the name Jiboku. We know that four years later, in 1466, he was receiving the same stipend as had been granted to Shubun and that he served the shogun as a professional painter. Again, it is known that he produced *fusuma* paintings at such places in and around Kyoto as the Ishiyamadera, the Shosen-ken, the Untaku-ken, and the Takakura Imperial Palace and that he died in 1481 at the age of sixty-eight. The famous *Oguri Hangan Monogatari* (Tale of the Magistrate Oguri) is traditionally said to be a portrayal of this painter's life, but of course we do not know what connection he may have had with the story.

We now face the very difficult problem of estab-

95. Reeds and Wild Geese *(two-panel* fusuma *painting)*, *by Sotan and Sokei. Ink and colors on paper; each panel: height, 169.2 cm.; width, 115.8 cm. Dated 1490. Kyoto National Museum (formerly in the Yotoku-in, Daitoku-ji, Kyoto.*

lishing just what kind of pictures Shubun's successor Sotan painted. The *Onryoken Nichiroku* states that in 1490 Sotan's son Kitabo Sokei produced some *fusuma* paintings (Fig. 94) in the Yotoku-in of the Kyoto temple Daitoku-ji and that at that time he also completed the *fusuma* painting *Reeds and Wild Geese* (Fig. 95), which Sotan had left unfinished in the same Yotoku-in. Sokei's *fusuma*, as well as the *Reeds and Wild Geese*, are now in the Kyoto National Museum. Apparently Sokei remained altogether faithful to his father's style in his completion of the *Reeds and Wild Geese*, for we can distinguish no difference in the brushwork throughout the whole painting. In fact, there is a close similarity among all these Yotoku-in *fusuma* landscapes, and in overall style and technique they differ in a number of respects from the previously noted

paintings in the Shubun tradition, suggesting the possibility that perhaps the greater part of the *Reeds and Wild Geese* was painted by Sokei. If, however, we assume that the Yotoku-in paintings represent the Sotan style and, on this basis, search for evidence of that style in other paintings of the time, we find some points in them that recall the Seikado *Landscape of the Four Seasons* (Fig. 71), and therefore this pair of screens, traditionally attributed to Shubun, is being examined today from this point of view. The screens are rather special works that differ in feeling from the numerous pairs of screens mentioned earlier and have certain elements that seemingly link them with the Yotoku-in paintings. It is thus possible that paintings attributable to Sotan or Gakuo may be mixed in with paintings long attributed to Shubun, and we find

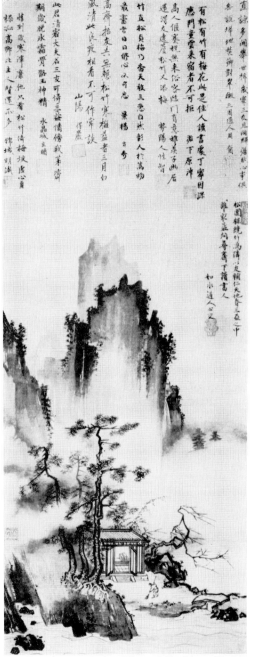

96. Hermitage of the Three Worthies *(San'eki Sai)*, attributed to Shubun, with inscriptions by Gyokuen Bompo and eight other priests. *(See also Figure 76.)* Ink on paper; height, 110.5 cm.; width, 38.8 cm. Dated 1418. Seikado, Tokyo.

here an indication of the general direction that future research could take to solve the puzzling problems surrounding Shubun and Sotan.

Having looked at these enigmatic painters, both of whom were at the very center of the Muromachi-period academy, we find ourselves in the situation of having to await the results of new research before any solutions can be reached. As we have observed, research proceeding directly from the paintings and research on the basis of biographical sources are often likely to proceed along two parallel lines that make no connection with each other. Thus our arguments must of necessity proceed by a circuitous route if we are to reach any kind of conclusions at all. Another difficulty in distinguishing among the artists is that the stereotyped quality of the works and their themes does not allow the personality of the individual artist to shine through. The reason for the stereotypes may lie in the direction that Muromachi *suiboku* landscape painting took when the style of the shogunate academy solidified into a strong tradition that came to dominate the whole painting world of the time. Again, the reason why the academy painters achieved prominence lay in the very power that this traditional realm of painting possessed rather than in any individual qualities the artists themselves may have had. This particular characteristic of the academy is represented both by the confusion regarding seals and signatures and by the examples of Shokei and Gakuo Zokyu, who were so long confused with Shubun and had to exist under his name.

In the next chapter we shall discuss Sesshu, the first artist to break out of the academy and establish his own independent realm. Sesshu's greatness appears quite different from that of Shubun, although there is no denying the teacher-student relationship that existed between them at the Shokoku-ji. Therefore we have to confront the problem of Shubun-style elements in Sesshu's painting. There is also the interesting matter of how Sesshu managed to break away from the shogunate academy.

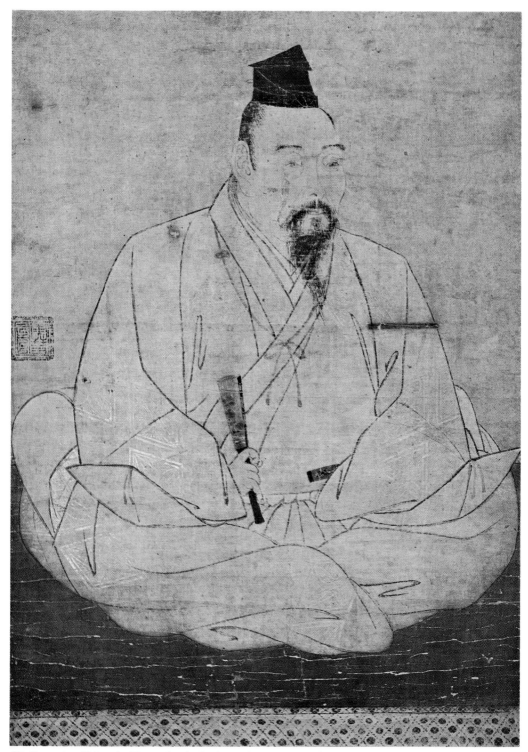

97. Portrait of Masuda Kanetaka, *by Sesshu, with an inscription by Chikushin Shutei (see Figure 165). Ink and colors on paper; dimensions of entire painting, including inscription: height, 82.1 cm.; width, 40.3 cm. Dated 1479. Collection of Kaneharu Masuda, Tokyo.*

98. Flowers and Birds of the Four Seasons *(left-hand screen of a pair of sixfold screens), attributed to Sesshu. Ink and colors on paper; height, 151.6 cm.; width, 366 cm. Early sixteenth century. Collection of Akiko Shinagawa, Toyama Prefecture. (The right-hand screen is shown in Figure 166.)*

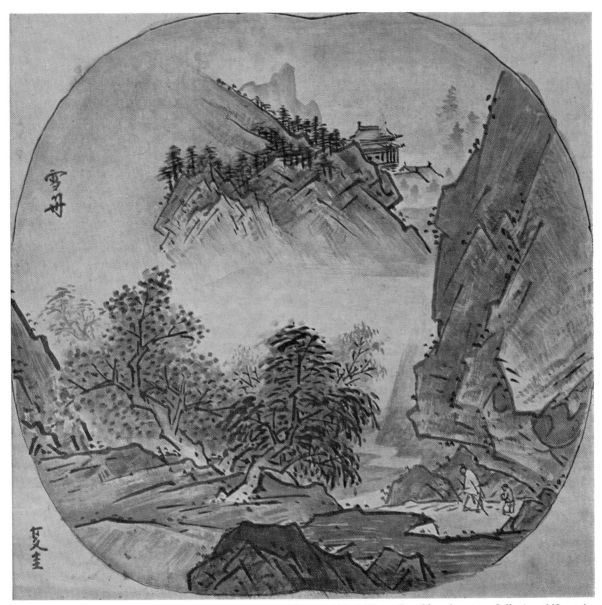

99. Landscape, *by Sesshu. Ink and colors on paper; height, 30.2 cm.; width, 30.7 cm. Late fifteenth century. Collection of Nagatake Asano, Tokyo.*

100. Winter Landscape, *by Sesshu. Ink on paper; height, 46.3 cm.; width, 29.3 cm. Late fifteenth century. Tokyo National* ▷ *Museum.*

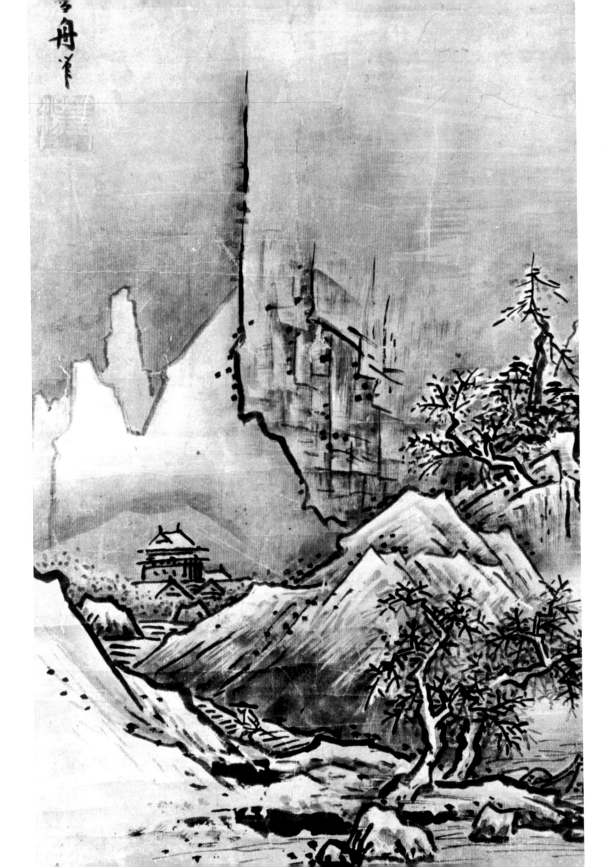

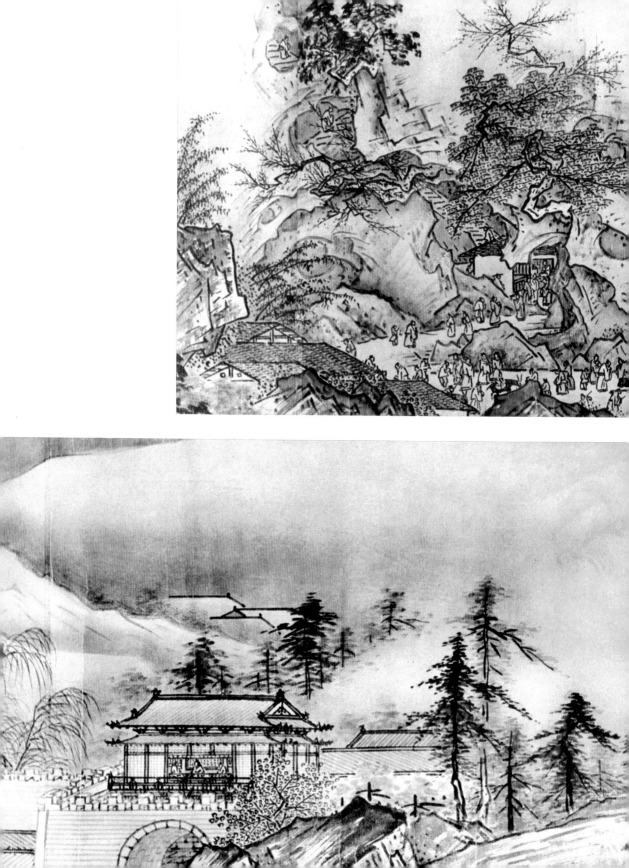

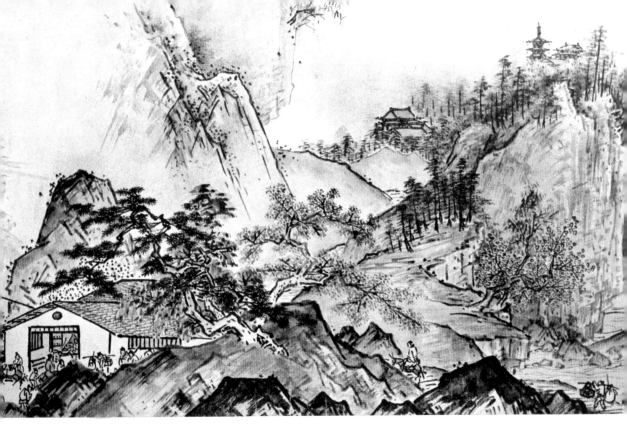

101. Two sections from the Long Landscape Scroll (Sansui Chokan), by Sesshu. Ink and colors on paper; dimensions of entire scroll: height, 40 cm.; length, 1,807.5 cm. Dated 1486. Mori Foundation, Bofu, Yamaguchi Prefecture. (See Figures 122 and 169 for other sections of the scroll.)

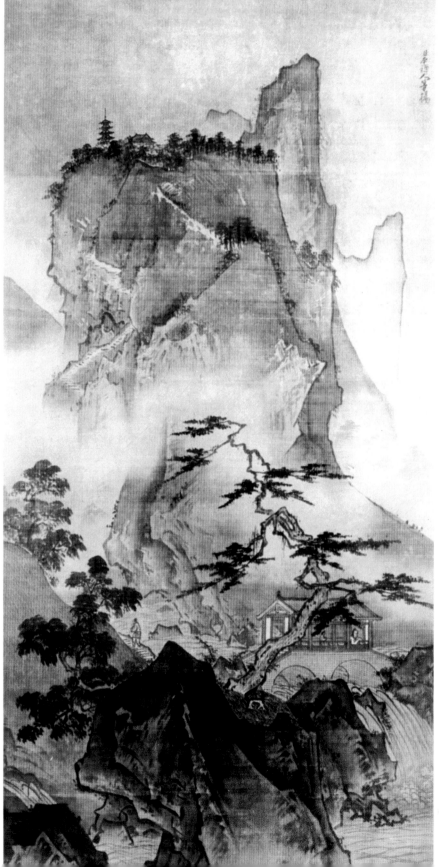

102. Summer Landscape *from* Landscapes of the Four Seasons *(see Figure 106), by Sesshu. Ink and colors on silk; height, 149.3 cm.; width, 75.7 cm. About 1468. Tokyo National Museum.*

CHAPTER FOUR

Sesshu, a Painter
Outside the Academy

SESSHU'S CAREER Unlike the lives of the academic painters Shubun and Sotan, the life of Sesshu Toyo is well enough defined for us to grasp its general outline. We may infer from the fairly numerous surviving records and also from the rather numerous paintings bearing dates or notations of his age when he completed them that Sesshu was born about 1420. Tradition says that he was born in Akahama, a rural village on the Inland Sea, in Bitchu Province (the present Okayama Prefecture). The social position of his family is not clear, although it seems doubtful that it was of an extremely low class. Tradition also says that he was placed at an early age in the Hofuku-ji (still today a large temple in the city of Soja) in Iyama, near the village where he was born. At that time it was the custom to place all but the eldest son of the family in Buddhist temples, where they would undergo religious training as acolytes. The Hofuku-ji is supposedly the scene of the famous legend that relates how Sesshu, tied to a tree in punishment for some misdemeanor, drew a rat with the tears he had shed and then watched with delight when it came to life, gnawed the ropes that bound him, and thus set him free.

Later he entered the Shokoku-ji in Kyoto and served Shunrin Shuto, who was the *sorokushi* (manager of general affairs) and who eventually became chief abbot. During his twenties and thirties Sesshu seems to have practiced Zen discipline under Shuto. By 1464, when he was already past forty, he had moved to Yamaguchi in Suo Province (the present Yamaguchi Prefecture), where he established a studio called the Unkoku-an and gained renown as the "priest-painter of Unkoku."

Our knowledge of the existence of the Unkoku-an comes to us from a record kept by Sesshu's old friend the Tofuku-ji Zen priest Koshi Eho, who visited there, but its exact location is a matter of conjecture. One theory places it at Tenge in the present Yamaguchi City, while a second theory favors nearby Kumogatani in Yoshiki County. Today the latter location is the more widely accepted by scholars. It is not clear why Sesshu moved to Yamaguchi, but it is safe to say that he was looking for an opportunity to travel to Ming China for study.

At this time Yamaguchi was the castle town of the powerful Ouchi daimyo family whose influence extended to Kyushu and Shikoku. The town was so flourishing as a cultural center that it came to be called Little Kyoto. After the civil war of the Onin era (1467–77), which devastated Kyoto and dispersed its culture to the provinces, Yamaguchi continued to thrive. The Ouchi family played a leading role in the Japanese trade with Ming China and

had strong ties with the wealthy traders of Sakai (the port for Osaka), who were also quite active in foreign trade.

In 1468, soon after the Onin War broke out, Sesshu finally had the opportunity to cross over to China on one of the Ouchi ships. The trade with China at that time had three main participants: the shogunate government and the powerful Hosokawa and Ouchi families. A large fleet consisting of the ships of all three was made ready for the voyage. Ten'yo Seikei, a Zen priest of the Kennin-ji, was appointed as senior envoy by the shogunate, and a large number of traders from the ports of Sakai and Hakata were among the travelers. Only the Ouchi ships, however, managed to set out on schedule, thus allowing Sesshu to reach China before the remainder of the fleet arrived.

During his year in China (he returned to Japan in 1469) Sesshu traveled from the southern port of Ningpo, where he landed, all the way north to Peking, devotedly pursuing both his religious and his artistic training at every opportunity. In the Szuming district, where Ningpo lay, he went to the temple T'ient'ung, one of the Five Great Zen Temples of China, to undertake further practice of Zen discipline. One of his artist signatures is "Shimei Tendo Daiichi Za" (Occupant of the First Seat at T'ient'ung in Szuming), indicating that he had been accorded the honor of the "first seat" in the temple's meditation hall—the seat next to the abbot.

As for his painting during this sojourn in China, Sesshu relates in his own inscription on the *Haboku Landscape* (Figs. 103, 171) in the Tokyo National Museum that there were very few teachers he could admire but that he did learn the *haboku* (broken ink) technique and the use of colors from Chang Yu-sheng and Li Tsai. The former is a name not found among biographies of Chinese painters, but the latter was a first-rank painter at the Ming court academy and a prominent member of the Che

◁ *103.* Haboku Landscape, *by Sesshu, with inscriptions by the artist and six priests. (See also Figure 112.) Ink on paper; height, 149 cm.; width, 33 cm. Dated 1495. Tokyo National Museum.*

104. *Garden of the Joei-ji, Yamaguchi Prefecture, traditionally said to have been designed by Sesshu.*

school. Some of his paintings survive in Japan.

Sesshu's close friends Bofu Ryushin and Ryoan Keigo, in their *Tenkai Togaro Ki* (Account of the Tenkai Togaro) and *Tenkai Togaro Goki* (Later Account of the Tenkai Togaro), which deal with the studio he established after his return from China, tell us that he produced a splendid wall painting in one of the government offices in the Ming capital of Peking and that it was lavishly praised. We also learn from these records that Sesshu traveled extensively throughout the Chinese countryside, making a great many sketches directly from the landscapes he saw.

In the Muromachi period it was rare indeed for a Japanese painter to go straight to the continent in search of Chinese art. Consequently, Sesshu was a true pioneer in the sense that he sought training in

Chinese painting by going directly to its source. His extraordinary passion and forcefulness are clearly reflected in the solid composition and strong brushwork of his paintings.

Upon his return to Japan in 1469, Sesshu went to the province of Bungo (the present Oita Prefecture) in Kyushu and there established a studio called the Tenkai Togaro: the Heaven-created Painting Pavilion. The studio apparently occupied a seashore site with a magnificent view away from the city of Oita, where it was located. The above-noted records by Sesshu's friends relate episodes from his life there. He seems to have been accorded a great welcome as a painter just returned from China. All kinds of people, from daimyo and samurai down to commoners, came to him with requests for paintings, all of which he tried to fulfill.

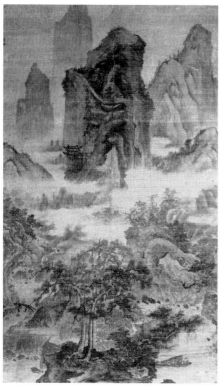

105 (left). Landscape, *by Li Tsai. Ink and colors on silk; height, 139 cm.; width, 83.3 cm. Ming dynasty, fifteenth century. Tokyo National Museum.*

106. Landscapes of the Four Seasons *(right to left: spring, summer, autumn, winter), by Sesshu. Ink and colors on silk; each scroll: height, 149.3 cm.; width, 75.7 cm. About 1468. Tokyo National Museum.*

We are told that Sesshu would often begin his work by gazing out upon the broad landscape of sea and mountains that lay beneath his windows. After a drink of sakè, he would pick up his bamboo flute and play a sonorous, lingering melody to establish the right mood. Only then would he take up his brush and begin to paint. He must have been truly prolific, for we learn that the floor of his studio was constantly covered with scattered pieces of used and unused paper. His landscape entitled *The Jinta Waterfall* (Fig. 107) was painted in Oita in 1476, but unfortunately it was destroyed in the great Kanto earthquake of 1923.

At some unknown date Sesshu returned to the Unkoku-an in Yamaguchi. The famous *Sansui Chokan,* or *Long Landscape Scroll* (Figs. 101, 122, 169), in the collection of the Mori family in Yamaguchi Prefecture, has a postscript dated 1486, and even earlier, in 1479, he had painted a portrait of Masu-

da Kanetaka (Fig. 97), the daiymo of the neighboring Iwami Province (now part of Shimane Prefecture). The geographical relationship of these two works thus seems to indicate that Sesshu was already in Yamaguchi in the late 1470's.

His practice of *zazen* and his custom of making leisurely pilgrimages to various Buddhist temples and monasteries seem to have given him a strong body and robust health, so that until he reached quite an advanced age he was able to travel on foot to various parts of the country, painting realistic pictures of the places he visited along the way. His famous *Ama no Hashidate* (Fig. 111) is a masterly depiction of this well-known scenic spot (the name means "Bridge of Heaven") as he saw it during his sojourn there. The painting already displays the beginnings of a new kind of realism that was amazing for its time. It can be dated sometime after 1501, for among the buildings it depicts is the

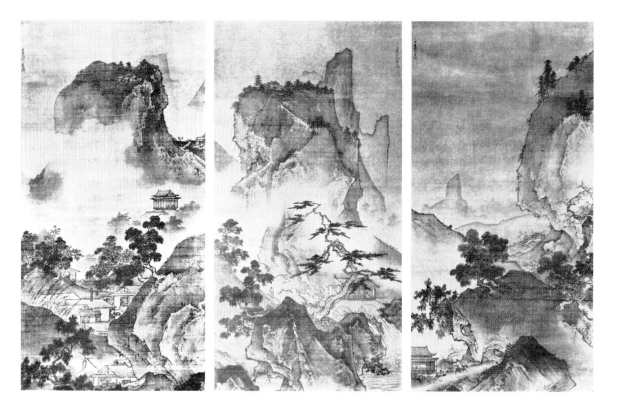

tahoto, or single-story pagoda, of the Chion-ji, which was erected in that year. Even if Sesshu had painted the work that very year, he would have been eighty-one years old, but its strength and power belie his age. If Sesshu died in 1506 at the age of eighty-six, as is commonly accepted, this work serves as proof that he must have been vigorously healthy right up to the very end of his life.

We know from a Kano-school copy that Sesshu also painted a view of the Risshaku-ji (also called Yama-dera) in Yamagata Prefecture, but the original painting no longer exists. Above the painting was an inscription written in 1483 by Son'an Reigen of the Nanzen-ji. Two years earlier, Sesshu had visited the Shoho-ji in Mino Province (the present Gifu Prefecture), met the poet Shitto Banri, and painted pictures that included a view of the Chinshan Temple in China. His visit to the Risshaku-ji probably took place in 1482. Again, late in

life, Sesshu traveled with his disciple Toshun in Kaga and Noto provinces (the present Ishikawa Prefecture) and visited the Hatakeyama and Togashi daimyo families.

The foregoing is at best a brief outline of Sesshu's long, full life. Let us summarize it concisely here before going on to other aspects of his career. As a youth in Kyoto, he entered the Shokoku-ji and underwent Zen training under the guidance of Shunrin Shuto. By his forties he had already left Kyoto and built a studio in the Yamaguchi region. His reasons for moving there no doubt included the hope of improving his chances of someday going to the continent to study Chinese ink painting at first hand. Around the age of fifty he returned to Japan from a sojourn in China, having finally fulfilled his long-standing ambition. He then set up a studio in Oita and later returned to his Unkoku-an studio in Yamaguchi, at the same time making pilgrimages

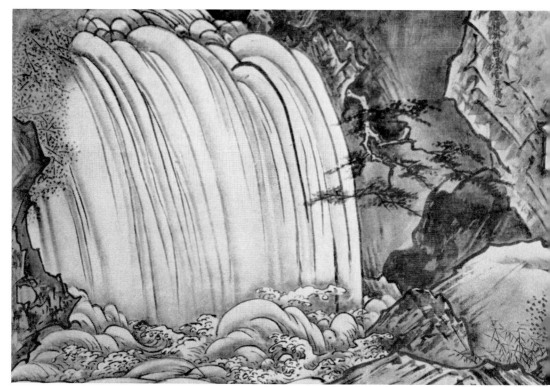

107. The Jinta Waterfall, *by Sesshu. Ink on paper; height, 41.8 cm.; width, 87.3 cm. About 1476. Destroyed by fire in 1923.*

to numerous places in Japan. It was at the Unkoku-an that he lived out the rest of his long life.

The second half of Sesshu's life, dating from the time when he abandoned the central painting circles in Kyoto and went into the provinces, was the real period of his painting activity. There is a tradition to the effect that upon his return from China he was recommended as Sotan's successor at the shogunate academy but declined the appointment and suggested Kano Masanobu (1454–90) instead. Whether this story is true or not, it is certain that Sesshu did not reside in Kyoto after he returned from China. It is also certain that the leadership of the central academy passed from Oguri Sotan to Kano Masanobu and his son Kano Motonobu (1476–1559), bypassing Sesshu. That is to say, the leadership of the academy, which had previously been held by the Zen priests Josetsu and Shubun, was at some point turned over to lay painters of samurai origin. Consequently, Sesshu's existence as a kind of outsider working in his own independent realm assumes a special significance. He was a wandering painter whose free-and-easy pilgrimage throughout the land—and, indeed, through life itself—enabled him to enter deeply into his art, at the same time linking him with the Japanese artistic tradition that includes such other wanderers as the *renga* (linked verse) poet Sogi (1421–1502), who lived in the same period; the poet-priest Saigyo, who lived in the twelfth century; and the *haiku* poet Basho (1644–94), who lived in the Edo period (1603–1868). The world of rather rough strength

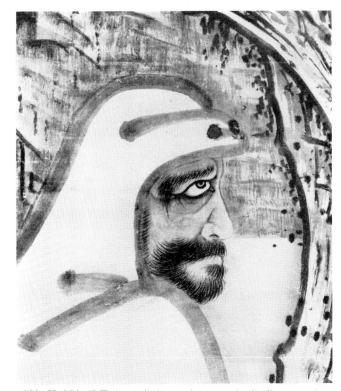

108. Hui-k'o Offering His Severed Arm to Bodhidharma *(detail showing head of Bodhidharma), by Sesshu. Ink and colors on paper; dimensions of entire painting: height, 182.7 cm.; width, 113.6 cm. Dated 1496. Sainen-ji, Aichi Prefecture. (For another portrayal of Hui-k'o and Bodhidharma, see Figure 22.)*

and firmness that Sesshu constructed in his paintings is one of his special accomplishments. One feels that he probably saw little hope for stylistic development among future artists and that for this reason he had a profound sense of the need for an independent individual existence.

Still, we cannot deny the student-teacher relationship between Sesshu and the two older priest-painters Josetsu and Shubun, for it was he himself who wrote on the *Haboku Landscape:* "Josetsu and Shubun are my two predecessors." Nor can we deny that he had students of his own, for he gave this same landscape to his disciple Soen Zusu as proof of his artistic succession. But when we try to single out paintings by Sesshu that demonstrate his relation with Josetsu and particularly his relation with Shu-

bun, we are immediately perplexed because we are not clear concerning the works that preceded his visit to China.

In the *Sesshu Niji Setsu* the Rokuon-in *sorokushi* Ryuko Shinkei explains the significance of the two characters that make up the name Sesshu (雪舟). He tells us that Sesshu first used this name in the Kansho era (1460–66), when he was forty-four or forty-five, because he was very fond of a piece of calligraphy in which the Yuan Zen priest Ch'u-shih Fan Ch'i (in Japanese, Soseki Bongi) had written these two characters for him. Although his art name before this time remains unclear, we must try to determine it if we are to learn the full story of Sesshu's career.

I once presented a tentative theory to the effect

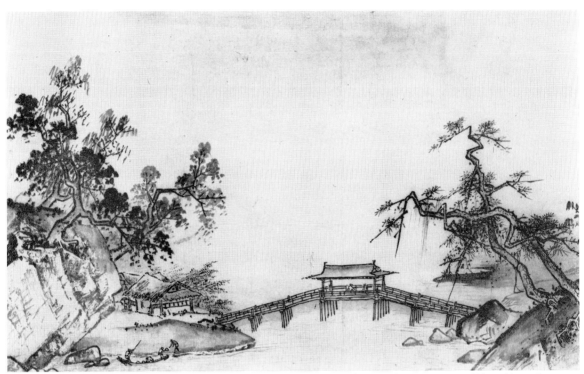

109. *Section from* Landscape Scroll, *attributed to Hsia Kuei. Ink on paper. Southern Sung dynasty, twelfth to thirteenth century.* National Palace Museum, Taipei.

that the painter's earlier art name, or *go*, was perhaps Sesshu Toyo (拙宗等揚), in which the "Sesshu" is written with different characters but still pronounced the same way. However, because this theory did not receive much scholarly support and because another theory, which also appears reasonable to me, suggests the name Unkoku Toyo (雲谷等揚) rather than Sesshu Toyo, further discussion of this important matter will have to wait until a later date. Instead, let me attempt to confirm Sesshu's link with Shubun by calling attention to two *shigajiku*.

One of these is a landscape (Fig. 120) bearing inscriptions by two Korean officials, known in Japan as Ri Son and Boku Kobun, who perhaps were members of a delegation from Korea that visited Japan in 1479. The painting pictures a towering mountain peak and a building with a high roof in the middle ground—two elements that are shared with the so-called Shubun-style *shigajiku*. The date of the work also makes it a not unreasonable selection to serve as evidence that Sesshu studied with Shubun.

The other *shigajiku* is also a landscape (Fig. 119), in this case with inscriptions by the priests Bokusho Shusho and Ryoan Keigo, who were long-time friends of Sesshu's. The composition here omits the central mountain peak and presents, instead, a broad view of a distant shore with a "modern" kind of horizon line unusual for the medieval period. While the mansion and the tall pines in the middle ground are derived from the *shigajiku* tradition, we can observe Sesshu's creative power in the way he placed these elements to provide a frame for the

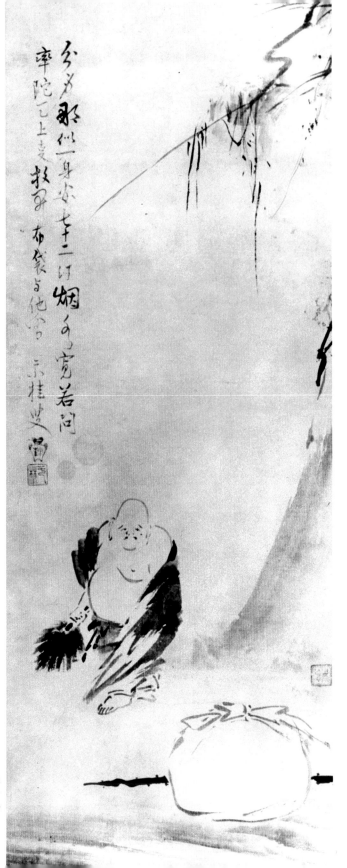

110. Hotei *(Pu-tai), by Shutoku, with an inscription by Senrin Sokei. Ink on paper; height, 97.5 cm.; width, 38.8 cm. Sixteenth century. Collection of Sotaro Kubo, Osaka.*

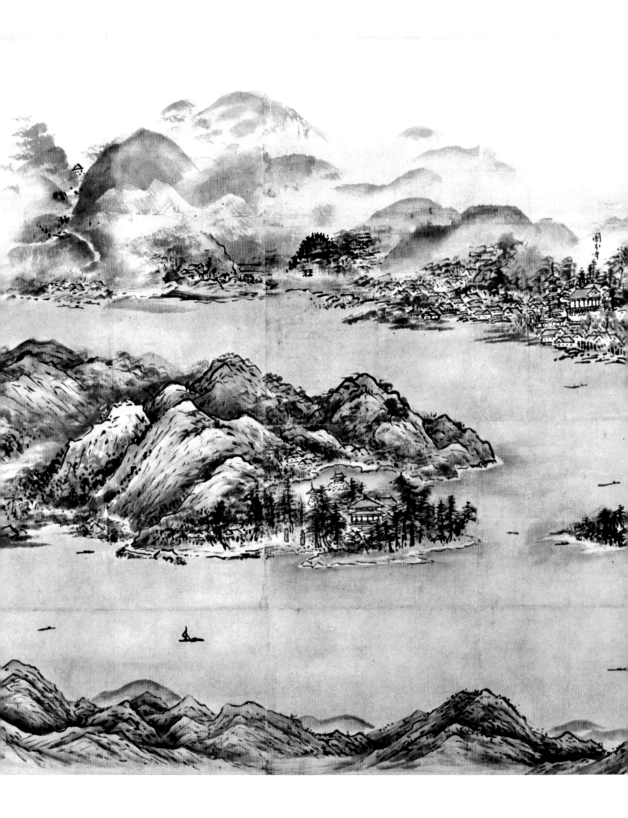

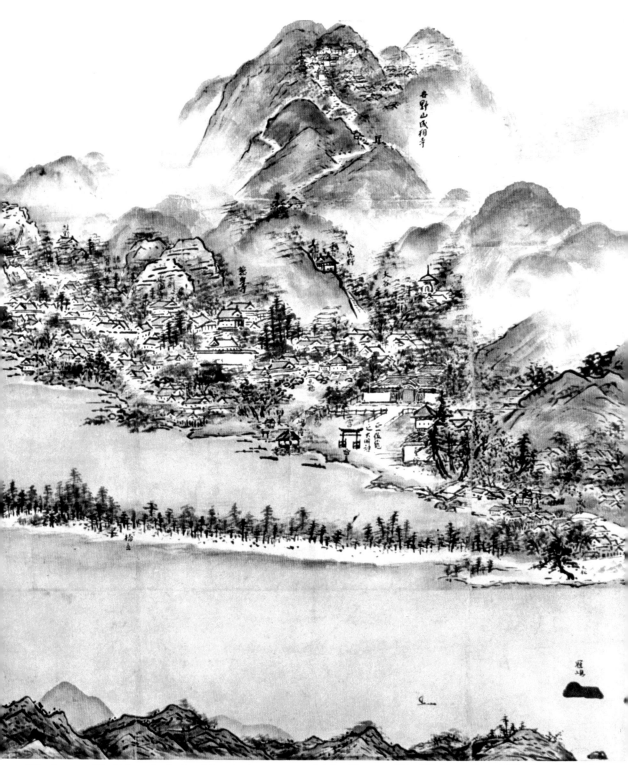

111. Ama no Hashidate, *by Sesshu. Ink and colors on paper; height, 90 cm.; width, 178.2 cm. About 1503. Kyoto National Museum.*

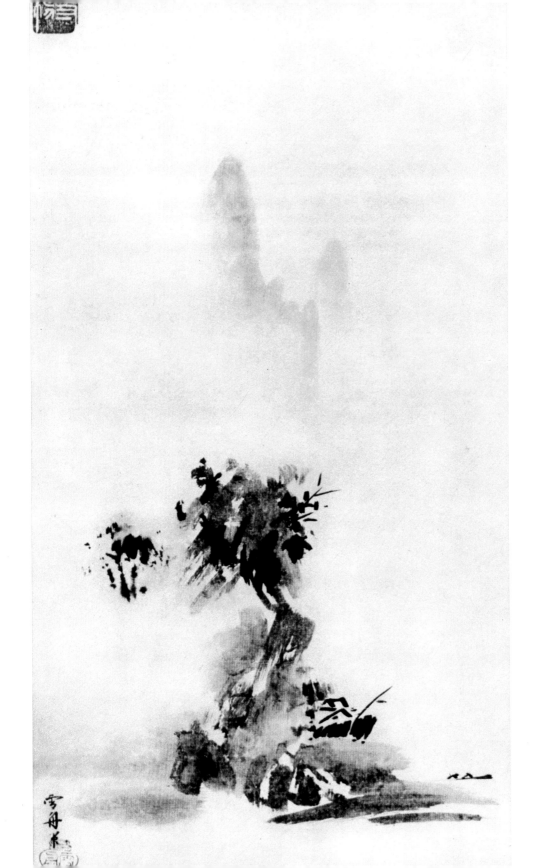

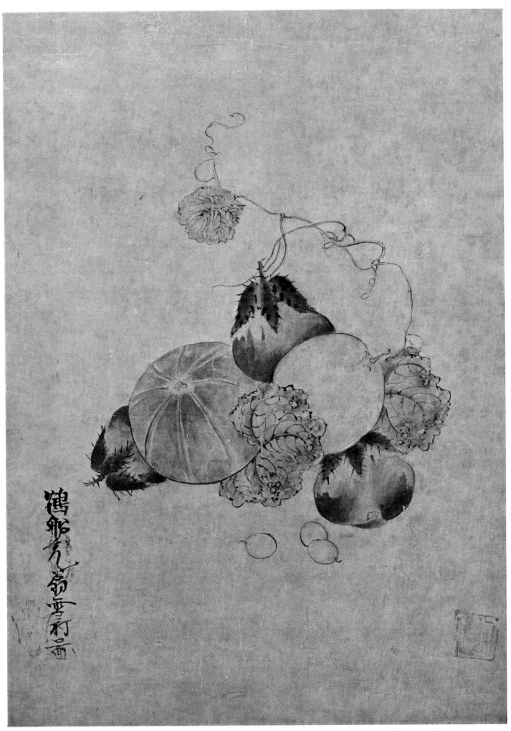

113. Melons and Eggplants, *by Sesson. Colors on paper; height, 72.5 cm.; width, 36.6 cm. Sixteenth century.* Collection of Soichiro Takishima, Tokyo.

◁ *112.* Haboku Landscape, *by Sesshu, with inscriptions by the artist and six priests (see Figure 103). Ink on paper; dimensions of entire painting, including inscriptions: height, 149 cm.; width, 33 cm. Dated 1495. Tokyo National Museum.*

114. Hibiscus and Quail, *by Toshun, with an inscription by Keijo Shurin. Colors on paper; dimensions of entire painting, including inscription: height, 46.1 cm.; width, 35 cm. Early sixteenth century. Collection of Sogoro Yabumoto, Osaka.*

115, 116. Camellias and Small
Bird (115) and Hibiscus and In-
sect *(116), by Soyo. Colors on
paper; each painting: height, 26.2
cm.; width, 29.2 cm. Early sixteenth
century. Shinju-an, Daitoku-ji,
Kyoto.*

117. Landscape *(two panels from right-hand screen of a pair of sixfold screens), by Shikibu (formerly attributed to Ryuko). Ink and colors on paper; dimensions of entire screen (see Figure 174): height, 153 cm.; width, 346 cm. Early sixteenth century. Seikado, Tokyo. (A section of the left-hand screen is shown in Figure 175.)*

118. Section from Landscape Scroll, *attributed to Hsia Kuei. Ink on paper; dimensions of entire scroll: height, 43.6 cm.; length, 106.6 cm. Southern Sung dynasty, twelfth to thirteenth century. Collection of Nagatake Asano, Tokyo.*

painting's spatial depth. Ryoan Keigo's poetic inscription, written in 1507 when he visited the Unkoku-an after Sesshu's death, laments: "Boku-sho has left his poetry behind. Sesshu has passed away."

The style of this hanging-scroll landscape, more refined than that of the first, enables us to date it slightly later. The painting demonstrates the influence of the Shubun style on Sesshu, at the same time showing his ability to develop it further. But the new development in Sesshu's painting was not stimulated by the traditional academic style of the day. It resulted, rather, from his determination to go to China and study Chinese art at its source and his endeavor to master a realism derived not from other paintings but from direct observation of the actual world around him. It was in this way that Sesshu escaped from the bonds of the academy and proceeded to create his own personal artistic realm.

SESSHU'S PAINTING STYLE

The four extant hanging scrolls known as *Landscapes of the Four Seasons* (Figs. 102, 106), which Sesshu seems to have painted abroad, provide evidence that he studied the work of such artists as Li Tsai of the Che school. The *rakkan* on each of the paintings reads "Nihon Zenjin Toyo" (Toyo, Japanese man of Zen). It requires only a glance to tell us that the four scrolls share a number of characteristics with the actual Li Tsai painting presented in Figure 105. Although Sesshu faithfully studied the painting techniques of the Che school, he was certainly not an unabashed admirer of the school, for, as we have already noted, he found very few painters in China whom he could admire. The inscription is, in effect, an evaluation of Ming painting, and in this connection we should note that the Ming-period Che school broke away from the model created by such Sung

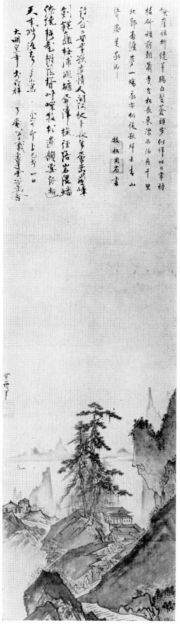

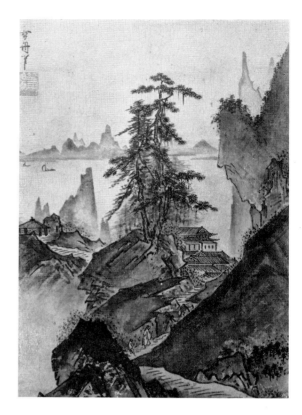

119. Landscape *(entire scroll and detail)*, *by Sesshu, with inscriptions by Bokusho Shusho and Ryoan Keigo. Ink on paper; dimensions of entire scroll: height, 117.4 cm.; width, 35.2 cm. Late fifteenth century. Private collection, Japan.*

painters as Ma Yuan and Hsia Kuei and proceeded in a direction that might be labeled baroque, for both the composition and the brushwork acquired a baroque style of movement. But paintings in this style tended to become agitated and rough, and Sesshu became extremely dissatisfied with such tendencies. Perhaps this is the reason why, as he himself notes in the latter part of the inscription, he gained new respect for his predecessors Josetsu and Shubun, who also set out with Sung painting as their model but who did not yield to the same tendencies as those displayed by the Che-school painters.

Sesshu seems not to have been conscious of the existence of the Wu school, which stood in contradistinction to the Che school and comprised the Ming-period gentry class—in other words, the *wen jen* (in Japanese, *bunjin*), or literati painters, as represented by Ch'en Shih-t'ien. The Wu school

eventually developed into the so-called Southern school of painting, known in Chinese as *nantsunghua* and Japanese as *nanshuga*. Although Sesshu was probably unaware of its status as a school, he apparently absorbed elements from the pioneering artists who comprised it.

The *Sansui Shokan*, or *Small Landscape Scroll* (Figs. 121, 123), shows that Sesshu also studied the work of the Yuan literati painter Kao Yen-ching (in Japanese, Ko Genkei), whose style was popular in China at the time of Sesshu's visit there. One section of this scroll included a scene that Sesshu is said to have painted in imitation of Kao, but unfortunately this section was cut from the scroll and replaced with a copy by one Hasegawa (Fig. 123)—perhaps the Momoyama-period artist Hasegawa Tohaku (1539–1610). The copy seems to indicate that Sesshu used soft and wet brush techniques (*himashun*) rather than hard brush techniques (*fuhekishun*) and hence perhaps used a brush made of something like shredded linen fibers. A Chinese painter known to the Japanese as Ko Nenki was highly acclaimed in Muromachi painting circles, but since his name does not appear in Chinese painting histories, perhaps the name is a corrupted Japanese pronunciation of Kao Yen-ching's name. (Kao Yen-ching was also known as Kao K'o-kung.) This artist's style produced soft, suave landscapes well suited to the Japanese taste. As we have noted, Sesshu came under its influence while he was in China. The pair of six-panel landscape screens formerly in the Kuroda Collection (Fig. 125) comprise a Sesshu painting in the Kao Yen-ching manner. This work, completed after his return to Japan, adds to the evidence that he studied a broad range of styles during his sojourn on the continent.

In selecting among the various Chinese painting schools of the time, Sesshu took a critical attitude and did not respond indiscriminately to everything he observed. From this fact we can reconstruct the situation in Japanese painting circles of the time with respect to the acceptance of Chinese models. In Japan the model for *suibokuga*, particularly landscapes, was either the classical Chinese painting style—a rather static style harmonizing form and content, as in the works of such Sung academic

120. Landscape, *by Sesshu, with inscriptions by two Korean officials known in Japanese as Ri Son and Boku Kobun. Ink on paper; height, 88.5 cm.; width, 36.9 cm. About 1479. Collection of Eisaku Oda, Osaka.*

121. Section from first part of Small Landscape Scroll, *by Sesshu. Ink on paper; dimensions of first part of scroll: height, 22.7 cm.; length, 408.2 cm. About 1474. Collection of Nagatake Asano, Tokyo.*

123. *Copy of a landscape in the style of Kao Yen-ching from the second part of Sesshu's* Small Landscape Scroll. *Signed by an unidentified artist of the Hasegawa school. Ink on paper; height, 22.7 cm. Date uncertain. Collection of Nagatake Asano, Tokyo. (See Figure 121 for an authentic excerpt from the Sesshu scroll.)*

painters as Ma Yuan and Hsia Kuei—or the works of Zen priests like Mu Ch'i and Yu Chien. In either case, however, the model for the Japanese was an age behind and thus showed none of the more recent tendencies found in the literati painting of the Southern school, which arose at the end of the Yuan dynasty. Sesshu himself also took Sung painting as a standard and made copies of various Sung masters. The round-fan paintings in which he copied the styles of Li T'ang, Hsia Kuei, Liang K'ai, Mu Ch'i, and Yu Chien are excellent examples of some of his Sung studies (Figs. 99, 126–29).

Collecting copies of Chinese paintings represents a basic trend in Muromachi painting circles and at the same time suggests how the Muromachi painters used such copies as keys to understanding the individual styles of famous Chinese painters. For example, Japanese literary sources often contain passages about painters who produced works based on models referred to as the "Ma Yuan style" or the "Mu Ch'i style." Sesshu's copies show us how Muromachi painters could correctly use such models to produce individual works of their own. But Sesshu is a rather special case because, unlike most of the other artists, he was enabled by his remarkable creative power to evolve from these models a style that was entirely his own. His round-fan paintings, for example, include one abbreviated landscape painted after the style of Yu Chien (Fig. 127)—a style he also used in his celebrated *Haboku Landscape* (Figs. 103, 112), as we know from an inscription written on it (in addition to Sesshu's own) by another Zen priest. Now, while paintings by Yu Chien extant in Japan have a rather severe contrast of light and dark ink (Fig. 141), Sesshu developed the style into a personal one by adding a bit

◁ 122. *Section from the* Long Landscape Scroll *(Sansui Chokan), by Sesshu. Ink and colors on paper; dimensions of entire scroll: height, 40 cm.; length, 1,807.5 cm. Dated 1486. Mori Foundation, Bofu, Yamaguchi Prefecture. (See Figures 101 and 169 for other sections of the scroll.)*

124. Autumn Landscape (*from* Autumn and Winter Landscapes), *by Sesshu. Ink on paper; height, 46.3 cm.; width, 29.3 cm. Late fifteenth century. Tokyo National Museum.*

125. Landscapes of the Four Seasons *(section of right-hand screen of a pair of six-panel screens), by Sesshu. Ink on paper; dimensions of entire screen: height, 159.5 cm.; width, 277.4 cm. Late fifteenth century. Private collection, Japan (formerly in the collection of the Kuroda family).*

more dampness to the tone of the ink. It should be noted here that although Yu Chien's style is actually derived from the method known in Chinese as *p'o mo* and in Japanese as *hatsuboku*—that is, splashed ink—in Japan the method seems to have been mistaken for the *haboku* (broken ink) method, which is also pronounced *p'o mo* in Chinese but is written with a different character for *p'o*. The confusion apparently arose from the spoken rather than the written Chinese, although in Japanese pronunciation the difference is clear. The *haboku* method should be assigned not to Yu Chien but to the previously mentioned Kao Yen-ching.

Among Sesshu's round-fan paintings is a winter landscape in the style of Hsia Kuei (Fig. 129) that is clearly related to the winter landscape shown in Figure 100, but a comparison of the two paintings instantly reveals a great difference between them.

We can readily see how Sesshu, supported by his creative genius and the firm strength of his brush, was able to achieve the ideal represented by the second of these two paintings. I think these two examples suffice to show that Sesshu was by no means content merely to imitate the styles of famous Chinese masters but made a great effort to open up new aspects of these styles to create a solid artistic world of his own.

The celebrated *Long Landscape Scroll* (Figs. 101, 122, 169), which Sesshu painted in 1486 at the age of sixty-six, is another work in which he demonstrates that he learned from Hsia Kuei. This masterpiece displays quite clearly the broad range of his landscape painting. That it derives in style from Hsia Kuei can be immediately confirmed by comparing it with surviving sections of landscape scrolls attributed to the Chinese master (Figs. 109, 118).

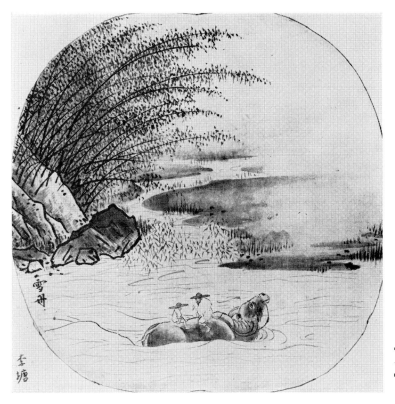

126. Cowherds *(after Li T'ang)*, *by Sesshu. Ink and colors on paper; height, 33.5 cm.; width, 31.4 cm. Late fifteenth century. Collection of Nagatake Asano, Tokyo.*

Sesshu was certainly not the only painter who respected Hsia Kuei, but he was decidedly one of the best of those who absorbed his style and then went on to employ it in their own individual ways. Generally speaking even among Southern Sung landscapes, Hsia Kuei's paintings have a spacious and luxuriant quality that puts them in contrast with the well-defined and tense one-corner compositions of the school of Ma Yuan, a name with which Hsia Kuei's is often linked. There is a suggestion here that it was these elements in Hsia Kuei's painting that led Sesshu to his own great achievement.

Ama no Hashidate (Fig. 111), a work of Sesshu's last years, shows hows the aged master has softened the styles of artists like Hsia Kuei and Yu Chien and created true Japanese landscape painting: painting that is intimately linked with the Japanese setting. This work, based on rough sketches, combines a sturdy, realistic portrayal of the natural setting, including the dampness of the enveloping mist, with a startling sureness of the artist's own descriptive powers, making the viewer feel that even in the tradition-bound medieval world he can at last discern the dawn of a modern age.

Sesshu created his own personal realm of painting by studying Sung masters, absorbing some of the new Yuan and Ming styles, and adding the knowledge he thus acquired to the experience he had gained from making realistic drawings from actual landscapes over a long period of years. He most decidedly did not shut himself up in a narrow, isolated world, nor did he display the least sense of self-importance. He flexibly absorbed as much knowledge as he could, synthesizing it to construct an individual world of art. His brushwork shows not only that he carefully studied Northern and

Southern Sung models but also that its inherent power, expressing everywhere his characteristic self-confidence, was the very backbone of his art. His paintings, composedly built on this firm skeletal structure of brushwork, are without rival throughout the whole Muromachi period.

In concluding this chapter I should like to add a note concerning the *rakkan* (signatures) that always appear on Sesshu's paintings. The custom of adding *rakkan* was common after the medieval period but, as we have already noted, was still rare during the Muromachi period. Sesshu was probably the first to announce himself by the use of clearly visible *rakkan*, and this may be taken as an indication that in him the individual's consciousness as an artist reached such heights for the first time. He thus represented the vanguard in a natural trend toward artistic independence as painting progressed from the religious to the purely aesthetic.

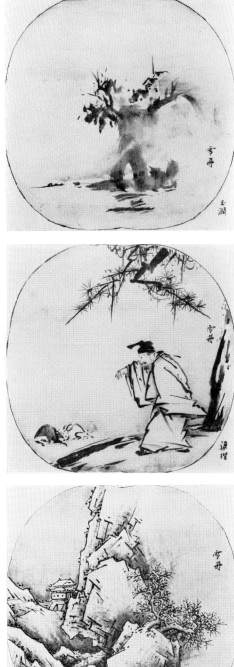

127 *(top)*. Landscape *(after Yu Chien)*, *by Sesshu. Ink on paper; height, 30 cm.; width, 30.6 cm. Late fifteenth century. Collection of Goro Katakura, Tokyo.*

128 *(center)*. The Taoist Immortal Huang Ch'u-p'ing *(after Liang K'ai)*, *by Sesshu. Ink on paper; height, 30 cm.; width, 31.2 cm. Late fifteenth century. Collection of Yasunari Kawabata, Kanagawa Prefecture.*

129 *(bottom)*. Winter Landscape *(after Hsia Kuei)*, *by Sesshu. Ink and colors on paper; height, 30.2 cm.; width, 30.7 cm. Late fifteenth century. Collection of Nagatake Asano, Tokyo.*

CHAPTER FIVE

Advances in the World of Late Medieval Painting

**TRENDS AND INFLU-
ENCES IN THE
CENTRAL PAINT-
ING CIRCLES**

Let us now look into the circumstances of the Muromachi shogunate academy in Kyoto during the time when Sesshu was painting in Yamaguchi, far away from the mainstream of the painting world. Around the middle of the fifteenth century there unfolded in Kyoto the so-called Higashiyama culture, which centered around the eighth Ashikaga shogun, Yoshimasa, and was named for the part of the city in which he built his famous Silver Pavilion. While Yoshimasa failed his test as a politician, he was a man of considerable ability and talent in cultural and artistic matters and, in the latter role, is often praised as the person who brought medieval culture to its height. During his period of rule the great civil wars of the Onin and Bummei eras (1467–87) broke out in the very center of Kyoto. The internal strife was beyond government control, and Japan was plunged into a period of conflict and destruction that became known as the Sengoku Jidai, or the Age of the Country at War (1482–1558). Yoshimasa was unable to deal with the turmoil, for he had practically no power over the various contending daimyo and, even in his own household, was ruled by his strong-willed wife, Hino Tomiko. The city of Kyoto, which had long been a thriving political and cultural center, lay in ruins as a result of the ceaseless battles that took place in and around it. The *Onin Ki* (Chronicle of the Onin Era), a contemporary record of the events of the times, laments: "As you must know, the capital has been reduced to mere fields, and even if you look up at the sight of a lark rising in the evening sky, you cannot stop the falling tears."

The sorrows of the age were increased by the numerous agrarian uprisings and the consequent famines. Those who survived the warfare, having already fallen into poverty and suffered the loss of families and friends, were brought to the verge of starvation and forced to wander throughout the countryside in search of any food they could find.

Earlier in the Muromachi period the political power of the shogunate had been established through the support of the great landowning daimyo. The shogunate authority prevailed, and there developed around the shoguns Yoshimitsu (1358–1408) and Yoshimochi (1386–1428) the vigorous movement known as the Kitayama culture, which took its name from the Kyoto district where Yoshimitsu built his villa and the celebrated Golden Pavilion. By Yoshimasa's time, however, the shogunate had already reached the summit of its power and had fallen into serious decline.

Yoshimitsu's Golden Pavilion (Kinkaku) and

130. Garden of Ashikaga Yoshi-
masa's Silver Pavilion (Ginkaku),
Jisho-ji, Kyoto.

Yoshimasa's Silver Pavilion (Ginkaku) are two aesthetically refind examples of architecture that symbolize Muromachi culture. In contrast with the brightly flowering Kitayama culture of the first half of the period, as represented by the Golden Pavilion, the Higashiyama culture, epitomized by the unassuming Silver Pavilion, gives the impression of a world of tarnished silver enveloped in indistinct shadows—a world in which the aesthetic concepts of *wabi* and *sabi*, or refined simplicity and rusticity, predominated, as they did during the latter half of Muromachi. It will be of interest here to consider the origin and progress of the change from the Kitayama to the Higashiyama culture.

Although the influence of Zen Buddhism on Japanese culture and art has already been discussed, there is still another, and separate, current that must not be overlooked in any survey of Muromachi culture: the form of Buddhism known as Jodo Nembutsu. By Muromachi times, Jodo Nembutsu already had a long tradition extending as far back as the Heian period. It represents an aspect of Muromachi culture that ranks in importance with Zen.

Jodo Nembutsu is an absolute *tariki* faith—that is, a faith in which the believer relies completely upon his belief in the power of the "original vow of Amida Buddha" to save him. As such, it would appear to be indisputably opposed to Zen, which insists upon *satori* (enlightenment) and is fundamentally a *jiriki* faith: one in which the individual relies on his own self-control and his own efforts to attain salvation. But Zen, as a dialectic philosophy of denial, also has an aspect that fuses the *jiriki* and *tariki* concepts. This aspect is perhaps best represented by the extraordinary Zen priest Ikkyu (1394–1481; Fig. 131), whose *satori* led him to change his faith from *jiriki* to *tariki*. By analogy, I

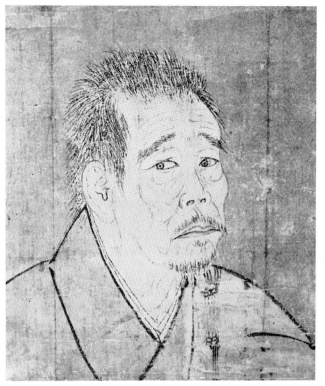

131. *Portrait of Ikkyu (detail), by an unknown artist. Ink and colors on paper; dimensions of entire painting: height, 43.6 cm.; width, 26.3 cm. Before 1481. Tokyo National Museum.*

132. Zazen ishi *(stones for Zen meditation), garden of* ▷ *the Saiho-ji, Kyoto.*

think that the whole of Muromachi culture has a quality of synthesis and fusion. We may note, for instance, that the Golden Pavilion and the Silver Pavilion are not merely examples of Zen architecture, for each of them contains a Buddhist-altar room (*butsuma*) as concrete evidence of a belief in Amida Buddha and a reflection of the paradise in which he dwells.

The central painting academy was not maintained exclusively by Zen priests like Josetsu and Shubun, for the shoguns were surrounded by many other artists of a very different nature who played important roles in creating the cultural life of the shogunate court. These people, called *doboshu,* had the basic task of performing miscellaneous services for the shogun, and many of them had their own particular talents. Some were painters, while others were craftsmen, garden designers, and teachers of Noh and Kyogen, the two forms of drama that

reached their finest flowering in the Muromachi age. The social status of the *doboshu* was far from elevated, and their ranks even included some who were referred to as *kawaramono* (riverbed people): a term meaning not only beggars and outcasts but also actors and other people of the theater, all of whom lived in the *sanjo,* an *eta* (outcast) community where no taxes were levied.

Zen'ami, the famous garden designer under Yoshimasa, seems to have come from such a background. The two Chinese characters for *ami* in his name are found quite frequently among the names of *doboshu* artists and artisans, indicating that they were members of the Jishu sect of Buddhism. This sect, included within Jodo Nembutsu, was founded by Ippen Shonin (1239–89), who gave it a solid base through his extensive proselytism among the common people and whose life is the subject of a famous picture scroll (Fig. 28). With the increasing

popularity of the arts and crafts among people of the *doboshu* class, there appeared some artists who achieved enough recognition to rise in social position to a level where they could serve the shogun and contribute to the cultural and artistic development that took place within the upper military class.

Three remarkable painters who exercised their talents in the shogunate academy as *doboshu* represented three generations of the Ami school: Noami, the grandfather; Geiami, the son; and Soami, the grandson. Noami (1397–1471), also known as Shinno, served the shogunate during the first half of the Muromachi period. Geiami, or Shingei (1431–85), served Yoshimasa during the middle of the period. Soami, or Shinso (?–1525), continuing the tradition of his father and his grandfather, was active during the latter half of Muromachi. Noami painted two well-known hanging scrolls portraying

the White-robed Kannon, one of them a nimble depiction in the Mu Ch'i style (Fig. 136), the other employing stronger brushwork in the angular, formal *kai* style and bearing an inscription to the effect that it was painted for his son Shuken (Fig. 38). Geiami is represented by his *Viewing a Waterfall* (Fig. 37), which is also in the *kai* style and was painted for his student Shokei. Soami left a fairly large number of paintings, but his most typical works are probably the *fusuma* paintings in the Daisen-in of the Daitoku-ji (Fig. 133). These are done in a suave, abbreviated manner that recalls Sesshu's painting in the Kao Yen-ching style. While this style of painting is considered Soami's specialty, his other surviving works clearly indicate that he also handled the *kai* (Fig. 36), *gyo* (moving or rounded), and *so* (cursive, indistinct) styles with great skill.

The Ami school, centering around these three

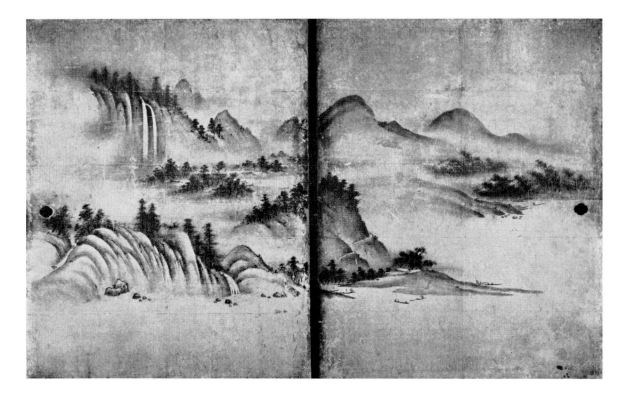

painters, achieved a status equal to that of the priest-painters of the Shokoku-ji tradition and, from the early years of the Muromachi period, participated in the painting activities sponsored by the shogunate. Along with the general trend of the age, this school seems to have played a subtle role in the drift of the academy away from Zen-influenced continental painting toward the creation of a painting style that was genuinely a part of the Japanese environment.

Sotan, who became a Buddhist priest after he inherited Shubun's post, seems to have come from a samurai family. Kano Masanobu, who in turn took over Sotan's position, was also a painter of samurai origin and was an adherent of the Hokke (Lotus) sect founded by Nichiren (1222–82). In other words, the character of the academy had shifted from one dominated by Zen priests to one controlled by professional painters (*eshi*) who at that time held sway over the tastes of the military rulers When Masanobu's son Motonobu combined his duties as head of the academy with those of the imperial court's painting bureau, the Edokoro Azukari, the transition reached the stage where the shogunate academy supplanted the *yamato-e* academy that had existed since the ancient period. The central force that precipitated such a qualitative change within the shogunate academy was the activity of the Ami-school *doboshu*.

Now, with respect to the above-noted three Ami-school artists, I should like to note that they were not only painters but also undertook all kinds of other work related to artistic matters under the shogunate. They were delegated to make a critical appraisal of all sorts of art objects in the shogunate collection that had come from the continent, including not only paintings but also calligraphy, swords, and craft articles. They also estimated the

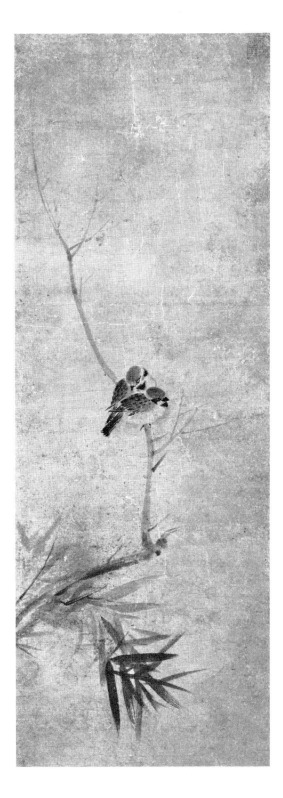

133. Landscape (*formerly a two-panel* fusuma *painting*), *by Shinso (Soami). Ink on paper; each section: height, 174.8 cm.; width, 139.7 cm. About 1513. Daisen-in, Daitoku-ji, Kyoto.*

134. Bamboo and Sparrows (*also known as* Sparrows in the Rain), *attributed to Mu Ch'i. Ink on paper; height, 84.6 cm.; width, 30.9 cm. Southern Sung dynasty, twelfth to thirteenth century. Nezu Art Museum, Tokyo. (The painting bears the seal of Zen'ami in its upper right-hand corner.)*

value of these objects and arranged for their proper display. The famous *Kundaikan Sa-u Choki*, which Soami finally completed by continuing the work begun by his grandfather, is a catalogue of Chinese paintings in the shogun's collection, including classification and criticism of the works and their artists. The names of more than one hundred painters, mainly from the Sung and Yuan periods, are enumerated and placed in one of three classes: upper, middle, and lower. Each class is then further divided into three subdivisions. Noami had earlier compiled the *Gyomotsu Gyoga Mokuroku*, a catalogue that enumerated the themes of famous paintings in the shogun's collection together with the names of their painters. Such catalogues enable us to understand the views of the members of the Ami school who compiled them and to see how such art criticism greatly influenced the character and development of the shogunate academy.

Investigating these catalogues, we discover that the works listed are nearly all *karamono* (Chinese objects) that had been passed from generation to generation as masterpieces of the shogun's collection (*meibutsu*) or as Higashiyama *gyomotsu*—that is, treasures from Higashiyama. Such paintings were often hung for appreciation in the rooms where the then popular *chakai*, or tea-drinking parties, were held. Since the place for displaying such paintings was the tokonoma, or decorative alcove, let us introduce here a brief discussion of this architectural feature and the *shoin* style—the main residential style of the period—of which it formed a part.

Historians of Japanese architecture usually explain the establishment of the *shoin* style as an answer to the requirements of the medieval military

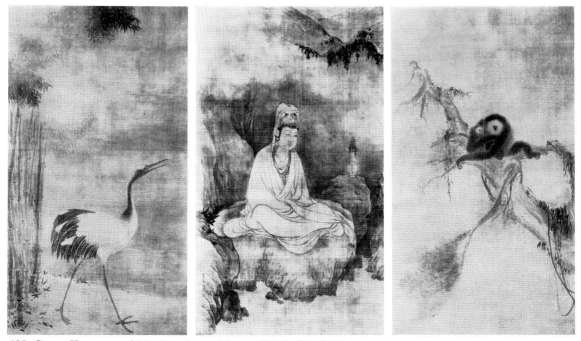

135. Crane, Kannon, and Monkeys *(a set of three scrolls), by Mu Ch'i. Ink and colors on silk. Central scroll : height, 172 cm.; width, 98 cm. Left and right scrolls : height, 174 cm.; width, 59 cm. Southern Sung dynasty, twelfth to thirteenth century. Daitoku-ji, Kyoto.*

class and describe it as having derived from important elements of the *shinden* style—the aristocratic residential style of the Heian period. But, in addition, we must not overlook the role played by Zen temples in bringing the *shoin* style to perfection. The *shoin* room is related to the *shosai*, which we have noted earlier as the secluded study of a Zen priest. The principal furnishings of the study were a reading desk, a bookshelf, and—of most interest to us here—an altar or alcove where one placed such decorative objects as a Buddhist painting or sculpture. This alcove was called the *toko*. While the desk, the bookshelf, and the *toko* (later to become the tokonoma) were three special features of the shoin style, they had already existed in the *shinden*-style residences of the Heian period. At that time, however, the rooms had no individual character and were merely spaces partitioned off by *fusuma*. The furnishings were all readily movable and consisted

mainly of the *toko,* which at this time was nothing more than a single board known as the *oshi-ita;* a small *fuzukue* (low table) for a desk; and a freestanding bookshelf. In the *shoin* style, however, the *toko* evolves into a raised platform set off by walls on three sides and thus becomes the tokonoma; the table or desk is now built in as the broad sill of a rather spacious window and is called the *tsuke-shoin;* and the bookshelf takes the form of the *chigai-dana:* ornamental shelves placed at different heights on the wall adjoining the tokonoma (Fig 137). In a word, the once easily movable elements have now acquired their own special fixed positions, and the function and character of the tokonoma achieve clear definition. Thus the tokonoma, which originally served as a kind of altar for the display of religious painting, became an important stage for the display of purely aesthetic painting— a stage, in fact, upon which the transition be-

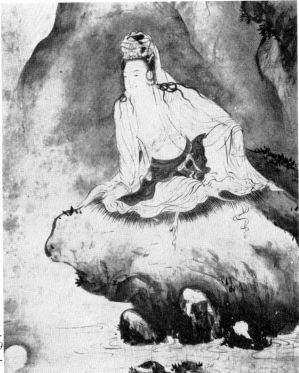

136. White-robed Kannon *(detail), by Shinno (Noami).*
Ink on paper; dimensions of entire painting: height, 109.9
cm.; width, 38.2 cm. Fifteenth century. Collection of Naga-
take Asano, Tokyo.

tween these two types of painting was carried out.

Naturally, the forces that motivated this transition included the Zen sect's denial of the worship of religious images, but from the historical point of view this was only one aspect of the movement that transformed the ancient into the medieval world. The tokonoma not only represents in concrete form the change in direction from religious painting to purely aesthetic painting but also, as we have just noted, served as the stage for its accomplishment. The movement in medieval art that brought such aesthetic painting into existence must be viewed as one of epoch-making significance. Still, we must not overlook the fact that the Zen denial of image worship was by no means a denial of spirituality and that, although painting was no longer expressly religious, it was no less spiritual than before. The landscapes and the flower-and-bird paintings are not simply portrayals of nature but expressions of the inherent Oriental pantheism that sees a spirit in every aspect of nature—that sees nature as a manifestation of the "Buddha heart." A clear recognition of this intent will perhaps enable us to understand the aesthetic heights reached by the tokonoma paintings of the medieval period.

We come now to the subject of formulas for tokonoma decoration. They included fairly intricate rules for the arrangement of flowers, incense burners, and candles in relation to the hanging scroll, either pictorial or calligraphic. There were also rules for the hanging of scrolls in sets of three or five. The *Okazari Ki* (Notes on Decoration) appended to the previously mentioned *Kundaikan Sa-u Choki* compiled by Soami explains in detail the formulas for tokonoma decoration, furnishing diagrams as well. The artists who actually applied these rules were of course no other than the three who constituted the core of the Ami school: Noami,

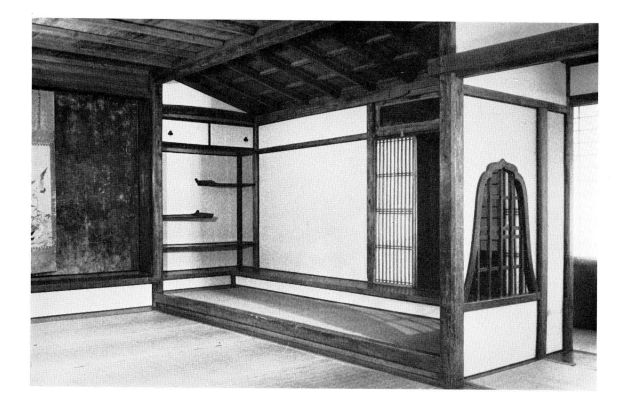

Geiami, and Soami. There was a weakness in all this, however, for when such codifications of aesthetic appreciation were carried too far, there was a tendency to restrict artistic freedom. Along with the "aristocratization" of the Ashikaga shoguns, Muromachi culture and art gradually began to rely on established rules of form and style that eventually brought about the ossification of its own tradition. The tendency to settle into a mold reached its climax in the development of the early-modern feudal system—particularly in the structure of the Tokugawa shogunate. The dignity of tokonoma art declined to the point where the art itself became a mere symbol of the rulers and, in the end, amounted to nothing more than weak and insipid ornamentation.

The tokonoma is closely related to the art of the tea ceremony (cha-no-yu), since it became the principal decorative feature of the formal tearoom. As we have already observed, tea was esteemed as a medicine and as a cure for drowsiness during the practice of zazen. Tea drinking gradually permeated the everyday life of the temple and that of the warrior class and, eventually, that of other classes as well. As a custom of great popularity, it played an important role in the development of Muromachi art. One impetus to its popularity came from the chonin (townsmen), particularly those of the merchant class who were active in foreign trade. For example, the merchants of the port town of Sakai sponsored chakai (tea parties) at which they used exotic utensils brought from overseas. These parties were the occasion for the game of tocha: a competition in which the guests vied in distinguishing the difference between the prized tea of Togano-o (honcha) and the less admired tea of other regions (hicha), as noted earlier. They were also the occasion for the nouveau-riche chonin to mingle

137. Interior of room in early shoin *style, showing tokonoma and adjacent shelves at left and* shoin *window at right of center. Yoshimizu-jinja, Nara Prefecture.*

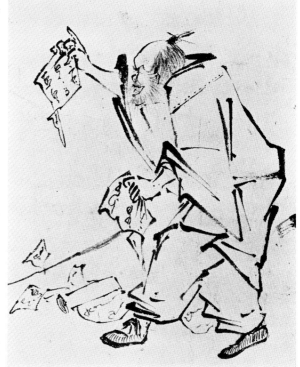

138. Tearing Up the Sutras *(a* soshizu, *or picture of a Buddhist patriarch), by Liang K'ai. Ink on paper; height, 72.9 cm.; width, 31.6 cm. Southern Sung dynasty, twelfth to thirteenth century. Collection of Takanaru Mitsui, Tokyo.*

socially with upper-class warriors and court nobles. Chinese paintings and other art objects brought back by Japanese trading vessels were often presented as souvenirs or used as stakes for gambling in the game of *tocha*. The earlier tea parties were in fact often quite rowdy. Later, however, these affairs took on a certain sedateness that was accompanied by a heightened appreciation of the calligraphy or the painting hung in the tokonoma of the tearoom. Thus, from the medieval into the early modern period, the *chakai* developed as a medium for social intercourse among the nobles, the military, and the merchant-class townsmen, all of whom could boast either political power or wealth or both. It was in this kind of environment that the aesthetic world of *sado*, the way of tea, came into existence.

Somewhat later, in the Momoyama period (1568–1603), the *chakai* flourished even more brilliantly as a result of the relationship between Sen no Rikyu (1521–91), honored as the patriarch of the way of tea, and the powerful military leaders Oda Nobunaga (1534–82) and Toyotomi Hideyoshi (1536–98). The quiet mood of the tearoom became a part of the rich and active lives of these leaders because tea masters like Rikyu adroitly guided their tastes. In the end, however, Rikyu was forced to commit suicide in consequence of a dispute with Hideyoshi. The detailed reasons for this tragedy need not concern us here, but we may observe that it was only natural for a clash to occur between the military and political leaders, who were bent upon uniting the country at the close of a century of civil strife, and the increasingly influential townsmen, who rose to high position by accumulating new wealth. It was this conflict that penetrated the world of tea and brought about the death of Sen no Rikyu.

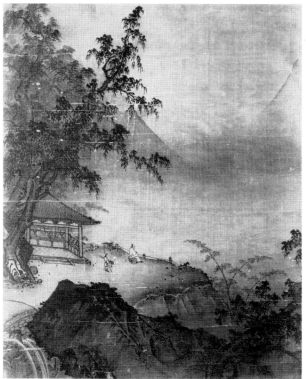

139. Landscape, *attributed to Sun Chun-tse. Ink on silk; height, 102 cm.; width, 83 cm. Yuan dynasty, thirteenth to fourteenth century. Private collection, Japan.*

140. Quail, *attributed to Li An-chung. Colors on paper; ▷ height, 24.2 cm.; width, 27 cm. Southern Sung dynasty, twelfth to thirteenth century. Private collection, Japan.*

Eventually the tea ceremony was incorporated into the ethic of the Tokugawa shogunate, which came into existence with the end of the struggle to unite the country. The same formalization occurred in other cultural and artistic spheres as well. For example, the Kano school of painters was consolidated and established as the Tokugawa shogunate academy, and nearly all the painting schools of the time were united under it. Those artists who refused to adhere strictly to the tenets and techniques of the leading Kano artists were often excommunicated from the school. The formerly free world of art was now closed up. In the realm of tea as well, a strict hierarchy was established, and a loss of freedom ensued, even though the tea ceremony continued to promote social intercourse and the development of a certain etiquette.

In relation to the development of the tokonoma and the vogue of the tea ceremony, I should like to speak briefly of the trends and conditions in the appreciation of Sung and Yuan painting during the Muromachi and Momoyama periods. When we read the diaries of Zen priests, the records of *chakai*, and other contemporary documents, we find an overwhelmingly large number of references to paintings by Sung and Yuan Zen priests and painters—paintings, that is, of the *karamono* category mentioned above in connection with the *Kundaikan Sa-u Choki*. The *chakai* records inform us that the most esteemed works among the hanging scrolls of calligraphy and painting displayed in the tearoom included *bokuseki*: examples of calligraphy by distinguished Chinese Zen priests (Fig. 154). Particularly prized was the calligraphy of the revered priests of the Yangch'i (in Japanese, Yoki) sect of Linchi (in Japanese, Rinzai) Zen, which had had very close connections with Japanese Zen from the Kamakura period. Among the Chinese priests who

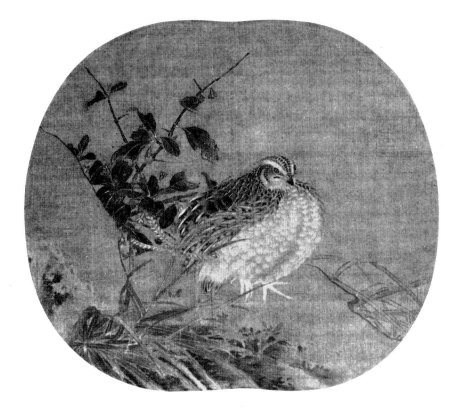

contributed to the vitality of the *bokuseki* were the illustrious Yuan-wu K'o-ch'in, one of the co-authors of the celebrated Zen classic *Pi Yen Lu* (Blue Rock Collection), as well as Ta-hui Tsung-kao, Wu-chun Shih-fan, Hsu-t'ang Chih-yu, and Chung-feng Ming-pen. (In Japanese, these priests are known as Engo Kokugon, Daie Soko, Bushun Shiban, Kido Chigu, and Chuho Myohon, and the *Pi Yen Lu* is called the *Hekigan Roku*.) We must add to this list the names of Chinese priests who came to Japan, including Lan-ch'i Tao-lung (Rankei Doryu) of the Kencho-ji, Wu-hsueh Tsu-yuan (Mugaku Sogen) of the Engaku-ji, and I-shan I-ning (Issan Ichinei) of the Rinzai sect. It is also worth noting that while the Chinese in general had great admiration for calligraphic technique, they seemed to display little appreciation of the *bokuseki* of Zen priests. In Japan, on the other hand, the popularity of *bokuseki* was tremendous, and the ap-

preciation of such calligraphy arose from the aesthetic of the tea ceremony.

Along with the esteem granted the *bokuseki* in Japan, there was extreme admiration for Chinese paintings. Records like the *Kundaikan Sa-u Choki* enable us to grasp the breadth of the taste for such works within the shogunate academy. The Chinese hanging-scroll paintings displayed at the tea ceremony vividly demonstrate the attitudes of artists who painted both in colors and in *suiboku*. Their themes ranged from *doshaku* (Taoist and Buddhist subjects) to landscapes and flowers and birds: the three themes that made up the core of Sung and Yuan painting.

We can also gain from the *chakai* records an understanding of the aesthetic tastes and standards of the daimyo and wealthy merchants who not only participated in the *chakai* but also were tea masters themselves. The Sung and Yuan paintings that

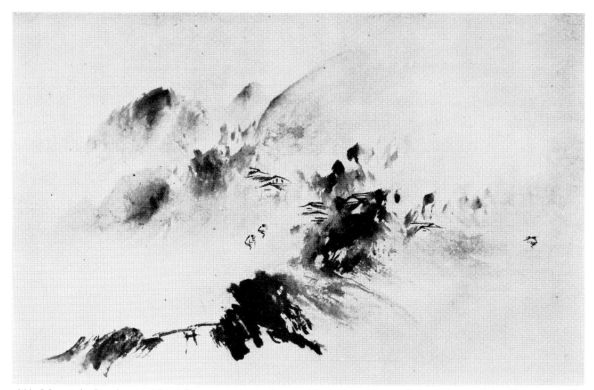

141. Mountain Landscape *(detail from a painting in the set entitled* Eight Views of the Hsiao and the Hsiang*), by Yu Chien. Ink on paper; dimensions of entire painting: height, 33 cm.; width, 84 cm. Southern Sung dynasty, twelfth to thirteenth century. Collection of Ayako Yoshikawa, Tokyo.*

commanded their deepest appreciation included such realistic works in color as Li Ti's *Pink and White Hibiscus Blossoms*, Li An-chung's *Quail* (Fig. 140), Ch'ien Shun-chu's *Cockscombs*, and the emperor Hui Tsung's *Peach Blossoms and Dove*—all works by members of the court academy. Among landscapes, the works of Ma Yuan, Hsia Kuei (Figs. 109, 118), and Sun Chun-tse (Fig. 139) were treasured. Even more favored than the works of the academic painters were the fresh, lively *suibokuga* painted in "abbreviated" style by Zen priests. In Japan the reputations of Mu Ch'i (Figs. 134, 135) and Yu Chien (Fig. 141) almost completely eclipsed those of the Chinese academic painters, but in China, as in the case of the *bokuseki*, there was much less enthusiasm for their works. The more intimate

relationship between medieval culture and art and the Zen religion in Japan made this preference quite natural. No doubt the Japanese developed a fondness for the free-and-easy expression in the *suibokuga* of these Chinese Zen priests because the style was more suited to their tastes than the stiff formality that characterized the paintings of the Chinese academy.

In the Momoyama-period *Tohaku Gasetsu*, a record of the artist Hasegawa Tohaku's opinions and theories about painting, we find some interesting observations on famous Sung and Yuan paintings. Tohaku notes, for example, that Mu Ch'i's brushwork displays the free dexterity and concentration of a skillful juggler. Concerning the story that Mu Ch'i painted a work called *Hitome no*

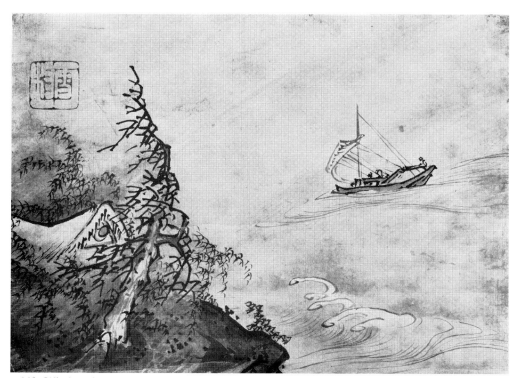

142. Wind and Waves, *by Sesson. Ink on paper; height, 22.2 cm.; width, 31.4 cm. About mid-sixteenth century. Private collection, Japan.*

Suzume (Sparrows with Human Eyes), he observes that the title was probably a popular name for the *Nure Suzume* (Sparrows in the Rain), which is attributed to Mu Ch'i (Fig. 134). Again, when he speaks of Liang K'ai, who received the honorary golden sash of the academy but never wore it, he notes most pertinently that Liang's paintings are "plain and peasantlike and not at all academic in style" (Fig. 138). A similar admiration for Liang K'ai is reflected in the story that Sen no Rikyu's adopted son Suiraku Sokei, tea master of Sakai, when he was shown a Liang painting of a bird on a willow branch, exclaimed in wonder: "Ah, what a serene painting!" The story, whether true or not, reveals the special feeling that lovers of tea and the tea ceremony had for this kind of painting.

Sung and Yuan paintings enjoyed tremendous popularity in Japan from the medieval period on, both as models for Japanese painters and as objects of aesthetic appreciation by Japanese connoisseurs, but we must note that there was a time lag as well as a slight aberration in the process by which art currents flowed from the continent to Japan. These factors are especially noticeable in relation to Chinese literati painting, which dates from the Sung dynasty, and the emergence of the Northern and Southern schools. Neither of these developments was taken note of in Japan until after the beginning of the Edo period (1603–1868). Before that time it was quite natural that the medieval schools of Japanese painting, instead of following the aesthetic theories and techniques of any single Chinese

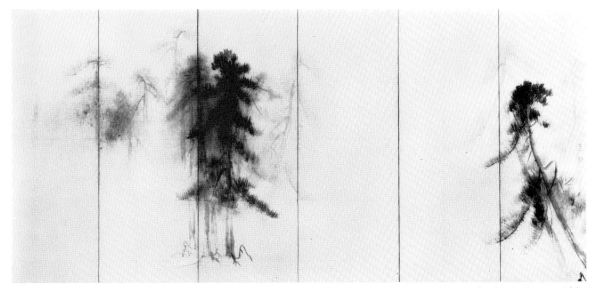

143. Pine Grove *(right-hand screen of a pair of sixfold screens)*, by Hasegawa Tohaku. Ink on paper; height, 156 cm.; width, 364 cm. Late sixteenth century. Tokyo National Museum.

144. The Hermit Lin Ho-ching *(one of a number of small paintings mounted on a pair of sixfold screens)*, by Toshun. Ink ▷ and colors on paper; height, 46.1 cm.; width, 35 cm. Early sixteenth century. Collection of Sogoro Yabumoto, Osaka.

145. Daruma *(detail)*, by Bokkei. Ink on paper; dimensions of entire painting: height, 148.5 cm.; width, 58 cm. Dated 1465. ▷ Shinju-an, Daitoku-ji, Kyoto.

school, heightened their esteem for the kind of impressionistic painting that reflected characteristically Japanese taste and sensitivity. In this attitude of Japanese painters we can observe the special quality of the autonomous development in medieval art and culture.

THE STATE OF PAINTING IN THE PROVINCES

Let us now look briefly at the state of the regional painting circles, which stood in contrast with those that surrounded the shogunate academy and were subject to its traditional authority. The model provincial artist of the time, as well as the finest, was of course Sesshu, whom we have already discussed at some length. But a great deal of other activity was taking place in the provinces at this time in addition to that of Sesshu and his own circle of painters. The relationship between the central painting academy and the provincial painting circles reflected that of the Muromachi shogunate and the Sengoku-period daimyo who held sway over their own domains. By and large, the importance of the central painting authority declined, just as the power of the central political authority weakened, and its tradition and style gradually faded away. The successive emergence of warrior-painters from the many conflicts that spread across Japan was one of the remarkable phenomena of the age.

In the Yamaguchi area the Sesshu school produced such well-known artists as Shugetsu (Fig. 153), Shutoku (Fig. 110), and Toshun (Figs. 114, 144). Shutoku apparently succeeded Sesshu as the owner of the Unkoku-an. Shugetsu was born into a wealthy family in the province of Satsuma (the present Kagoshima Prefecture) and had for his disciples such active painters as Tosatsu, Togei, and Toha. Toshun, a native of Yamaguchi, is said to

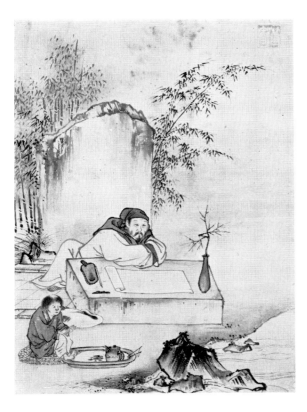

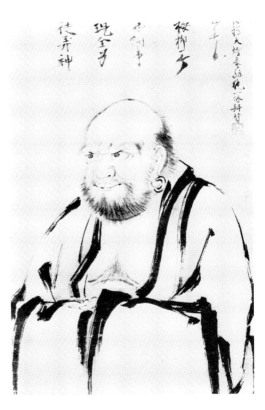

have accompanied Sesshu on the trip he made late in life to Kaga and Noto provinces. The early modern age brought the establishment of the Unkoku school and the emergence of its leading painter, Unkoku Togan, who earnestly propagated the Sesshu style during the Momoyama period. Toshun's famous disciple Hasegawa Tohaku (Fig. 143) vied with Togan over the right to be declared the legitimate successor to the Sesshu painting tradition.

The artist Jasoku (also called Dasoku), to whom are attributed the *suiboku fusuma* paintings in the Shinju-an at the Daitoku-ji (Figs. 73, 151), appears to have been one of a school of painters surrounding the celebrated Ikkyu, abbot of the same temple. More research on Jasoku is required, but we know that the school itself developed out of the Soga family, which served the Asakura daimyo clan of Echizen Province (the present Fukui Prefec-

ture). Artists of this school whose history and works are known include Hyobu Bokkei (Fig. 145), Soga Shosen, and Soyo (Figs. 115, 116, 161). The founder of the school is traditionally said to have been the Korean painter Ri Shubun (Fig. 152), whose art name Shubun is pronounced like that of the famous Shubun of the Shokoku-ji but employs a different character for *shu*. According to the recently discovered *Bokuchiku Gacho* (Black Bamboo Picture Album), Ri Shubun came to Japan in 1424. It is therefore possible that he had some connection with the more celebrated Shubun's trip to Korea. Although research on the subject is still insufficient, the school seems to have been established in the Hida district of the present Gifu Prefecture (bordering on the former province of Echizen), since paintings with the Ri Shubun seal have been discovered in this area.

The Kanto region of eastern Japan, where

146. Ema *(votive plaque)*, *by Gonome Sadashige. Ink and colors on wood. Dated 1563. Wakamatsu-dera, Yamagata Prefecture.*

147. Toto Tenjin *(the scholar-statesman Sugawara Michizane in China)*, *by Takeda Shoyoken Nobukado. Ink on paper. Before 1582. Chozen-ji, Yamanashi Prefecture.*

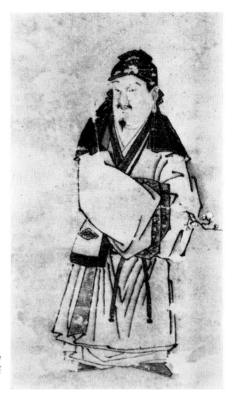

activity centered in the Five Great Zen Temples of Kamakura, had long been absorbing the influence of Sung art. Not long after the middle of the Muromachi period there appeared the artist Shokei (Fig. 80), who had studied painting with Geiami, the previously noted *doboshu* of the Ashikaga shogun, and who served as secretary of the Kencho-ji in Kamakura. Shokei's solid painting style was transmitted to his disciples Keiboku and Keison. We also note the appearance of Chuan Shinko, or Koseido, who seems to have been Shokei's senior at the Kencho-ji, and of Soen, a follower of Sesshu who was in charge of the sutra repository at the same temple. The Kamakura painters displayed a vigor that matched that of the painters in Kyoto and Yamaguchi.

The Izu region (the present Shizuoka Prefecture), not far from Kamakura, was the home of Kano Masanobu (Fig. 82) and his son Motonobu

(Figs. 81, 167), who is traditionally said to have inherited the mantle of Sotan and to have become the shogun's official painter. The Odawara Kano school, a branch of the main Kano school, served the powerful daimyo family of Hojo and produced such artists as Gyokuraku, Soyu, and Shuboku.

Another provincial painter of note is Sesson, who came from the Tohoku region of northeastern Japan. Sesson had his own extraordinary painting style (Figs. 16, 113, 142, 170), and his name reflects his admiration for Sesshu, for the first of its two characters is the same as the first character of Sesshu's name. He achieved his first fame as a painter under the patronage of Ashina Moriuji, castle lord of Aizu (located today in the western part of Fukushima Prefecture). Later in life, in nearby Miharu, he set up his own painting studio, which still exists, and there he continued his long and productive life. Sesson diverted his style from the sturdiness and

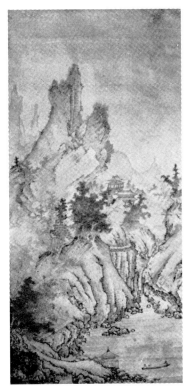

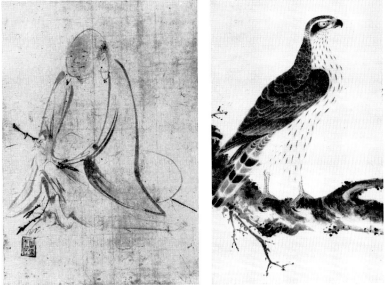

148 (left). Landscape, *by Nagao Kagenaga. Ink and colors on paper. Before 1528. Collection of Shoji Akima, Tochigi Prefecture.*

149 (center). Hotei *(detail), by Yamada Doan. Ink on paper. Before 1573. Private collection, Japan.*

150 (right). Hawk *(detail), by Toki Raigei. Ink and colors on paper. Before 1583. Private collection, Japan.*

severity that characterized the work of Sesshu, developing instead a strongly personal and agitated manner of painting that reflected the turmoil of society during the Age of the Country at War. Although we may speak of him as a provincial painter, we must note at the same time that he was renowned throughout Japan.

While the many provincial painters who appeared on the scene during this age of civil strife added a great deal of variety to the world of Japanese painting, they vied with one another for leadership in their own regions and thus created a climate of school factionalism that would afford no opportunity for unification until the late Momoyama and early Edo periods. The contending schools were finally brought together with the establishment of the Edo-period shogunate and the creation of a central authority under the first Tokugawa shogun, Ieyasu (1542–1616).

There was practically no end to the activities of regional priest- and professional painters, but we must turn now to the avocational paintings of the Sengoku-period military class and examine some of the more notable ones among them. To begin with, a number of talented warrior-class painters appeared from the Toki family, castle lords of Mino Province, which now forms the southern part of Gifu Prefecture. Among the works of these men, we have authenticated paintings by Fukei and Raigei (Fig. 150), but the most representative of this group is probably Toki Dobun, who employed a broad range of subjects, including flowers and birds, human figures, and landscapes. But to determine just who this artist was requires further research, for we do not come across his name in the Toki family tree. All the painters of this school were particularly skillful at painting hawks, a theme of natural enough interest for the military classes of the Sen-

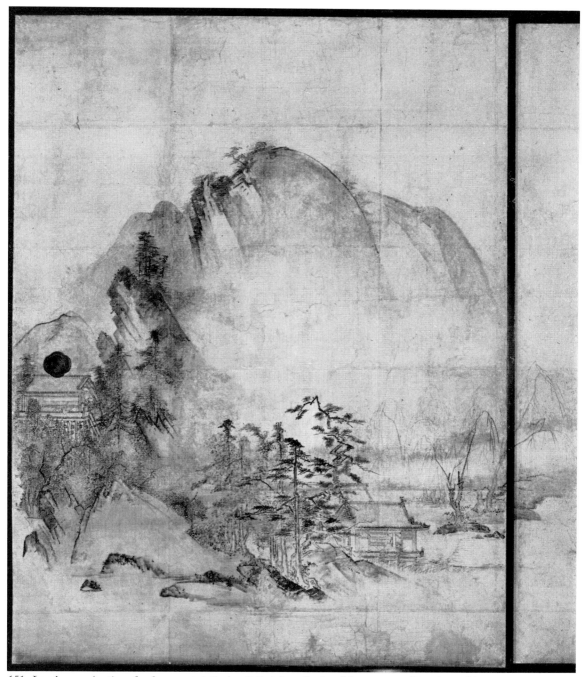

151. Landscape (section of a fusuma *painting), attributed to Jasoku. Ink on paper; dimensions of* fusuma *panel: height, 179 cm.; width, 143 cm. Dated 1491. Shinju-an, Daitoku-ji, Kyoto.*

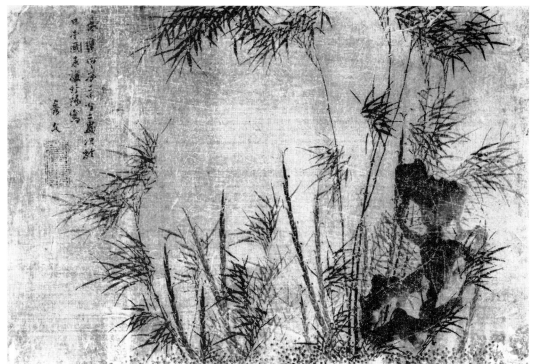

152. Bamboo Grove (*from the* Black Bamboo Painting Album), *by Ri Shubun. Ink on paper; height, 30.6 cm.; width, 45 cm. Dated 1424. Private collection, Japan.*

goku age. Their paintings, however, were not mere haphazard and unspecific depictions of this predatory bird. On the other hand they were quite carefully executed realistic pictures of strong, fierce hawks, often including actual portraits of famous hunting hawks.

Among artists who achieved fame during late Muromachi and early Momoyama times was Yamada Doan, of Yamada Castle, near Nara. Tradition has it that the art name Doan was used by three generations of painters in this line, but the works themselves seem to indicate only a first-generation artist and two second-generation artists who used it. Whichever the case may be, all these artists excelled in depictions of the mythological Shoki the Demon Queller. They also produced a large number of landscapes, flower-and-bird paintings, and paintings of human figures as well as

supernatural beings (Fig. 149). The first-generation Doan was a particularly fine painter who seems to have been an accomplished sculptor as well, if we are to judge by one of the stories about him. In 1565, we are told, the head of the Great Buddha at the Todai-ji in Nara was destroyed in one of the periodic battles of the Sengoku age, and Doan, unable to bear the sight of the mutilated statue, repaired it without delay. He is also said to have made a statue of the god Baramon (Brahma) for the Kofuku-ji in Nara.

In the Kanto region, in addition to the already mentioned Kamakura painters, we should note the artist Nagao Kagenaga and other members of his family, who were the castle lords of Iizukayama, near Ashikaga in the present Tochigi Prefecture, and who had ties with the renowned Muromachi-period warrior Uesugi Kenshin. Of special note are

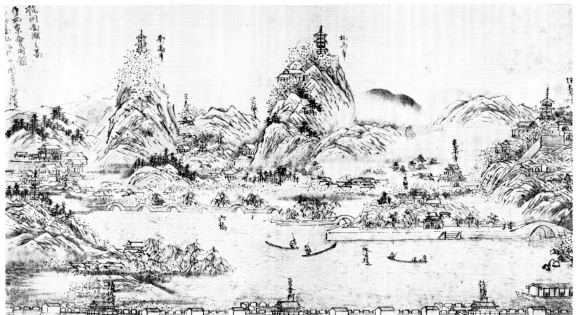

153. West Lake, by Shugetsu. Ink on paper; height, 46.6 cm.; width, 84.8 cm. Dated 1496. Ishikawa Prefectural Art Museum Kanazawa. This is Shugetsu's depiction of the famous Chinese scenic spot at Hangchow.

Kagenaga's landscapes (Fig. 148), which almost eclipse those of the Kano school in grandeur. Kagemitsu, who may have been Kagenaga's son, also painted some excellent works. Another talented artist of the Kanto region was Shoyoken Nobukado (or Nobushige; Fig. 147), a younger brother of the warrior Takeda Shingen of Kai Province (Yamanashi Prefecture). Among his works is a striking memorial portrait of his deceased parents. Although his brother Shingen painted only as a hobby, he too left some commendable works, including a lively representation of Daruma (Bodhidharma), the patron saint of Zen.

In the Tohoku region, around the same time that Sesson was active there, the Mogami clan of Dewa Province (now Yamagata Prefecture) employed the services of the artist Gonome Sadashige, who painted Bodhisattvas and precisely detailed depictions of flowers and birds. Sadashige also left a masterly

example of *ema* (votive plaque) painting in the Wakamatsu-dera in Yamagata Prefecture (Fig. 146).

A particularly noted artist who was active at the time of the Onin War was Hosokawa Shigeyuki of Awa Province (Tokushima Prefecture), a warriorpainter closely connected with the main house of the Ashikaga clan. Among his students at one time was Toshun, whom we have already noted as a disciple of Sesshu. The surviving works of Ashikaga Yoshitsugu, a descendant of the Ashikaga clan, and of Hojo Ujishige, who is thought to have been a member of the Hojo clan of Odawara, indicate that they too were skillful representatives of the warriorpainter class.

The foregoing general look at the art world of the late medieval period reveals that the regional painters were remarkably active and that they all

154. Bokuseki *(specimen of calligraphy by a distinguished Chinese Zen priest) showing characters for "tea" (right) and "to enter" (left), by Wu-chun Shih-fan. Ink on paper. Southern Sung dynasty, early thirteenth century. Private collection, Japan.*

had their own spheres of influence. Unhampered by the restrictions and predilections of the central academy, the local schools developed independent styles attuned to their own particular regions. Individual artists produced interesting works derived from a realism that was deeply a part of their own lives. The above-noted paintings of hawks, for example, certainly reflect this realistic attitude, just as does Sesson's still life of melons and eggplants in Figure 113—a painting with an intimate smell of the soil that is not to be found in the naturalistic but nevertheless academic works of the central painting circles. The realism of these regional paintings, though perhaps rough and immature, evokes a fresh aesthetic feeling. The strength of the painters lay in the fact that they did not merely absorb Sung and Yuan styles but also proceeded to create styles of their own that were intimately related to the places where they actually lived.

The succeeding Momoyama period brings Japanese ink painting to the stage where Sung and Yuan traditions are completely assimilated in a style that displays the freshness of the new *kinsei,* or early modern, painting. It was in this period that artists like Hasegawa Tohaku (1539–1610) and Kaiho Yusho (1533–1615) mastered the styles of Mu Ch'i and Liang K'ai and created a new world of truly Japanese *suiboku* painting, as exemplified in Tohaku's *Pine Grove* screen (Fig. 143).

In bringing to a close this historical examination of medieval painting, I should like to mention another topic worthy of consideration but beyond the scope of the present book: the manner in which, during the roughly two and a half centuries of the Edo period, the flower of this art was made to wither under the feudalistic social system of the Tokugawa shogunate and its strict policy of closing the country to outside influence.

Commentaries on the Major Illustrations

FIGURE 9. Portrait of Sesshu, by Tokuriki Zensetsu. A fairly large number of portraits of Sesshu survive today, but all of them are copies of earlier works, and none survive from Sesshu's time. According to the inscription on the copy in the Fujita Museum in Osaka, there once existed a self-portrait that Sesshu painted at the age of seventy and gave to his disciple Shugetsu. Most of the portraits handed down to us seem to draw on the tradition of this one. Of the copies there are two by artists whose names we know for certain: one by Unkoku Toeki and the other, presented here, by Tokuriki Zensetsu. Zensetsu, who became the official painter at the Hongan-ji in Kyoto during the early Edo period, died in 1680 at the age of eighty-one. As a Chinese-style painter of his time, he had a sound technique, and it is therefore reasonable to suppose that this painting is a faithful copy of the original. The imposing figure, wearing a black gauze cap and priestly garments, appropriately suggests an artist who painted in a serene and sedate style. A record written on the box that contains this hanging scroll informs us that the chief priest Seigan of the Daitoku-ji wrote an inscription above the painting itself, but it was apparently removed, for it is not there today. Since Seigan died in 1661, it can be assumed that the painting dates from before that year. The painters of the early Edo period, no mat-ter what their school, all revered Sesshu as a patri-arch of ink painting, and for this reason his portrait was often painted, as in this superb example.

FIGURE 10. *Catching a Catfish with a Gourd*, by Josetsu. (See also Figure 65.) The scene shows a strange-looking figure attempting the seemingly impossible task of catching a catfish with a gourd. This rather unfathomable painting theme is taken from a Zen *koan*, a kind of examination problem given to monks when they practice *zazen*. Above the painting (see Figure 65) are inscriptions by some thirty Zen priests. Although the present format is that of a hanging scroll, the descriptive note written above the painting by the priest Daigaku Shusu of the Nanzen-ji states that it was originally mounted on a *tsuitate* (a single-panel standing screen) that was placed at the side of the Ashikaga shogun. On one side of the screen was the painting, on the other side the above-noted inscriptions, one of which states that the priest Josetsu painted this picture in a "new style" at the request of the *daishoko* (shogun-chancellor). The meaning of the xpression "new style" is not clear, but the best explanation seems to be that it refers to the fresh Sung painting style rather than to the subject matter of the picture. The work is done in a style that places it close to that of the Southern Sung painter Liang K'ai—a style that gradually became popular in Japan from about

155 (left). *Seal of Choga as it appears on right-hand painting in Figure 44 (infrared photograph)*.

156 (right). Fudo Myo-o, *by Choga. Ink on paper; height, 172.9 cm.; width, 99.1 cm. Thirteenth century. Daigo-ji, Kyoto.*

this time. Josetsu's *Wang Hsi-chih Painting on Fans* (Fig. 68) and *Three Teachers* (Fig. 66) are painted in essentially the same style. The date of the painting under discussion here can be ascribed to the Oei era (1394–1428), since the priests who wrote the inscriptions on it were all active at that time, but there are two theories that attempt to set the date more precisely. The first of these points out that the *daishoko* who commissioned Josetsu to paint the work must have been one of the Ashikaga shoguns who had the right to the title *daishoko* (that is, who was chancellor as well as shogun) and must therefore have been the third Ashikaga shogun, Yoshimitsu. Thus the work must have been painted before 1408, the year in which Yoshimitsu died. But this explanation leaves some doubt because one of the priests who inscribed the painting would have been a little too young at the time. The second

theory suggests that the *daishoko* was the fourth shogun, Yoshimochi, thus dating the work slightly later. This theory deserves careful consideration, for among the Ashikaga shoguns Yoshimochi was especially fond of art and was himself a painter. Furthermore, the term *daishoko* seems not to have been strictly limited to shoguns who had also assumed the position of chancellor. Whichever the case may be, the painting is an important work of Josetsu's in terms of both style and historical value.

FIGURE 11. *Shaka Practicing Austerities*, attributed to Jasoku. Here the artist has skillfully used a pliant brush to depict the Buddha Shaka (Sakyamuni) as he rests on the grass in the midst of his exhausting religious austerities. The painting is attributed to Jasoku, one of a number of painters who worked for the chief priest Ikkyu at the Daitoku-ji in the mid-fifteenth century. A painter

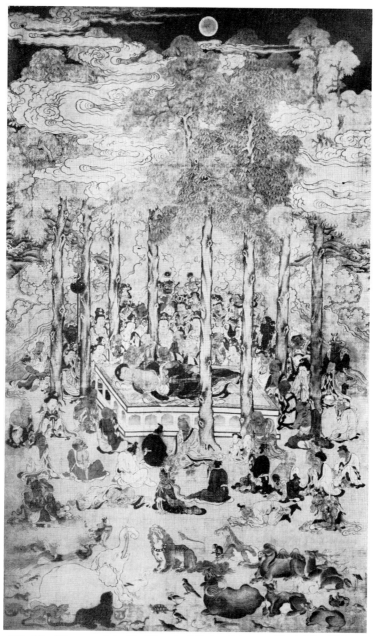

157. The Nirvana of the Buddha, *by Mincho. Colors on silk; height, 876 cm.; width, 531 cm. Dated 1408. Tofuku-ji, Kyoto.*

named Jasoku is listed in the death registry of the Shinju-an, a subtemple of the Daitoku-ji, but a great many problems must be resolved before we can identify him with certainty. The inscription at the top was written by Ikkyu in 1456 at the Shuon-an (popularly called the Ikkyu-ji), a temple in Takigi, near Kyoto, and we may assume that the painting itself was produced around that time. The so-called Jasoku group of artists surrounding Ikkyu at the Daitoku-ji were of the Soga school and were originally men who served the Asakura clan of Ichi-jogatani in Echizen Province (the present Fukui Prefecture). Ikkyu himself also seems to have had a close relationship with the Asakura clan. The famous *fusuma* landscapes in the Shinju-an, also attributed to Jasoku, are discussed in the commentary for Figure 73.

FIGURE 12. *The Nirvana of the Buddha*, by Rei-sai. Reisai, traditionally identified as a disciple of Mincho, was an *ebusshi* of the Tofuku-ji school. This Nirvana painting is probably the masterpiece among his surviving paintings. When we compare his style with that of Mincho in the Nirvana painting in Figure 157, we note that Reisai's strained brushwork, using strokes of varying thickness, is more elaborate and detailed. The inscription on the back of the mounting of this work, although of a later date, notes that the painting was produced in 1435 to serve as the main object of worship in a group of Nirvana paintings at the Jokyo-ji in Suruga Province (the present Shizuoka Prefecture). In 1463, Reisai went to Korea as an envoy of Shibukawa Norinao, a man of influence and power in Hakata. Korean historical records tell us that Reisai painted a White-robed Kannon and presented it to one of the Korean Zen patriarchs. As in the case of Shubun, it is very interesting to note this connection with Korea, but the influence of Korean painting on Reisai's style is as yet unclear. Reisai also

158. Small Landscape of Lake and Mountains, *by Ten'yu Shokei, with an inscription by Koshi Eho. Ink and colors on paper; height, 121.3 cm.; width, 34.6 cm. Fifteenth century. Collection of Akira Fujii, Osaka.*

excelled in *doshaku* paintings in ink, as exemplified in his famous depictions of Monju (the Bodhisattva Manjusri) and Han-shan (Fig. 64).

FIGURE 13. Scroll from *The Five Hundred Rakan*, by Mincho. This is a representative work by the priest-painter Mincho (also known as Cho Densu), who served at the Tofuku-ji in Kyoto as *densu*, or official in charge of the various temple buildings. The scroll is one of a set of fifty, each of which portrays ten members of an assemblage of five hundred *rakan* (*arhats*), or Buddhist ascetics who have attained enlightenment. The majority of the scrolls, together with their ink *shita-e* (underdrawings or sketches), are preserved at the Tofuku-ji. An inscription by the Tofuku-ji priest Shokai Reiken on a self-portrait by Mincho (today only a copy survives) informs us that Mincho patterned his work after the Yuan painter Yen Hui's *Five Hundred Rakan*, which had been kept at the Kencho-ji, that he devotedly painted the scrolls over a period of years, and that he finally completed the set in 1386 at the age of thirty-four. We also know that Mincho's work on the scrolls prevented him from visiting his aged mother, who lived on the rather distant island of Awaji, and that he sent her a self-portrait instead. The refined color and line of these masterpieces show that Mincho carefully studied Sung and Yuan painting. He also produced *doshakuga* in ink that display powerful brushwork (Fig. 63) and left a few *shigajiku* landscapes in ink as well (Fig. 57). In short, Mincho was a priest-painter who did pioneer work in a broad range of Sung and Yuan painting themes.

FIGURE 14. Portrait of Daito Kokushi. Daito Kokushi (Shuho Myocho), founder of the Daitoku-ji, was well known for his extreme severity and forcefulness. The unknown painter of this *chinzo* (portrait of a priest) skillfully captures the Zen master's penetrating look and distinguishing facial features. The rendering of the priestly garments is also done with admirable skill. Unlike the half-length portrait of Muso Kokushi in Figure 15, this is a formal full-length portrait: a masterpiece of *chinzo* painting that vividly recalls the appearance of the great fourteenth-century priest.

FIGURE 15. Portrait of Muso Kokushi, by

Muto Shui. Muso Kokushi (Muso Soseki), founder of the Tenryu-ji in Kyoto, was a famous Zen priest whose strong ties with the Ashikaga shogunal family enabled him to take part in certain affairs of government. From under his tutelage there emerged a succession of distinguished priests. This portrait in the Myochi-in of the Tenryu-ji, with a *rakkan* identifying it as the work of an acolyte named Muto Shui, ranks as a masterpiece among the extant portraits of Muso Kokushi. Such portaits of eminent Zen masters are known as *chinzo*. When a Zen monk practiced asceticism under a renowned master and achieved a high degree of understanding, thereby qualifying as a successor to the doctrine, he received an inscribed *chinzo* of the master in recognition of his attainment. The *chinzo* was thus a kind of certificate that served as proof of the teacher-student relationship. Muto Shui, the artist whose work is seen here, was a fourteenth-century priest-painter who left such well-known works as *Carp*, *Rakan*, and *Ten Oxen*. His long service at Muso Kokushi's side enabled him to capture quite realistically the famous priest's personality. His keen observation and careful fine-line depiction have created a portrait that stands among the masterpieces of his age.

FIGURE 16. Self-portrait, by Sesson. Sesson was active during the second quarter of the sixteenth century, when the Muromachi period was drawing to a close. He went to Aizu, in the present Fukushima Prefecture, at the invitation of Ashina Moriuji, the castle lord of Aizu Wakamatsu; erected his studio, the Sesson-an, in nearby Miharu; and spent his last years in a half-religious and half-secular kind of existence. The dates of his birth and death are uncertain, but he appears to have lived almost to the age of ninety. He greatly admired Sesshu as one of his masters but gradually developed his own independent style. Although he lived in the Tohoku region, far away from the center of painting in Kyoto, his name was widely known throughout the painting circles of his time. The painting shown here, a decidedly realistic depiction of an aged priest holding a *nyoi* (a scepterlike symbol of authority), is thought to be Sesson's self-portrait. The background, with its eerie, faint full moon above towering snow-covered

mountains, suggests the scenery of Sesson's native region. The painting is inscribed with an old Chinese poem on the theme of visiting a friend on a snowy evening.

FIGURES 36–38. *Viewing a Waterfall in the Lushan*, by Shinso; *Viewing a Waterfall*, by Shingei; and *White-robed Kannon*, by Shinno. The artists presented here are the three most famous members of the Ami school: Noami (Shinno), Geiami (Shingei), and Soami (Shinso). Noami, the first of the three Amis, as they are called, left two well-known paintings of the White-robed Kannon. One is painted in the flexible, slightly cursive *gyo* brush style derived from Mu Ch'i's *White-robed Kannon* and is shown in Figure 136. The other, shown in Figure 38, is painted in the more angular *kai* style. The long *rakkan* on this work states that Noami painted it at the Myogen-in of the Sennyu-ji in 1468 at the age of seventy-one for his son Shuken. The very scarcity of source material about Noami and the other Ami-school painters makes the painting and its *rakkan* valuable as evidence of the school's activities. In addition, we learn from the *Onryoken Nichiroku*, a record kept by the priests of the Shokoku-ji, that Shuken was a monk in charge of food supplies at a Zen temple. We also know, of course, that Noami was among the artists who served the Ashikaga shoguns. These *doboshu*, as they were called, often began their service while still quite young, and Noami himself served for many years. The date of his death had long been uncertain, but a recently discovered record tells us that he died in 1471 at the Hase-dera in Nara. Accordingly, the *White-robed Kannon* is a work from his very last years.

Noami's son Geiami (Shingei) left several paintings bearing his *rakkan* and seal. The most representative among them is *Viewing a Waterfall* (Fig. 37). It has a *rakkan* reading "Painted by Geiami at the age of fifty" as well as inscriptions by three Zen priests. The inscription by Osen Keisan of the Nanzen-ji states that the work was painted for Shokei, secretary of the Kencho-ji, when he was about to return to Kamakura after a three-year period of study with Geiami that began in 1478 (Fig. 162). We can therefore assume that Geiami painted it around 1480. It offers us a rather com-

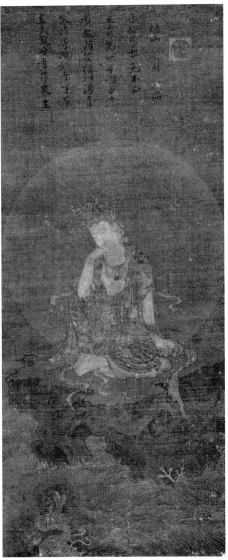

159. Nyoirin Kannon *(Cintamanicakra)*, by an unknown artist, with an inscription by Kyodo Kakuen. *(See also Figure 48.) Colors on silk; height, 87.8 cm.; width, 36.3 cm. Late thirteenth century. Taiju-ji, Aichi Prefecture.*

160. Signature of Takuma Eiga, reading "Eiga hitsu," or "brush of Eiga" (actual size; detail from Figure 45).

plicated representation of a waterfall that comes foaming down from a precipice. Behind the cascade is a mountain retreat, and in the foreground we see the figures of two travelers. The *kai* style of the brushwork perhaps reflects the brush technique of Noami. A notation in the above-mentioned *Onryken Nichiroku* leads to the speculation that Geiami may have died in 1485.

Geiami's son Soami (Shinso) also painted a waterfall, in this case an imaginative representation of a scene in the Lu-shan mountains of China. This work, entitled *Viewing a Waterfall in the Lu-shan* (Fig. 36), is done in the firm *kai* style. It stands as one of the best of the many paintings of the period that depicted this popular theme. The inscription (Fig. 163) was written by Genryu Shuko, a Zen priest at the Hoju-in of the Shokoku-ji who died in 1508, and the painting can therefore be dated not later than that year. A notation in the record known as the *Sanetaka Koki* informs us that Soami died in 1525. The fact that he painted many soft, "wet" *suiboku* landscapes in a free and informal manner

has led to the popular opinion that this style of painting is a particular characteristic of the Ami school as a whole. Nevertheless, Soami also produced works in the *kai* style like the one discussed here, and we must conclude that paintings in this style formed the backbone of the school's achievement.

FIGURE 39. *Hotei*, by Mokuan. Mokuan went to Yuan China during the early years of the fourteenth century (perhaps about 1326) and lived there for the rest of his life. Thus he was at one time considered to have been a Yuan Zen priest rather than a Japanese. This assumption was not unreasonable, for his *suiboku* paintings display a rather high degree of Sung stylistic influence. He visited the Five Great Zen Temples of China and at one of them, the Yuwang-ssu (in Japanese, Io-ji), practiced asceticism under the guidance of Yueh-chiang Cheng-yin, whom the Japanese call Gekko Shoin. Mokuan died around 1345.

Hotei (in Chinese, Pu-tai) is traditionally considered to have been a tenth-century Chinese priest and is now one of the seven Japanese Gods of Good Fortune. In the present painting, Mokuan has portrayed him with a "dry" brush and slight washes of ink. The brushwork shares characteristics with that of the Mu Ch'i tradition of Southern Sung painting. In fact, there is an interesting legend to the effect that when Mokuan visited the temple Lut'ung-ssu (in Japanese, Rikutsu-ji) in China, he was given a great welcome as the reincarnation of Mu Ch'i. Be that as it may, Mokuan can be regarded as an important Zen *suiboku* painter of the early fourteenth century—a contemporary of Ryozen and Kao Ninga.

FIGURES 40, 41. *The Priest Hsien-tzu* and *Bamboo and Sparrow*, by Kao. Each of these two hanging scrolls has two artist's seals reading Kao and Ninga. In Figure 40 the priest Hsien-tzu (literally, "the clam priest"), a T'ang-period hermit who lived on clams, shrimp, and similar foods, is pictured standing beneath an overhanging cliff with a net in one hand and, in the other, a freshly caught shrimp that he joyously holds over his head. The artist has used a strong, thick line and a rapidly moving brush to paint Hsien-tzu's robe and the rocks, at the same

time depicting the priest's laughing face with a thin, tense line that fittingly suggests the impetus for *satori* (enlightenment) in even the most common everyday event. Similarly, in *Bamboo and Sparrow* Kao has rendered the bamboo with a strong brush and quick, easy strokes. He shows us only a single sparrow chirping on a rock, but the bird's song, almost before we know it, draws us into the picture and seems even to transform the viewer into the sparrow itself. The faultless representation captures a delicate action in the midst of silence and enables us to sense a single, complete world in the painting. The work has a spiritual force that surpasses any kind of objective realism—a force inherent in *suibokuga*. We are in a realm that no mere skilled professional painter can attain: a realm achieved by a Zen priest-painter who has a long experience of asceticism.

While no reliable literary sources about Kao Ninga exist, one of his paintings does have an inscription by Issan Ichinei, the Yuan-dynasty priest mentioned in connection with the *Daruma* of Figure 46. We are thus able to make a rough guess that Kao lived in the first half of the fourteenth century. He was long confused with Ryozen (Figs. 42, 43) in painting histories and biographies, but recently discovered works confront us with the necessity of making a distinction between the two artists. Ryozen, whose brush displays *ebusshi* tendencies, painted a large number of *doshakuga* and Buddhist works in nonclassical style, but Kao's paintings, by contrast, express the unaffected dignity of a Zen priest who painted for his own enjoyment. Thus there would seem to be room for consideration of the possibility that Kao Ninga was the same person as Kao Sonen, the famous Zen priest of the Nanzen-ji who lived in the first half of the fourteenth century. But the name Ninga, written with the *ga* meaning "feliciations," indicates a possible connection with the Takuma school, which of course belonged to the *ebusshi* tradition. Moreover, an old tradition links Kao Ninga to this school. Before any firm conclusions can be reached, however, additional research must be carried out.

Kao achieves a good balance between *suiboku* techniques and Zen spiritual themes, both of which

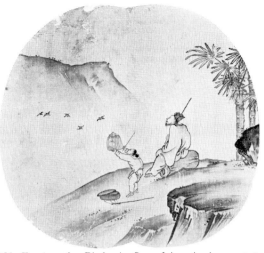

161. Freeing the Birds, *by Soyo. Ink and colors on paper; height, 26.2 cm.; width, 29.2 cm. Early sixteenth century. Shinju-an, Daitoku-ji, Kyoto.*

he brings to a rather high level of development in his paintings. Generally, such harmony between technique and theme was attained only in the fourteenth century—the period that saw the rise of the Zen sect—and was practically nonexistent before that time. Later on, ink painting became independent of Zen and proceeded with its own autonomous development. Around the time of Sesshu, to be sure, ink painting contained elements of Zen, but they had been moved more or less into the background, while the individuality of the painter advanced into the foreground. The painters were no longer *ebusshi* but had begun to take on the character of early modern artists. The conjunction between the rising vitality of *suibokuga* and the spiritual strength of Zen generated the sparks that produced the transition in early Muromachi painting.

FIGURES 42, 43. *Monju Bosatsu* (the Bodhisattva Manjusri) and *White-robed Kannon*, by Ryozen. Ryozen, a painter in the *ebusshi* tradition, was active from the closing years of the Kamakura period through early Muromachi times. We know

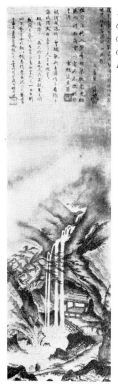

162. Viewing a Waterfall, *by Shingei (Gei-ami), with inscriptions by Osen Keisan and two other priests. (See also Figure 37.) Ink and colors on paper; height, 105.8 cm.; width, 30.3 cm. Dated 1480. Nezu Art Museum, Tokyo.*

163. Viewing a Waterfall in the Lu-shan, *by Shinso (Soami), with an inscription by Genryu Shuko. (See also Figure 36.) Ink on paper; height, 113.8 cm.; width, 29.5 cm. Early sixteenth century. Private collection, Japan.*

very little about his life, but his extant works suggest that he painted many *doshakuga* of Kannon, Shaka, and Daruma in which he employed *suiboku* techniques and that he did not produce Buddhist paintings in classical style. The *rakkan* on one of his paintings describes him as a "man from west of the sea," indicating that he may have come from the southern island of Kyushu or perhaps even from the Asian continent. The two paintings under discussion here are signed "brush of Ryozen" (Fig. 43) and "work of Fuhyosanjin Ryozen" (Fig. 42) respectively. In the latter signature three of the characters are written in mirror-image fashion, a peculiarity that may be noted in other paintings by Ryozen. The reason in the present case may be that this portrayal of Monju Bosatsu was intended as part of a triptych with the Buddha Shaka at its center and that Ryozen therefore tried to indicate some relationship with the central image. Both the

Kannon and the *Monju* carry inscriptions by Kempo Sudon, a noted Zen priest who resided first at the Shoten-ji in Hakata and later at the Tofuku-ji, the Nanzen-ji, the Kencho-ji, and finally the Engaku-ji. The *Monju* painting employs light colors and gold, but the *Kannon* painting is done entirely in *suiboku*. In the early years of the Muromachi period, *suiboku* painting finally came into its own and proceeded to evolve in the direction of painting for aesthetic appreciation alone. Ryozen was active at the time when *suiboku doshaku* painting was first beginning to establish itself.

Figures 44, 45. *Two Attendants of Fudo Myo-o,* by Choga, and *Fudo Myo-o,* by Takuma Eiga. Fudo Myo-o (Acala) is the most powerful of the Buddhist deities known as the Five Great Kings of Light (Go Dai Myo-o) and is often represented in the company of two or more boy attendants called *doji*. Takuma Eiga's portrayal of Fudo Myo-o and

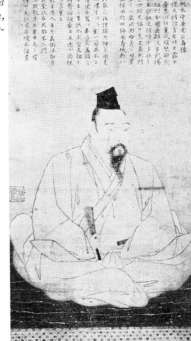

165. Portrait of Masuda Kanetaka, *by Sesshu, with an inscription by Chikushin Shutei. (See also Figure 97.) Ink and colors on paper; height, 82.1 cm.; width, 40.3 cm. Dated 1479. Collection of Kaneharu Masuda, Tokyo.*

164. Bird and Flowers, *by an unknown artist, with an inscription by Zuikei Shuho. (See also Figure 79.) Colors on paper; height, 86.6 cm.; width, 31.7 cm. Dated 1473. Collection of Yasunosuke Ogihara, Tokyo.*

his attendants Kongara and Seitaka standing on a beach pounded by waves (Fig. 45) is not characterized by *suiboku* tendencies, but it displays a remarkable degree of Sung influence in its brushwork. A gap in the rocks in the lower half of the painting contains a *kakushi rakkan* (hidden signature), done in gold, that clearly identifies the artist as Takuma Eiga (Fig. 160). The Takuma school, a new school of Buddhist painting that began to establish a reputation during the late Heian and early Kamakura periods, was still a part of the *ebusshi* tradition, but it absorbed the influence of Sung-style brushwork at a comparatively early stage in its development. Eiga, a painter of the early Muromachi period, was the last representative of the school. It is of interest to note here that Takuma-school artists generally used the character *ga* (meaning "felicitations") in their art names.

The paintings of the two *doji* attendants of Fudo Myo-o in Figure 44, each with the seal of Choga, are the left- and right-hand scrolls of a triptych that has a painting of Fudo Myo-o himself as its center, but this painting is perhaps a later addition to the set, for it bears no seal and is clearly by a different brush. The two scrolls by Choga, like the *Nyoirin Kannon* in Figure 48, show a considerable amount of Sung influence, particularly in the forceful brushwork. We run across Choga's name in literary sources from about the mid-thirteenth century and note that he is mentioned for his Buddhist painting and his *chinzo*. His painting style and his name, which contains the above-noted character *ga*, seem to indicate that he was a member of the Takuma school. The style of his paintings of the two *doji* attendants, which are the only surviving examples of his work, shows him to have been an artist who preceded Eiga and who broke ground in the Kamakura period for a new type of Buddhist painting.

166. Flowers and Birds of the Four Seasons *(right-hand screen of a pair of sixfold screens), attributed to Sesshu. Ink and colors on paper; height, 156.1 cm.; width, 366 cm. Early sixteenth century. Collection of Akiko Shinagawa, Toyama Prefecture. (The left-hand screen is shown in Figure 98.)*

FIGURES 46, 47. *Daruma* (Bodhidharma). In these two full-length representation of the patron saint of Zen seated in meditation on a rocky ledge we have noteworthy masterpieces of early Zen painting by unknown artists. The Kogaku-ji painting (Fig. 47) is done with a skillful brush, for the lines of the red garments that enfold the bulging figure display not a trace of hesitation. Although it looks like a genuine Sung painting, I think we can safely consider it a Japanese work because the *shumpo* technique used in rendering the texture of the rock produces a characteristically Japanese effect. In his inscription above the painting, Rankei Doryu (Daikaku Zenji), founder of the Kencho-ji, states that he wrote it for Ronen Koji, who seems to have been a man of influence at the time of the regent Hojo Tokimune (1215–84). Interestingly enough, the Kencho-ji owns a portrait of Rankei Doryu (Fig. 53) with a personal inscription to the effect that he wrote it for the same Ronen Koji. This inscription is dated 1271. Since Rankei Doryu died

only seven years later, the date of the Kogaku-ji Daruma painting may be close to that of the portrait in the Kencho-ji. This portrayal o Daruma, done in the Sung style, is one of the earliest of such works, and it clearly shows the stage to which Japanese painting had already evolved.

The *Daruma* in the Tokyo National Museum (Fig. 46), while closely resembling the Kogaku-ji *Daruma* in such details as the *shumpo* technique used for the rocks, has attained still more of the pure *suibokuga* quality. The refinement of line in the painting gives the figure of Daruma a somewhat lighter character. The inscription was written by Issan Ichinei (I-shan I-ning), a Zen priest who came to Japan from China in 1299. As an envoy of the Yuan dynasty, which not long before had mounted two unsuccessful invasions of Japan, he was at first disliked, but his scholarly attainments gained him the respect of his colleagues, and his poetry and calligraphy are still greatly admired today. Issan Ichinei served as chief priest at both

the Kencho-ji and the Nanzen-ji. Since he died in 1317, his inscription on this *Daruma* dates the painting to sometime between 1299 and 1317—that is, slightly later than the Kogaku-ji *Daruma*. The work itself, in which both the colors and the brushwork have become somewhat lighter, gives evidence of the process by which Buddhist devotional painting evolved toward painting for purely aesthetic appreciation.

FIGURE 48. *Nyoirin Kannon* (Cintamanicakra). The Nyoirin Kannon is one of several manifestations of the Bodhisattva Kannon. In this painting by an unknown artist (only part of the painting is shown here) we see him seated in meditation on a rock buffeted by ocean waves: a typical pose for representations of this divinity. The serene beauty of the figure, the subdued colors (enhanced by the use of gold dust), and the strong brushwork reveal the influence of Sung painting. Stylistically, the work appears to have been painted around the time when *suiboku* portrayals of Kannon became popu-

lar. Above the painting is an inscription by Ching-t'ang Chueh-yuan (in Japanese, Kyodo Kakuen), a Chinese priest who came to Japan with Wu-hsueh Tsu-yuan (Mugaku Sogen) in 1279, became the chief priest of the Kencho-ji in Kamakura around 1300, and died in Japan in 1306 at the age of sixty-two. Because the inscription was written while Kakuen was chief priest, the painting probably dates from the last few years of the thirteenth century—that is, the late Kamakura period. Buddhist painting in the preceding Heian period represented an assimilation of T'ang models that had evolved during the Nara period, but after the beginning of the medieval age it was gradually influenced by the newer Sung styles and proceeded to develop in a new direction. The *Nyoirin Kannon* shown here is an invaluable work that gives evidence of this transition.

FIGURE 72. *Landscape,* by Shuko. Shuko, honored patriarch of the tea ceremony, practiced Zen discipline under the celebrated priest Ikkyu, who is

said to have given him a specimen of calligraphy by the Chinese priest Yuan-wu K'o-ch'in (in Japanese, Engo Kokugon). This treasured gift was hung in Shuko's tearoom. His several surviving works indicate that he was quite a talented painter as well as a renowned tea master. While the landscape shown here is a rapidly painted and quite simple depiction, the firm brushwork and the solid composition show it to be the work of an accomplished artist. The *hatsuboku* (splashed ink) technique employed here may very well be derived from the style of the Chinese painter Yu Chien (Fig. 141)—a style that was popular at the time and was admired by Sesshu and other artists as well. But this work, unlike those of professional painters, has a tranquility and a gentleness that clearly reflect the artist's aesthetic sensibilities as a tea master.

FIGURE 73. *Landscape,* attributed to Jasoku. (See also Figure 151.) The Shinju-an, a subtemple of the Daitoku-ji in Kyoto, was built in 1491 with the support of Owa Sorin, an active Buddhist layman and a wealthy merchant of the port town of Sakai, which prospered from the flourishing overseas trade of the time. It was probably in the same year that the landscape shown in Figures 73 and 151 was painted on the *fusuma* of the Shinju-an. Although not all the *fusuma* survive, the work is particularly valuable because the only other *suiboku fusuma* paintings left to us from this era are those in the Yotoku-in, another subtemple in the Daitoku-ji compound. The painter of the *fusuma* landscape in the Shinju-an is traditionally said to have been Jasoku, whom we have already taken note of in the commentary for Figure 11. According to the Shinju-an death register, however, Jasoku died in 1482, nine years before the temple was built. Be that as it may, there is no doubt that these *fusuma* paintings were done by an artist of the Soga school, to which Jasoku belonged. There are several other extant works that may be of help in linking the paintings with the artist who produced them. One of these works bears a seal that can be deciphered as reading "Sekiyo"—presumably another art name of the painter in question. In any event, we can identify him as a painter who was active toward the close of the fifteenth century and who not only absorbed

elements of the Shubun style but also advanced them in the direction of early modern painting. We should also note that landscape painting up to this time lacked a clearly focused point of view or else employed methods of composition that caused the point of view to shift. Starting from about the time of the Shinju-an *fusuma* landscape, however, the point of view became fixed, and laws of perspective were worked out. Thus, when we compare this work with the screens attributed to Shubun (Fig. 75), we can sense in both its composition and its spirit the fresh breath of the approaching early modern age.

FIGURE 74. *Landscape,* by Gakuo Zokyu. The name Gakuo was for a long time considered to be merely another name for Shubun, but the discovery of the present painting, together with an entry in a fifteenth-century record mentioning the painter Zokyu, confirmed for the first time the existence of an artist named Gakuo Zokyu. The painting, now in the Tokyo National Museum, bears the *rakkan* "brush of Zokyu" and the seal "Gakuo" in its lower right-hand corner. The fifteenth-century record is the *Shaken Nichiroku,* a diary kept by the Tofuku-ji priest Kiko Daishuku, and among its entries for the year 1486 we find mention of a landscape by the priest-painter Zokyu, disciple of Shubun. Judging from the painting alone, one can understand how Gakuo was confused with Shubun. While the perpendicularly rising mountains have been moved a little to the right, the overall composition is not significantly different from that of the usual *shiga-jiku* painting. Moreover, the brushwork of the rocks and trees, while it is a little rough, reflects the so-called Shubun style of the early Muromachi period. With regard to the dating of Gakuo's works, it is of interest to note that not a few of the paintings now assigned to him carry inscriptions by Ryoan Keigo, a famous Zen priest of the Tofuku-ji who visited China during the Eisho era (1504–21) as an envoy of the Ashikaga shogunate. Ryoan Keigo knew Sesshu quite intimately and wrote inscriptions on his paintings as well. Hence Gakuo must have been active about the same time as Sesshu, although the styles of the two are considerably different and do not suggest a teacher-student relationship between

167. Landscape with Flowers and Birds *(formerly a* fusuma *painting but now mounted as two hanging scrolls), by Kano Motonobu. Ink and colors on paper; each painting: height, 178 cm.; width, 118 cm. About 1543. Reiun-in, Myoshin-ji, Kyoto.*

them. Gakuo was a painter of the conservative school who faithfully followed the style of his teacher and preserved the academic tradition.

FIGURES 75–77. *Landscapes of the Four Seasons* (Shiki Sansui), *Hermitage of the Three Worthies* (San'eki Sai), and *Mountain Landscape* (Suishoku Ranko), attributed to Shubun. Shubun, as we have noted at length in the main text, causes art historians a great deal of trouble, for not one of his paintings can be positively verified. Here we present three famous landscapes, all traditionally attributed to Shubun's brush and all painted during the period when he is thought to have been active. The *Mountain Landscape* scroll in Figure 77 (see also Figure 70) bears the inscriptions of three Zen priests above the painting. These men were Kosei Ryuha of the Kennin-ji, Shinden Seihan of

the Nanzen-ji, and Itoku Shinchu of the Tofuku-ji —all well-known priest-painters who were active in the fourth and fifth decades of the fifteenth century. Shinden Seihan, at the end of his inscription, records the date 1445, and the painting itself could thus also be dated about that time. The composition is that of the typical *shosai* (Zen priest's retreat) picture designed for the *shigajiku* (poem-and-painting scroll) format of the time. A rocky mountain peak soars up in the center of the picture, while a *shosai* surrounded by a bamboo grove and pine trees occupies the foreground. The depiction of the trees and rocks in this well-ordered work displays many elements of the so-called Shubun style.

The *Hermitage of the Three Worthies* (Fig. 76), a particularly famous scroll attributed to Shubun, is of an earlier date than the *Mountain Landscape.*

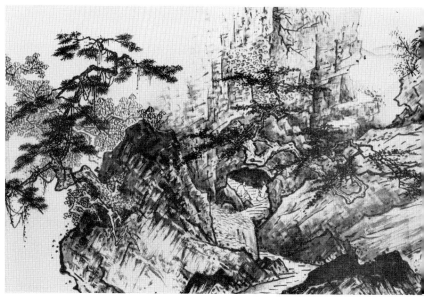

168. Signatures of Sesshu. Left: from Hui-k'o Offering His Severed Arm to Bodhi-dharma *(Fig. 108). Center: from the* Long Landscape Scroll *(Figs. 101, 122, 169). Top right: from* Landscapes of the Four Seasons *(Fig. 106). Bottom right: from* Winter Landscape *(Fig. 100).*

Again the composition features towering rocky mountains at the center and, in the foreground, a *shosai* surrounded by pine trees and bamboo and, in this case, plum trees as well: the "three worthies" or "three friends," as they are called, since they were regarded as the loyal companions of the literati and eventually came to symbolize the purity and integrity of men of this class. Above the painting are the poetic inscriptions of the well-known Nanzen-ji priest Gyokuen Bompo and eight other Zen priests (Fig. 96). Accompanying this scroll is a second one containing a long preface written in 1418 by Gyokuen Bompo. According to Bompo's account, the patriarch Chuwa Shonin of the Tofu-ku-ji commissioned this *shosai* picture from a professional painter and gave it the name by which it is known today: *San'eki Sai,* or *Hermitage of the Three Worthies.* It is a relatively early scroll among the *shigajiku* attributed to Shubun. The brushwork

shows an openheartedness and sprightliness that we do not find in the more mature brushwork of the *Mountain Landscape.* In fact, the contrast in technique is quite distinct, and any discussion of Shubun's painting must certainly take into account these two representative scrolls, even though there are two or three other paintings, presumably by Shubun, in which the brushwork resembles that of the *Hermitage of the Three Worthies.*

In addition to the *shigajiku* we must consider screen paintings. Numerous pairs of screens have been traditionally assigned to Shubun, among them the *Landscapes of the Four Seasons,* of which the right-hand screen is shown in Figure 75. This screen depicts the spring and summer landscapes, while the left-hand screen, shown in Figure 90, contains those of autumn and winte . The entire expanse of the two screens seems to portray some, if not all, of the celebrated Eight Views of the Hsiao and the

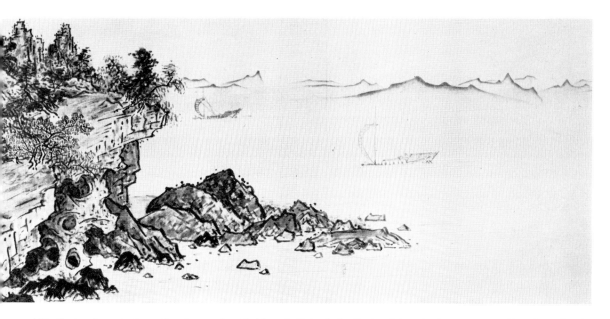

169. Section from the Long Landscape Scroll *(Sansui Chokan)*, by Sesshu. *Ink and colors on paper; dimensions of entire scroll: height, 40 cm.; length, 1,807.5 cm. Dated 1486. Mori Foundation, Bofu, Yamaguchi Prefecture. (See Figures 101 and 122 for other sections of the scroll.)*

Hsiang by joining several of the individual scenes together to form a single large-scale landscape. The method of combining separat scenes to compose a single large-scale work, as we observe it in the early examples of screen and *fusuma* painting, had a tendency to weaken the overall coordination by giving each section of the composition an independent quality. The screen presented here, although it still reflects this method, has to a certain extent achieved a coordination and harmony of the total painting surface.

The work bears no artist's seal or signature, but in one corner of each screen the Edo-period painter Kano Tan'yu (1602–74) has written his judgment that it is from the brush of Shubun. Whether Tan'yu was correct or not, these landscape-screen masterpieces from the early Muromachi period decidedly fit the concept of Shubun's style. In the *shigajiku* paintings the emphasis lies in the poetic inscriptions rather than in the pictures themselves, and in this respect many of them can perhaps be better treated as literature than as painting, since the pictures tend to be mere accompaniments to the writing. Screen painting, on the other hand, is true painting for its own sake, and the true landscape-painting tradition of the Muromachi period may be said to be more clearly represented by the *shoheiga* (screen and *fusuma* painting) than by the *shigajiku*.

FIGURE 78. *The Layman Yuima*, by Bunsei. For a long time Bunsei was confused with Josetsu, but today it has become clear that he was a separate individual from either Josetsu or Shubun. This splendid depiction of the Indian Buddhist layman Yuima (in Sanskrit, Vimalakirti) is one of several of Bunsei's recognized works. In 1457 Sonko Somoku, chief priest of the Tofuku-ji and the Nanzen-ji, wrote a long inscription above the painting to the

effect that the Zen priest Zenzai Suza, in fulfillment of the deathbed request of his father, Suruga no Kami Arakawa Akiuji, converted his father's estate into a temple and, in one of the buildings, hung this painting of Yuima to recall his father's image. Such an account seems entirely plausible, for this masterwork, painted with a forceful brush, depicts a man with a strong spirit. The fact that Bunsei also painted in the Korean style indicates the need for investigation of the relationship between his works in this style and Korean painting in general, for the Korean influence links him with Shubun and a number of other Muromachi painters.

FIGURE 79. *Bird and Flowers*. The painter of this carefully executed work in the flower-and-bird (*kacho*) genre is unknown, but the painting itself displays the influence of Sung and Yuan works in the naturalistic (*shasei*) manner. Such flower-and-bird paintings were popular among the later artists of the Kano and Sesshu schools, but this work is particularly valuable because it was done in the Bummei era (1469–87)—that is, at an early time for flower-and-bird painting in Japan. The inscription above the painting (Fig. 164) was written by Zuikei Shuho, who served as *sorokushi* (manager of general affairs) at the Kyoto temple Rokuon-in. Here he states that he is eighty-three years old (eighty-two by Western count) and gives the year as 1473. Since he died in the same year, this is one of the last examples of his calligraphy.

FIGURE 80. *Horse and Groom*, by Shokei. Shokei, as we have already noted in the discussion of Geiami's *Viewing a Waterfall* (Fig. 37), was the *shoki*, or secretary, of the Kencho-ji. He was also known as Kei Shoki (Secretary Kei) and had the art name Kenko as well. After some three years of study under Geiami in Kyoto, he returned to the Kencho-ji, became a leader in Kamakura painting circles, and taught such artists as Keiboku and Keison. In addition to his landscapes, which are characterized by strong brushwork resembling that of his teacher Geiami's *Viewing a Waterfall*, he produced paintings of human figures and of flowers and birds. His works in the latter genres demonstrate that he eagerly studied Sung and Yuan paintings. The *Horse and Groom* of Figure 80, a graceful, quiet pic-

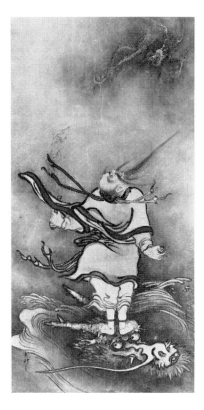

ture painted with an extremely fine, steady brush, points to his having studied the Yuan painter Chao Tzu-ang.

FIGURES 81, 82. *Crane on a Pine Branch*, by Kano Motonobu, and *Chou Mao-shu Admiring the Lotus Flowers*, by Kano Masanobu. The Kano school, founded by Kano Masanobu (1454–90), made its entrance into the Ashikaga shogunate academy when the leadership of the academy passed from Sotan to Masanobu and his son Motonobu in the second half of the fifteenth century. From that time on, for some four centuries, the Kano school monopolized the academy despite all the changes that took place in the political world—particularly the changes in leadership that ushered in the Momoyama and the Edo periods. Of the several Masanobu landscapes that survive, the one presented here (Fig. 82) pictures the Northern Sung man of letters Chou Mao-shu floating serenely in a boat

170. Ryodohin *(the Taoist Immortal Lu Tung-pin), by Sesson. Ink on paper; height, 118.5 cm.; width, 59.4 cm. About mid-sixteenth century. Yamato Bunkakan, Nara.*

171. Inscription by Sesshu on the Haboku Landscape *(Figs. 103, 112), dated 1495.*

and admiring the flowers in a lotus pond. This frequently used theme was one of four that reflected the predilections of the Chinese literati: Chou Mao-shu's lotus flowers, T'ao Yuan-ming's chrysanthemums, Li Ho-ching's plum blossoms, and Wang Shan-ku's orchids. Masanobu's painting takes us into the tranquil world of the literati by showing us Chou Mao-shu at ease among his favorite flowers.

It was Masanobu's son Motonobu (1476–1559) who firmly established the style of the Kano school. Among his masterpieces are the *fusuma* paintings in the Reiun-in, a subtemple of the Myoshin-ji in Kyoto that was built in the middle years of the sixteenth century. The work comprises a flower-and-bird landscape painted across several *fusuma*. In the sections shown in Figures 81 and 167, there is a marked contrast between the rushing movement of the waterfall in the background and the tranquility of the motionless crane in the foreground. The style of the painting, inherited from Masanobu, is ordered by Motonobu's firm, steady brush. This same style was transmitted to such later Kano masters as Eitoku (1543–90) and Sanraku (1559–1635), who represent the golden age of the Kano school.

FIGURE 97. Portrait of Masuda Kanetaka, by Sesshu. This is a portrait of the daimyo of Iwami Province, which today forms the western part of Shimane Prefecture. At the left of the painting is a seal reading "Sesshu," and at the top (see Figure 165) is an inscription by Chikushin Shutei, who was the chief priest of the Toko-ji in Iwami Province. The inscription states that the portrait was painted in 1479, the year in which Sesshu would have reached the age of fifty-nine. As we know, Sesshu was active chiefly in Suo Province (Yamaguchi Prefecture) both before and after his visit to Ming China in 1468 and 1469 and had strong ties with the Masuda daimyo family. In fact, there is a tra-

172 (far left). Enlargement of seals from Shikibu's Monkey (Fig. 173), reading (top) "Terutada" and (bottom) "Shikibu."

173 (left). Monkey, by Shikibu (formerly attributed to Ryuko). Ink on paper. Early sixteenth century. Private collection, Japan.

174 (right). Landscapes of the Four Seasons (right-hand screen of a pair of sixfold screens), by Shikibu (formerly attributed to Ryuko). Ink and colors on paper; height, 153 cm.; width, 346 cm. Early sixteenth century. Seikado, Tokyo. (Two panels of the screen are shown in Figure 117, and a section of the left-hand screen appears in Figure 175.)

dition to the effect that he died in Iwami. It is therefore not at all strange that he should have painted a portrait of Masuda Kanetaka. In this painting, instead of employing his characteristic strong brushwork in the Chinese style, he renders the face and the clothing with a delicate touch that seems to reflect the *yamato-e* tradition. But even here we see an uncommon firmness in the handling of the brush. The work is a rare one among portraits by Sesshu, and it reveals him to be a true master of realistic representation.

FIGURE 98. *Flowers and Birds of the Four Seasons,* attributed to Sesshu. (See also Figure 166). The painting shown here occupies the left-hand screen of a pair of sixfold screens depicting flowers and birds set in landscapes of the four seasons. The geese, sparrows, reeds, and blossoming plum tree represent autumn and winter. There is an interesting contrast between the strong rendering of the plum tree and the relaxed manner in which the geese are treated. The right-hand screen (Fig. 166) presents a forceful depiction of two cranes in a grove of pine trees and bamboo. Neither painting bears a signature or a seal, but both are decidedly in the typically strong Sesshu manner. There are several other flower-and-bird screens attributed to Sesshu, some with *rakkan* and even some with a date, but it is extremely difficult to determine whether any of these are authentic works of his or not. Still, it is not unlikely that he painted in this genre, for it was a popular one in his time, and many excellent works of the type were produced. In the several masterly screens like this one that exist today, we can recognize the unfolding of the contemporary Sesshu style. Such flower-and-bird painting, beginning with the artists of Sesshu's Unkoku-an studio, developed and spread throughout the various schools of the late Muromachi and the Momoyama periods, finally coming to a gorgeous climax in the Momoyama *fusuma* and screen paintings.

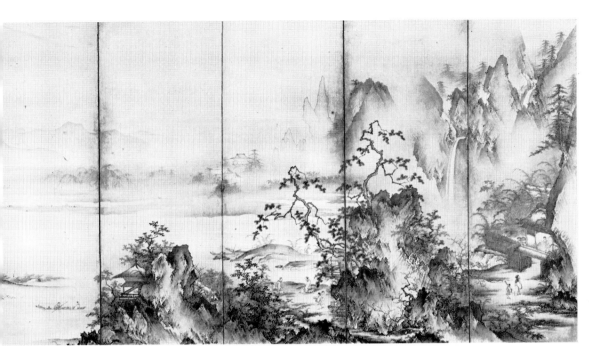

FIGURE 99. *Landscape*, by Sesshu. While Sesshu of course studied Ming landscape painting (it was Ming China that he visited), he also studied the works of various Sung and Yuan masters, as we can see in the several existing copies of these that he made, all in the round-fan shape. The landscape shown here is one such copy. It bears both Sesshu's *rakkan* and the name of Hsia Kuei, the Southern Sung artist who painted the original work. On other copies (Figs. 126–29) we find the names of Li T'ang, Liang K'ai, Mu Ch'i, Yu Chien, and other painters. Such copies formed the foundation for Sesshu's major works, and thus, among his own landscapes, we sometimes find paintings that reveal both an absorption and a mastery of these earlier continental styles.

FIGURE 100. *Winter Landscape*, by Sesshu. It is quite likely that this painting originally belonged to a set of hanging scrolls picturing landscapes of the four seasons, but today only the autumn and winter

landscapes survive. Sesshu produced copies of two landscapes by Hsia Kuei: the one discussed in the commentary for Figure 99 and the one shown in Figure 129. Since the latter painting is quite similar in composition to the *Winter Landscape*, it is possible that here we have a recasting of a Hsia Kuei work. In any case, Sesshu has reordered Hsia Kuei's complicated mountains and rocks and has constructed his usual solid composition. The powerful brushwork once again reveals another of Sesshu's intrinsic qualities.

FIGURE 101. *Long Landscape Scroll* (Sansui Chokan), by Sesshu. (See also Figures 122 and 168.) This superlative scroll, running to more than eighteen meters in length, is usually considered to be the greatest of Sesshu's surviving works. It pictures the progression of the four seasons: an old theme originally transmitted from China and so widely and eagerly employed by the Japanese that it will probably survive for ages to come. According to the

inscription at the end of the scroll, Sesshu painted this work in 1486 at the age of sixty-six. Although there is some doubt about the authenticity of the inscription because it was written on a separate piece of paper and attached to the scroll, the stylistic traits of the work tend to support the date.

We have already noted that Sesshu studied the styles of such Chinese artists as Hsia Kuei. Although the *Long Landscape Scroll* is indisputably in Sesshu's own highly personal style, we can see a fair degree of Hsia Kuei's influence in the techniques of representing the mountains and trees. While the majority of surviving Muromachi landscapes are in the form of hanging scrolls or screens, Sesshu skillfully employed the format of an extremely long horizontal scroll for an imaginative depiction of the scenery of China in a panorama of changing seasons. He includes landscape scenes made up of rugged mountains, fantastic rock formations, and boats floating down endless rivers. Into these scenes he inserts people's homes, villages and towns, and crowds including all manner of persons. All this is the product of his careful observation and the sketches he made during his year in China. Thus the scroll, painted after his return to Japan, is a clear reflection of his experience on the continent. Again, even though the work contains sections obviously derived from the style of Hsia Kuei, it more than adequately demonstrates the power and the creativity that enabled Sesshu to establish his own individual world of art.

FIGURE 102. *Summer Landscape,* by Sesshu. (See also Figure 106.) While most of Sesshu's surviving works were painted after his return from China, we have a few that were painted during his sojourn there. Particularly famous among the latter is the set of hanging scrolls known as *Landscapes of the Four Seasons* (Fig. 106), of which the *Summer Landscape* is shown here. Each of the scrolls has a seal and a signature reading "Toyo, Japanese man of Zen" (Fig. 168): the signature Sesshu used while he was in China. Unlike the works he produced after his return to Japan, the four scrolls reflect both the composition and the brushwork characteristic of Ming painting styles. In fact, the style of the Che school, popular in China at the time of Sesshu's

visit, is so strongly felt in these paintings that at one time they were considered likely to be authentic works of that school. Sesshu himself, in the inscription above the *Haboku Landscape* (Fig. 171), records that in China he learned from the two artists Li Tsai and Chang Yu-sheng. Chang Yu-sheng does not appear in histories of Chinese painting, but we know that Li Tsai was a Che-school artist. One of his surviving works in Japan (Fig. 105) is a landscape with a central mountain that closely resembles the one in Sesshu's *Summer Landscape*. Sesshu, however, was not satisfied with the Che-school style and soon abandoned it to set out in his own personal direction.

FIGURE 110. *Hotei,* by Shutoku. Among the immediate disciples of Sesshu we can name Soen, Shugetsu, Shutoku, and Toshun. Shutoku is said to have been the artist who inherited the Unkoku-an after Sesshu's death. A number of his works survive, including this *Hotei,* which is perhaps his most representative work. In this painting we can observe the influence of Sesshu, but the abbreviated style of brushwork is in an old tradition that predates Sesshu's time. The painting is embellished with a poetic inscription by the Daitoku-ji priest Senrin Sokei. (For an explanation of the Hotei theme, see the commentary for Figure 39.)

FIGURE 111. *Ama no Hashidate,* by Sesshu. Among Sesshu's paintings this work is famous as a naturalistic (*shasei*) depiction of an actual scene. One other such realistic painting by Sesshu was *The Jinta Waterfall* (Fig. 107), picturing a scene in Oita Prefecture, but unfortunately it was destroyed in the great Kanto earthquake of 1923. Ama no Hashidate (Bridge of Heaven) is one of the traditional "three most scenic spots" in Japan. Sesshu's painting of it was probably based on sketches done on the spot and, as such, is a forerunner of naturalistic portrayal in Japanese painting. It has the feeling of a rough sketch, but it effectively conveys the actuality of the scene: the bay and the mist-draped mountains as Sesshu saw them and remembered them. It leaves no doubt of his assurance in the realm of realistic painting.

Recent research concerning the date of the painting has produced some interesting and valuable

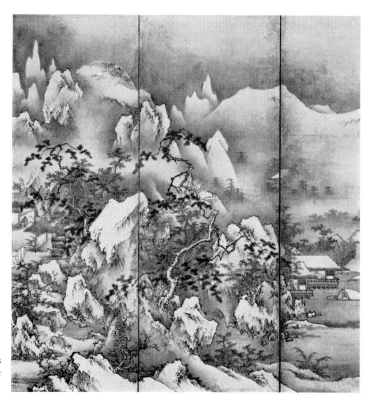

175. *Section of left-hand screen of* Landscapes of the Four Seasons, *by Shikibu. (See Figures 117 and 174.)*

information. We now know that the *tahoto* (single-story pagoda) of the Chion-ji, seen on the small wooded peninsula in the lower left half of the painting, was begun in 1500 and completed in the spring of 1501. We also know that the buildings of the Nariai-ji, which appear in the mountains at upper right, were burned down in 1507 in one of the periodic conflicts of the Sengoku age. (It is of interest to note here that Sesshu labeled a number of the sites in this painting.) Since Sesshu is thought to have died in 1506 at the age of eighty-six, he must therefore have painted the panorama of Ama no Hashidate when he was at least eighty-one. Most probably the date was around 1503. In any event, it is truly astonishing that even then, when he had reached such a venerable age, neither the power of his brush nor his ability to undertake long pilgrimages on foot showed the least indication of decline.

Figure 112. *Haboku Landscape,* by Sesshu. (See also Figures 103 and 171). This landscape was painted for Josui Soen, a priest-painter of the Engaku-ji, when he was about to return to Kamakura after completing his training under Sesshu. The painting, formerly kept in the Jisho-in of the Shokoku-ji and now in the Tokyo National Museum, has come to be known as the *Haboku Sansui* (literally, "Broken-Ink Landscape"), although it should more properly be called the *Hatsuboku Sansui* (literally, "Splashed-Ink Landscape"). The painting terminology in old Chinese books became confused in Japan because of the inherent difficulty in explaining it. In Chinese, both "broken ink" and "splashed ink" are known as *p'o mo,* although the character *p'o* is different in each case. In Japanese, the distinction becomes clear because "broken ink" is *haboku* and "splashed ink" is *hatsuboku.* The confusion undoubtedly arose from the similarity of the

two terms in spoken Chinese. Their written forms, however, are different.

At the top of the scroll are the inscriptions of six Zen priests: Getsuo Shukyo, Rampa Keishi, Ten'in Ryotaku, Seiso Ryoto, Ryoan Keigo, and Keijo Shunrin. Beneath these inscriptions, Sesshu has written a long one of his own (Fig. 171) in which he dates the work 1495, when he was seventy-five years old, and tries to encourage his pupil Soen by recalling his trip to Ming China, speaking of his own painting studies, and giving his opinions on his predecessors Josetsu and Shubun. The inscriptions of the Zen priests inform us that this landscape was painted in the *hatsuboku* method, which Sesshu had learned from Yu Chien, the famous poet-priest of the Yuan dynasty. Yu Chien's paintings of the mountain range Lu-shan and the Eight Views of the Hsiao and the Hsiang (Fig. 141) still survive in Japan today. Sesshu seems to have had great respect for Yu Chien, for he painted several abbreviated *hatsuboku* landscapes derived from Yu Chien's style, including the one shown here.

FIGURE 113. *Melons and Eggplants,* by Sesson. We have already taken note of Sesson and his self-portrait in the commentary for Figure 16. In addition to that work and other familiar portrayals like his unconventional representation of the *sennin* (hermit sage) Ryodohin (Fig. 170), he has left a number of fresh, realistic paintings of flowers and birds, fruits and vegetables, and the like. The present small scroll, handed down for years in the Aizu region, where Sesson lived, is a *shasei*-style work in which he uses a fine brush and soft colors to picture a group of melons and eggplants. His treatment reveals his thorough familiarity with his subject. Unlike most of his predecessors, he did not attempt to depict an ideal world through the use of traditional brush techniques. Instead, being altogether intimate with the earth, he dealt with subjects close at hand, viewed them directly, and painted them without any affectation at all. In this excellent still life, his melons and eggplants have the air of being fresh from the field, with the smell of the soil still upon them. And here we can sense the dawn of a new age in painting: the first intimations of the approaching early-modern era.

FIGURE 114. *Hibiscus and Quail,* by Toshun. Toshun was one of the disciples of Sesshu's old age. He began his studies in painting while he was still quite young, and it appears that he was the master's attendant on a number of his walking tours and pilgrimages. He is often mentioned in the *Tohaku Gasetsu,* a record of the Momoyama artist Hasegawa Tohaku's observations on painters and painting, and we gather that he was Tohaku's teacher. Among his surviving works is a pair of sixfold screens mounted with paintings of flowers and birds and of human figures. The work shown here is one of these paintings. Like the other paintings attached to the screens, it bears a poetic inscription by Keijo Shurin, a renowned poet-priest of the Shokoku-ji. According to a collection of Shurin's writings, these inscriptions were written around 1512 at the request of Ouchi Yoshinori, the powerful daimyo of the Yamaguchi region at that time. Because the Ouchi family was Sesshu's patron and because Yamaguchi was the location of the Unkoku-an studio, we can surmise that Toshun had a close relationship with Sesshu. The present *Hibiscus and Quail* is a superlative work in which Toshun demonstrates that he studied not only the style of Sesshu but also that of the realistic paintings of the Sung and Yuan academies.

FIGURES 115, 116. *Camellias and Small Bird* and *Hibiscus and Insect,* by Soyo. Soyo, a painter of the Soga school, had strong ties with the Daitoku-ji, and several of his paintings survive today in the Daitoku-ji subtemple Shinju-an. We are told that these paintings were originally pasted on the dais of a Buddhist altar. Although there is no certainty about the dates of Soyo's birth and death, it is supposed that he lived in the sixteenth century toward the close of the Muromachi period. The works presented here, like those of Toshun, show that Soyo studied Sung and Yuan academic painting in the *shasei* style. Such paintings in the flower-and-bird genre achieved popularity in the Muromachi period, and in the following Momoyama period their themes became those of the large-scale *shoheiga* (screen and *fusuma* painting), thereby undergoing a most brilliant development into decorative painting.

FIGURE 117. *Landscape*, by Shikibu (attributed to Ryukyo). (See also Figures 174 and 175.) In one corner of this pair of sixfold screens there are two seals reading "Shikibu" and "Terutada" that tell us this is the work of an artist named Shikibu Terutada. While there are a number of paintings bearing these two seals, heretofore they have been said to be the work of an artist named Ryukyo—a misattribution resulting from the difficulty of reading the seal-style characters for "Shikibu," which had long been misread as "Ryukyo" (Fig. 172). The name Shikibu comes up two or three times in painting histories and biographies but appears not to refer to only one person. It is therefore uncertain exactly who Terutada was, but his works, taken as a whole, seem to fit into the tradition of the Soga school, since their special characteristic is a busy painting surface covered by a very active brush. We note as a distinguishing feature the intricately angular depiction of rocks and trees. Such features had actually lain dormant from an earlier time within the Soga-school style, but they were violently exposed amidst the turmoil of the Age of the Country at War. This phenomenon, which leans toward the baroque, is one of the extremely interesting tendencies of the period.

The *"weathermark"* identifies this book as having been planned, designed, and produced at the Tokyo offices of John Weatherhill, Inc., 7-6-13 Roppongi, Minato-ku, Tokyo 106. Book design and typography by Meredith Weatherby and Ronald V. Bell. Layout of photographs by Ronald V. Bell. Composition by General Printing Co., Yokohama. Color plates engraved and printed by Nissha Printing Co., Kyoto. Gravure plates engraved and printed by Inshokan Printing Co., Tokyo. Monochrome letterpress platemaking and printing and text printing by Toyo Printing Co., Tokyo. Bound at the Makoto Binderies, Tokyo. Text is set in 10-pt. Monotype Baskerville with hand-set Optima for display.

Although the individual books in the series ar⌐ ⌐ose
subjects according to their personal interes⌐
will be of increasing reference value as ⌐
roughly chronological, as those of the o⌐
already been published or will appea⌐
rate of eight a year, so that the Eng⌐